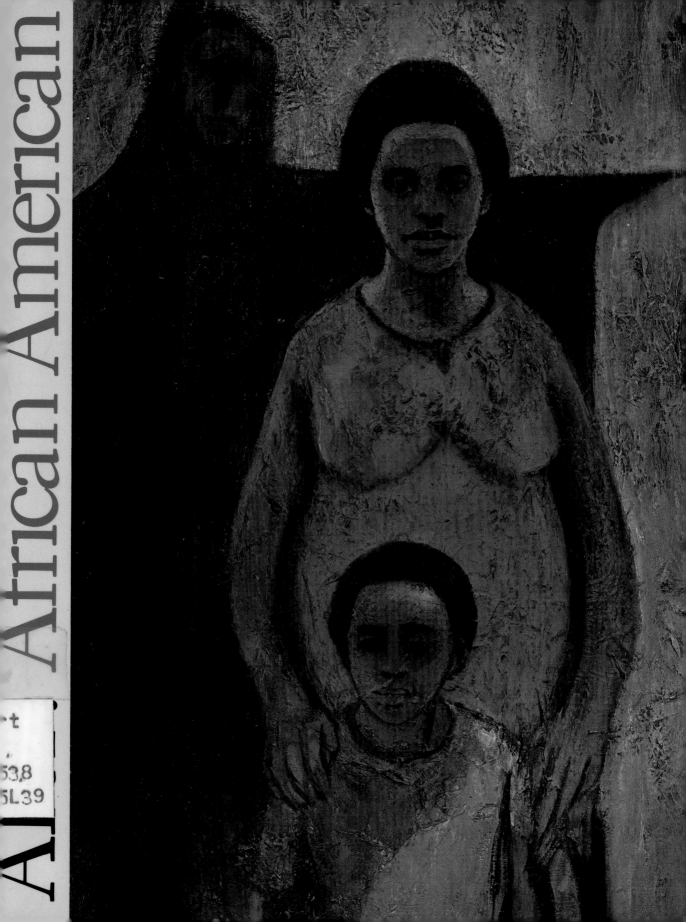

African American

ART: AFRICAN AMERICAN

ART:
African American

SAMELLA LEWIS

Scripps College, of The Claremont Colleges

HARCOURT BRACE JOVANOVICH, INC.

New York San Diego Chicago San Francisco Atlanta

Cover: Samella Lewis, *Royal Sacrifice*, 1969. Oil, 36″ × 24″.
Collection of Mary J. Hewett, Santa Monica, California.
(Photograph by Joseph Schwartz.)

ISBN: 0-15-503410-3

Library of Congress Catalog Card Number: 77-78732

Printed in the United States of America

Foreword

In the history of American art, the contributions made by Black people are significant and little understood or appreciated. There is a need to make known the uniquely creative, artistic, and philosophical aspirations, social motivations, and scope of Black artists throughout the development of the arts in the United States.

Beginning with the arts produced in the Colonial period, Dr. Lewis documents and interprets the flow of creative productions of a social segment of the American population. Her book shows that the range of art produced by Black artists covers the entire spectrum of craft productions through painting, sculpture, and printmaking. There is a progressive development of style that not only reflects the trends in particular periods but reveals an evolving pattern of indigenous qualities that are distinct.

The art community in general and the Black community in particular are fortunate to have Dr. Samella Lewis, for she has developed unusual authority in the area of Afro-American art. I know that *Art: African American* will be of great value educationally and that it will offer a stimulating and rewarding experience to all those who have the opportunity to view its contents.

Jacob Lawrence

*To those Black educators of the past who
helped to instill an appreciation of selfhood
and an abiding respect for personal dignity*

Preface

With all that is finally being written today about Black Americans and their past, there is still a need for much more related research and analysis. One area in which this need is very apparent is the history of the art of Black America. For like Black scientists, Black artists have been given little or no attention in histories of the United States. Of all Black artists only a few writers, vocalists, and musicians have occasionally made their way into the textbooks.

Art: African American is an attempt to remedy this omission by uncovering the contributions of Black visual artists and artisans in the United States. It begins with the remnants of seventeenth-century slave handicrafts and proceeds through the intervening centuries to the artistic explosion of the mid-twentieth century. Throughout the book the biographical sketch is used as the primary tool, for it reveals both the personal lives of the artists and the public attitudes of their times.

The many individuals who contributed to this work are too numerous to mention here, but I would like to express my appreciation to a few who were directly instrumental in making this publication possible.

My sincere thanks go to the many artists who contributed to this book in multitudinous ways. The use of photographs of their works and permission to publish their comments represent only a small measure of their coooperation. My thanks are also extended to the

individuals and institutions who permitted the publication of works from their collections.

Great assistance, insight, and inspiration were also rendered by James Grimes, my friend and former mentor, by David Simolke, my friend and former graduate assistant, as well as by my colleague E. J. Montgomery and other members of the National Conference of Artists.

Particular appreciation is extended to members of the publisher's staff—Merton Rapp, Carolyn Johnson, Lynda Gordon, and Harry Rinehart—for their dedication and sensitive guidance in the enrichment and production of this book.

My greatest indebtedness, however, is to the members of my family. Their continued encouragement, patience, assistance, and enthusiasm made the entire project a truly rewarding experience for me.

Samella Lewis

Contents

x

ART: AFRICAN AMERICAN

Introduction

Today African-American artists are energetic participants in a cultural revolution. Driven by needs that are both social and aesthetic, the African-American artist searches for cultural identity, for self-discovery, and for self-understanding.

Contemporary Black artists are creating their own kind of art. Unlike most of their predecessors, they refuse to be dominated by the accepted aesthetic standards, especially those by which their African forefathers have been erroneously labeled culturally primitive. Responding to their own life styles, Black Americans are creating an art from the depths of their own needs, actions, and reactions. They are again at long last accepting and using their own philosophies as the basis of their artistic expression.

Interest in Black art grows rapidly throughout the world. The emergence of Africa from foreign domination and that continent's struggle to regain its own ways of life while participating in a complex world structure contribute greatly to this increased interest.

Public interest in Black art also results from an increase in the number of artists who are devoting their energies to the production of works for the benefit of Black peoples. As a result, Black art is now evident in many aspects of the American and the international art scenes. There are Black galleries in every section of this country, and international exhibitions of Black art are not unusual. The number of Black students in art schools and art programs

in colleges and universities has increased in the last forty years from near zero to many thousands. And in art criticism and the study of art history, African Americans are rapidly increasing the number of distinguished positions they hold.

The alternatives for Black American artists have been quite clear. Either they must work to realize and promote the inherent qualities that make Black art a valuable, functional force in society or they must become absorbed in the dominant culture of the United States and lose the indigenous values of a vital Black cultural heritage.

Black artists today can do much to strengthen their role in society. In their search for direction, they must be mindful of the unique situations and purposes that confront them as artists. They must also be cognizant of their obligations and responsibilities to their communities. Since a lack of adequate knowledge of the past is frequently an obstacle to the present, a primary obligation of Black artists is to understand and use, whenever possible, remembrances of the African cultural heritage. A second obligation is to understand the power of art and the use of that power to inform and educate.

The Black artist should also establish a direct relationship with Black people at all socioeconomic and educational levels. In this role the artist is an interpreter, a voice that makes intelligible the deepest, most meaningful aspirations of the people. The artist is a channel through which their resentments, hopes, fears, ambitions, and all the other unconscious drives that condition behavior are expressed and become explicit. In this role the artist is a community resource, valued and supported because he or she forsakes the "ivory tower" and gets to the heart of community life.

What kind of art meets the Black artist's obligations to the community? First, these obligations require an art that is functional, an art that makes sense to the audience for which it was created. They also require a highly symbolic art that employs the symbols common to Black lives. Next, art by African Americans should reflect a continuum of aesthetic principles derived from Africa, maintained during slavery, and emergent today. The art that the Black artist produces should also be relatively inexpensive to buy. This does not mean, as one might suppose, that only drawings and prints rather than paintings and sculpture should be produced. It does, however, mean that volume production at a low cost is a primary consideration. Black art should also help to enrich the physical appearance of the community. This does not mean uncontrolled graffiti and fanciful

4

false facades on buildings. It does mean the use of every legitimate opportunity to enhance the quality of the environment. Finally, the obligations of the Black artist require a diverse art: an art that explores every avenue of search and discovery, an art that exploits every possible quality of individual difference in the artist who produces it.

The challenge to African Americans, especially African-American artists, is to find ways to use both the spiritual and material powers of art in such a way that the visual arts become a vehicle for the understanding of people. This will be possible only when the arts reflect the true spirit of all people and make explicit the African roots that enrich and strengthen African Americans.

This book is a review of the history of Black art in the United States. It is about the art of a people forcibly brought to this country from Africa as slaves, how they bent to forces outside their control but never broke, and how they struggled with cultural, economic, and social deprivation to become a strong, creative segment in American society.

Cultural Deprivation and Slavery
1619-1865

In 1619 a Dutch ship transported twenty Africans from West Africa to the British colony of Jamestown on the eastern coast of North America. Its arrival marked the beginning of the involuntary servitude of Blacks in North America, a condition that lasted for more than two hundred years.

This first shipment of Africans began their lives in America as indentured servants, and, for the next forty years, indentured but "free" Blacks participated regularly in the work force of Britain's North American colonies. During this period, Blacks held equal status with whites in similar work roles. Moreover, upon completion of their period of service, indentured Blacks were assigned land and viewed as freemen.

But as the economy of the colonies expanded, and it became increasingly difficult to meet the domestic and European demands for goods (partly because of a shortage of steady, cheap labor), the colonial attitude toward Blacks began to change. White indentured servants in the colonies were still too few in number to be an adequate work force, and the need to replace such workers when their period of servitude expired was a recurring problem. Once their indentures were completed, most workers imported from Europe soon left their assigned positions to venture out on their own. Those who remained stable employees often insisted upon exorbitant rates for their skills and products.

The ready solution to the colonies' labor problem appeared to be the enslavement of Africans: they seemed available in virtually inexhaustible numbers, and there was thought to be a moral justification for their importation. Would not the "good Christians" of the New World be rescuing the Africans from a "heathen existence of sin" and teaching them to follow the "one true path" to salvation?

The cultural cost of being "rescued" was high, for slavery had a damaging and thwarting influence on the creativity of Black Americans. As Alain Locke (1886–1954), the first Black Rhodes Scholar and a former professor of philosophy at Howard University, argued, particularly in the booklet *Negro Art: Past and Present* (1933), slavery not only transplanted Africans from their homeland but also abruptly cut them off from their cultural roots: it took away their languages, drastically changed their social habits, and placed them in the midst of a strange and frequently hostile society.

Slavery in the New World was indeed a traumatic cultural shock for transplanted Blacks; yet not all the African arts of myth and ritual, not all the traditional techniques of their native land, were completely lost to the slaves in their new environment. Many continuations of the cultural past thrived with the simple need to communicate. Since slaves from one area of Africa were often unfamiliar with the native language of those from another, and since talking while at work in the fields was usually forbidden, music, pantomime, dance, and cryptic signs became the established means of communication within many slave groups. Chants and "talking" drums provided the patterns later used in call-response work songs, and the vocal sounds of a language unique to Black Americans began to emerge.

THE CRAFT HERITAGE AS AN ECONOMIC RESOURCE

With respect to crafts the continuation of African artistic traditions under slavery had a somewhat more secure base. As the colonies expanded, the demand for skilled craftsmen exceeded the supply; for example, in 1731 there was reportedly only one potter in all of South Carolina. Consequently, slaveholders frequently found it worthwhile to use some of their slaves as artisans rather than as agricultural laborers. Many of the enslaved Africans proved to be familiar with one or more of the trades needed in the colonies' rap-

idly developing society; among these bondsmen were carpenters, metalworkers, potters, sculptors, weavers, and designers of various wares. Thus, during the late eighteenth century, a system of renting and apprenticing talented Blacks to white craftsmen developed in the colonies.

That a significant number of Blacks were so apprenticed, and in responsible occupations, is indicated by numerous advertisements in colonial newspapers; for example, the *Maryland Gazette* (2 November 1774) listed the sale of a slave craftsman who understood all types of engraving and woodcutting. Similarly, Edward Peterson's *History of Rhode Island* (1853) suggests that Gilbert Stuart, a white portrait painter from the New England colonies, received his first lesson in drawing from Neptune Thurston, a slave employed in a Boston cooper shop. The evidence in support of such a meeting is strengthened by an advertisement in the *Boston Newsletter* (7 January 1775) announcing the services of a Black man who "makes portraits at the lowest rates" and who "has worked with the best masters in London." Further documenting the existence of the slave craftsman, an edition of the *Pennsylvania Packet* (1 May 1784) lists a reward for the return of John Frances, a Black goldsmith.

Two basic types of slave-craft items survive from the colonial period. The first of these includes articles designed for the slaves' personal use and, in some cases, intended to have mythic implications; the second consists of articles for public or professional use—that is, those made upon demand for whites.

The first type of survivals includes numerous fetishes associated with voodoo or hoodoo; these were made in many different forms and of such varied materials as rags, wood, and feathers. Also typical of the homemade articles are the slaves' colorful patchwork quilts, whose patterns strongly suggest the woven and painted textiles of West and Central Africa [*Illus.* 1]. Among the other personal items created by slave craftsmen were pottery, shell beads, dolls, bone carvings, staffs, baskets, and gravestones. The symbolic and mythic meanings of articles in this category were held in rigid secrecy by their makers, and most of the rich folklore these artifacts expressed has long since been lost.

In such examples of the African-American spirit expressed in visual art forms, there can be found elements that are fundamental to the aesthetics of contemporary Black art. For instance, the artistic ways in which enslaved Africans used inexpensive raw materials and castoffs are reflected in today's collage and assemblage; the

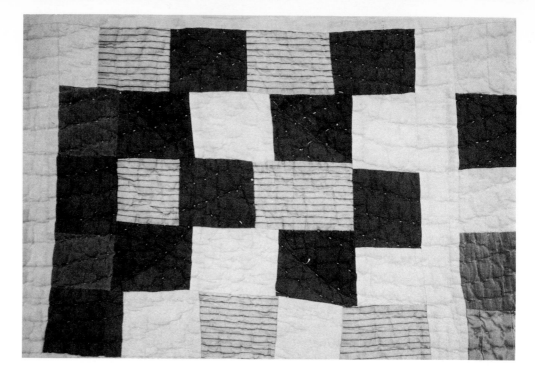

1 Patchwork quilt (detail), 1700s. Cloth, 6' x 4'. Collection of Hamp Johnson, Los Angeles.

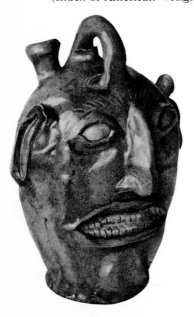

2 Grotesque jug, early 1800s. Stoneware, 8¾" x 4¼". National Gallery of Art, Washington, D.C. (Index of American Design.)

slaves' linkage of magic and art, in modern mojo forms; and their employment of low-key colors, in the dominance of earth tones in the work of some present-day Black artists.

The public, or professional, articles produced by slave craftsmen were, as suggested previously, an important aspect of the colonial economy. In the northern and middle colonies, Blacks were apprenticed as goldsmiths, silversmiths, cabinetmakers, printers, engravers, and portrait painters. Stoneware vessels made by Black slaves, some of which are still in existence, are viewed as examples of the colonies' flourishing pottery trade [*Illus.* 2]. In some instances, moreover, praise for the quality of slave artistry and craftsmanship was widespread; for example, a group of Black artisans in Andover, New Jersey, gained a reputation throughout the colonies for the excellent ironwork they produced.

Specific examples of the public work done by slave craftsmen are also known. James A. Porter's *Modern Negro Art* (New York: Arno Press and The New York Times, 1969) identifies African survivals in the construction and ornamentation of Janson House, a mansion built for a Dutch settler in 1712 on the shores of the Hudson River. Porter particularly cites the building's hand-forged hinges as being

of African origin. Another example of slave craftsmanship is provided by Isaiah Thomas' *History of Printing in America* (1810), which records that three Blacks in Boston, a man and his two sons, were apprenticed as printers by Thomas Fleet, who had emigrated to that city from England in 1721. The father is known to have made the woodcuts used to decorate several small collections of ballads composed by Fleet.

Many of the oldest buildings in Louisiana, South Carolina, and Georgia also incorporate reflections of African architectural and decorative techniques. In these states, buildings of French or Spanish design commonly feature African-inspired ornaments and supports, and some of these structural features are known to have been executed by slaves. One such building is the convent of the Ursuline Sisters in New Orleans [*Ilus.* 3]. Begun in 1734, it is counted among the architectural prizes of the city's original French Quarter.

3 Convent of the Ursuline Sisters, New Orleans, 1734–50. (Photograph by Gaal D. Cohen.)

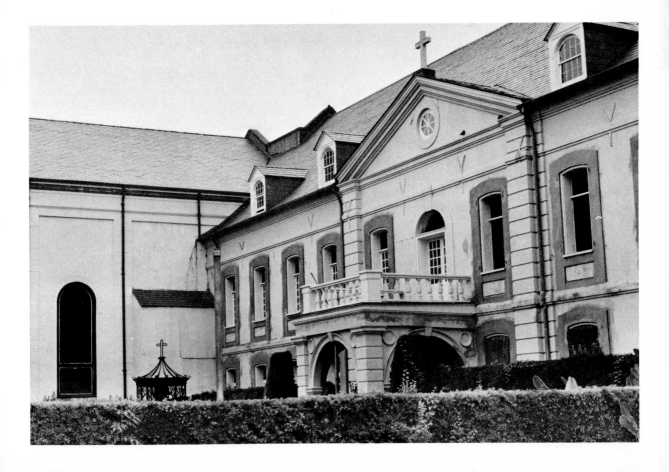

THE EMERGENCE OF PROFESSIONAL ARTISTS

During the eighteenth and nineteenth centuries, there were a few Black Americans who achieved a degree of personal recognition as artists and artisans in white society. Studies of this phenomenon in the history of Black art have been scanty and inconclusive; there is enough definite information on the subject, however, to make it worthy of mention here and thus, one hopes, to provide a basis for further scholarly research in the near future.

SCIPIO MOORHEAD (active 1770s) was an African slave and painter who lived in Massachusetts during the late eighteenth century. Although a slave, he enjoyed the usual rights of free workers, as did many Blacks in that state long before Emancipation. Poet Phillis Wheatley, a slave in the liberal household of Bostonian John Wheatley, mentions Moorhead in a collection of her poems published in London in 1773: "To S. M., a Young African Painter, on Seeing His Works." Wheatley's book also offers a description of Moorhead's *Aurora*, a symbolic painting of dawn, and mentions as well a painting in which he treats the legend of Damon and Pythias.

It seems likely that the poet was acquainted with the Reverend John Moorhead of Boston, who is thought to have been the owner of the young painter. Such an acquaintance seems implied in a eulogy written by Wheatley and dedicated to Reverend Moorhead's daughter, Mary, upon the death of her father. Sarah Moorhead, a teacher of art and the wife of the minister, probably helped Scipio in the development of his drawing and painting techniques.

No signed works by Scipio Moorhead are known to exist; it is possible, however, that the copperplate engraving of Phillis Wheatley that adorns much of her published poetry is his creation [*Illus.* 4].

THE REVEREND G. W. HOBBS of Baltimore, who was, in the late eighteenth century, the official artist of the Methodist Episcopal Church, is the first Black resident of the United States known to have painted a portrait of another Black person. The subject of this portrait, a pastel completed in 1785, was a former slave named Richard Allen, who, having purchased his freedom at age seventeen, became the co-founder and first bishop of the African Methodist Episcopal Church [*Illus.* 5]. One of the most significant Black social and religious leaders of the late eighteenth century, Allen also founded the Free African Society and, in 1830, sponsored the first National Negro Convention.

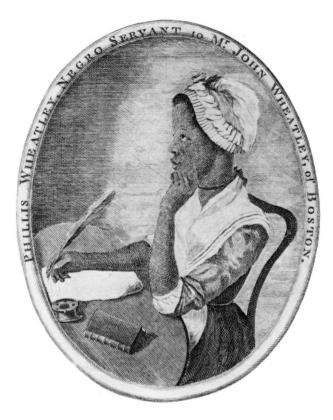

4 *Phillis Wheatley*, 1773.
Copperplate engraving, 5″ x 4″.
Library of the Boston Athenæum.

5 G. W. Hobbs, *Richard Allen*, 1785.
Pastel, 8½″ x 6½″. Howard University Museum,
Moorland-Springarn Research Center,
Howard University, Washington, D.C.

JOSHUA JOHNSTON (active about 1789–1825) was the first artist of
Black ancestry to gain public recognition in the United States as a
portrait painter. Information on his early life is hard to find. One
report of his era lists Johnston as the former slave of a portrait
painter from the West Indies; another identifies him as a mulatto
who had served a period of his life as a slave. And between 1796 and
1824, nearly every issue of Baltimore's directory of residents listed
Johnston as either a portrait painter or a limner. (The one exception
was the 1817 issue, in which Blacks were listed separately, and at the
end of the register, as "Free Householders of Colour." Though in
nine of the integrated listings race was ignored, the others used a
small cross or the phrase "black man" to distinguish the names of
Blacks.)

13

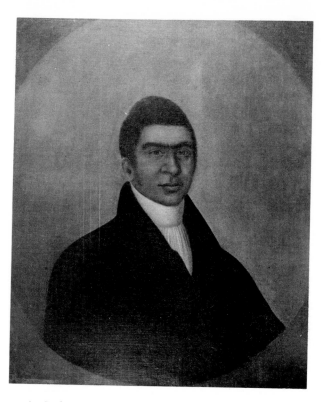

6 Joshua Johnston, *Portrait of a Cleric*
(detail), ca. 1805. Oil on canvas, 28″ x 22″.
Bowdoin College Museum of Art,
Brunswick, Maine.

While the majority of his subjects were members of wealthy slave-holding families, his impressive *Portrait of a Cleric* [*Illus.* 6] is a painting that depicts a Black man; J. Hall Pleasants, a leading authority on Johnston, has estimated its date as between 1805 and 1810. It is also possible that Johnston produced other paintings of Blacks; indeed, his sensitive handling of *Portrait of a Cleric* suggests that it was not his first attempt at depicting a Black subject. Close examination of the portrait also reveals a relaxed approach not evident in any of the artist's other surviving works.

There has been much speculation concerning the influences evident in the works of this early Black portrait painter. There is a very strong possibility that Johnston had some connection with Charles Willson Peale, Charles Peale Polk, and Rembrandt Peale—three other Baltimore painters of the 1790s. He may even have been apprenticed to one of them.

None of the paintings attributed to Johnston are signed or dated, but all bear similar stylistic traits. Neatly rendered portraitures, the works are distinguished by an unusually inflexible treatment of hands. Faces are usually shown in three-quarter view, with the glances of the elliptical eyes directed straight forward, giving the paintings a presence that is uncomfortable to viewers. Mouths are drawn in a linear style typical of the period. The paintings reveal no physical or psychological relationship between figures, which, in most cases, suggest the stiffness and lack of personality characteristic of many works done earlier in the eighteenth century. The tightly set lips, staring eyes, and seemingly inflexible bodies aptly illustrate that these were posed works, not the products of momentary impression. The backgrounds suggest only a partial knowledge of vanishing points; and often no single area of a painting is made dominant, either through color, placement of figures, or rendering of detail.

Professionally, Johnston followed the practice of other artists of the period and, in the main, portrayed members of aristocratic white families. It is hoped that this subject matter represents only a segment of his artistic production and that other Johnston works will be discovered which reveal a greater identification with the spirit of early Black Americans.

Because they were generally offspring of aristocratic white men, free Blacks in both the North and the South in the early nineteenth century enjoyed a measure of freedom uncommon to most Blacks at the time. Those who were acknowledged by their fathers were frequently provided with opportunities for education, generally including study abroad, and with a social life based upon the standards of their white contemporaries. Those who were not sent elsewhere for an education usually received special training and privileges as servants in the homes of their fathers.

JULIEN HUDSON (active 1830–40) was one such free Black man. His *Battle of New Orleans in* 1815 has as its principal subject Colonel Michel Jean Fortier, Jr., the white commander of a corps of free Blacks who fought in the battle. *Self Portrait* [*Illus.* 7], completed in the late 1830s and now housed in the Louisiana State Museum, is the only known self-portrait by a Black artist of the colonial period. The facial features of the figure indicate that the artist was of mixed ancestry, and the manner of dress suggests that he enjoyed the privileges of gentry. As a free Black in New Orleans,

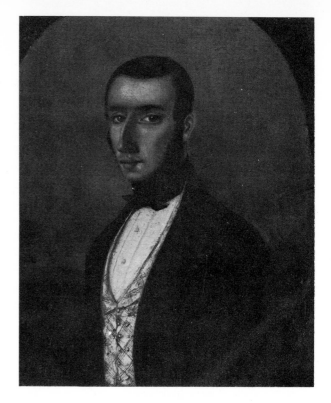

7 Julien Hudson, *Self Portrait* (detail),
1839. Oil on canvas, 8¾″ x 7″.
Courtesy of the Louisiana State Museum.

Hudson was exposed to the French tradition and to a lifestyle that reflected a level of elegance and flamboyance not then found elsewhere in the United States. His self-portrait helps depict the flavor and quality of life that was available to many free Blacks in nineteenth-century New Orleans.

Another interesting view of Black life in the New Orleans area during this period is provided by the Metoyer family. Descendants of one Marie Therese, who had been freed from slavery by the French commandant at Fort Natchitoches, and her husband, a Frenchman named Thomas Metoyer, this family maintained a way of life that reflected the elegant taste of the period. The mansion Metoyer ordered built for Marie Therese in 1750 is the oldest surviving dwelling constructed in the United States both by and for Blacks; it is also one of the oldest buildings in Louisiana. The famous African House [*Illus.* 8], a two-story building on the Metoyer grounds, has features reminiscent of the constructions found in West African villages or in Japanese Shinto architecture. Built of brick and cypress, the house is an impressive structure that stands as a monument to the ability of early Black architects and builders.

Still remaining in the mansion today are three interesting paintings of Metoyer family members. One is a portrait of Augustine,

8 Metoyer African House, New Orleans, ca. 1750. Brick and cypress. (Photograph by Ralph E. Day.)

Marie Therese's eldest son, that was painted in 1829 and signed with the name Feuville. The two others are undated and unsigned portraits of a grandson and a granddaughter. All three paintings are assumed to be the work of Black artists. In the mid-1800s, as a result of difficulties stemming from threatened slave insurrections, the Metoyer family, and many other Blacks, became victims of white reprisals; for the Metoyers in 1847, these reprisals included the takeover of their home.

FREE BLACKS AND THE ABOLITIONIST MOVEMENT

Free Black men, long involved in the creative arts but denied the privilege of personal expression, were ready in the 1850s and 1860s to assume their place in the fight for freedom and liberation. As the slavery struggle heightened, abolitionist movements gained strength. Since areas of the North had been emancipated, there was less hesitation in becoming involved in antislavery groups.

ROBERT M. DOUGLASS, JR. (1809–87), was one of the first Black artists to ally himself with antislavery leaders, among them Frederick Douglass and William Lloyd Garrison. His efforts to aid them were expressed both through painting and through literature. In 1833, for example, Robert Douglass created a lithographic portrait of Gar-

rison and, attempting to raise money for the abolitionist cause, sold copies at fifty cents each in New York and Philadelphia. There is no indication that any of these prints still exist, but published documents and letters remain that attest to Douglass' life as a creative pioneer.

Born a freeman in the city of Philadelphia, Douglass was the son of a West Indian immigrant and a freewoman from Philadelphia. Both he and his sister, Sarah, became Quakers and were educated in Quaker schools, where the curriculum included languages, shorthand, dramatic readings, and music. In spite of his educational achievements, however, Douglass found it nearly impossible to gain acceptance as a creative American. Racial prejudice closed to him most of the doors open to white citizens.

Funds for Douglass' artistic studies came from the abolitionist groups to which he belonged. Faith in the young artist was also expressed by Thomas Sully, a well-known Philadelphia portrait painter who, in introductory letters to friends in Europe, gave him "the highest commendations." At age twenty-four Douglass was also highly praised in the abolitionist newspaper *The Emancipator*, as in the following excerpt:

> *This gentleman is a very respectable colored gentleman, in Philadelphia, and has for several years carried on the business of sign and ornamental painting. His establishment is located at the corner of Arch and Front Streets. Few persons, if any, have made greater proficiency in this line than he has done for the time he has been engaged in the business. . . . He has lately turned his attention to portrait painting in addition to his other employment. In this too he has been eminently successful. We have seen several of his paintings that would scarcely suffer in comparison with those of many who are considered among the finest artists of our country.* [20 July 1833.]

In letters to his sister, Douglass indicated that he was finding the United States too repressive a place for his artistic pursuits and that he had chosen to seek more congenial environments in which to construct his thoughts, art, and life. Douglass was to be confronted with racial discrimination even in his bid to leave the country; his application for a passport to England was rejected on the grounds that "people of color were not citizens and therefore had no right to passports to foreign countries." This narrow rule did not stop Douglass, for he eventually managed to go both to England and to the West Indies.

In 1848 a letter from Douglass appeared in the *National Anti-Slavery Standard*; it was later printed in the *North Star*, a newspaper

edited and published by Frederick Douglass. Concerning the letter, the abolitionist leader made the following editorial comment:

> *Our friends in Eastern Pennsylvania will be glad to see the letter from Mr. Douglass, late of Philadelphia. It will interest our readers to know that Robert Douglass is an artist of skill and promise, who, in this country, was unable to gain a livelihood by his profession, though he added to it that of Daguerreotypist; and has therefore emigrated to a country where he hopes the colors he uses, and the way he uses them, will be the test of his merit, rather than that upon his own body, which he neither put on nor can rub off. [Quoted in Porter, Modern Negro Art, p. 33.]*

In spite of long absences from his homeland and other difficulties, Robert Douglass made impressive artistic contributions to the Black struggle. Among his known works are a portrait of Nicolas Fabre Geffrard, president of the Republic of Haiti from 1859 to 1867; a banner for the Grand Order of Odd Fellows, in Philadelphia; and drawings of missionary stations in Jamaica.

PATRICK HENRY REASON (1817[?]–50[?]), a Philadelphia engraver, is perhaps best known for his depiction of a chained slave who asks: "Am I not a man and a brother?" This work was used principally as the emblem of the British antislavery movement and for various other abolitionist causes.

Reason, whose parents had settled in New York during the early nineteenth century, attended the African Free School and—like many other talented Blacks associated with the abolitionist movement—was apprenticed to a white craftsman. His first public mention came when, still a student, he was given credit for the frontispiece of *The History of the African Free Schools* (1830), by Charles C. Andrews. The acknowledgment read: "Engraved from a drawing by P. Reason, a pupil, aged thirteen years."

Later, when Reason had become a free-lance engraver and lithographer, his work appeared in many publications sponsored by antislavery groups. During this period, abolitionist societies gave many free Black artists extensive support, frequently by awarding them commissions for portraits of the major reformers. Works of this sort done by Reason include a drawing of Granville Sharp, the English abolitionist, and two portraits of Henry Bibb, an escaped slave and abolitionist lecturer. The first Bibb portrait is a lithograph done in 1840; the later one, a copper engraving made in 1848 as the frontispiece for *The Narrative of the Life and Adventures of Henry Bibb* [Illus. 9].

9 Partick Henry Reason, *Portrait of Henry Bibb*, 1840. Lithograph. General Research and Humanities Division, The New York Public Library (Astor, Lenox and Tilden Foundations).

Though the artwork created by Reason reflects the typical stylistic conservatism of the nineteenth century, his concern for his fellow human beings was boundless. An enormous amount of his time was devoted to eradicating injustices, and he ranks high as a fighter for human dignity.

DISCRIMINATION AND THE PROBLEM OF PATRONAGE

Throughout the nineteenth century, Black artists were excluded from the academies, associations, and teaching institutions that were accessible to white artists in the United States. Black artists were thus rarely able to attract and sustain dependable patronage. Responses to this racial exclusion included the development of a union of Black families involved in the making of handcrafts. Allied for strength and protection, some of these families were themselves highly organized, with several publishing their own directories. These directories aided independent Black artists in their search for patronage. David Bowser belonged to one such family.

DAVID BUSTILL BOWSER (1820–1900), unlike his cousin and mentor Robert Douglass, was basically a "weekend" artist. His paintings grew out of a desire to record personal impressions and ideas; but, to support himself and his family, Bowser was obliged to work as a painter of emblems and banners for fire companies and fraternal organizations. His city of birth is uncertain, but it was most probably in the state of Pennsylvania, where he and his family resided for many years. (Bowser's grandfather, a former baker for the Continental Army, was one of the first Black schoolteachers employed by the city of Philadelphia.)

In 1852 an exhibition review in the *New York Herald* praised Bowser for his marine paintings. He has also been credited with numerous portraits of eminent persons, including two of Abraham Lincoln. One Bowser portrait of Lincoln, now lost, is believed to have been commissioned, and posed for, by Lincoln himself; the other is now located in a home for aged Blacks, in Philadelphia. Bowser's significant surviving works also include a portrait of a baby and several landscapes. Because Bowser was not a full-time artist, his output was limited; he brought to his relatively few works, however, an originality that compensated for his lack of technical expertise.

WILLIAM SIMPSON (active 1854–72) was first brought to public attention as an artist through the writings of a Black contemporary, Wil-

liam Wells Brown, author of *The Rising Sun, or The Antecedents and Advancement of the Colored Race* (1876). Brown wrote enthusiastically of Simpson's major works and collected most of the information now available on the artist's early life. According to Brown, at an early age Simpson displayed an aptitude for art and, in elementary school, often practiced his drawing instead of paying attention to classroom activities; on leaving school he became apprenticed to Mathew Wilson, a distinguished artist. Later, from 1860 to 1866, Simpson was among those listed in the Boston directories as an independent artist.

Simpson lived many of his subsequent years in Buffalo, New York, but his merit as a painter was known throughout the northern United States and in Canada. Principally a portrait painter, he is best remembered for two works known as the Loguen portraits; one painting depicts Bishop Jermain Wesley Loguen [*Illus.* 10], and the other his wife, Caroline. Loguen, a fugitive slave, was New York bishop of the African Methodist Episcopal Church. He was also a public speaker on behalf of the antislavery cause and an active participant in the underground railroad.

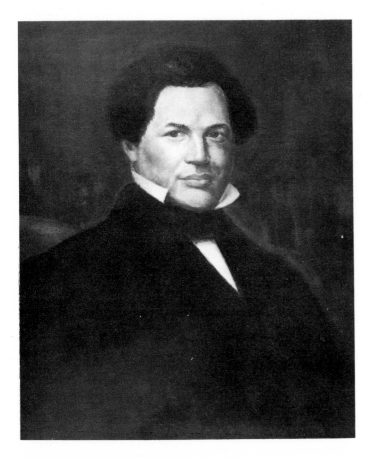

10 William Simpson, *Bishop Jermain Wesley Loguen*, 1835. Oil on canvas. Howard University Gallery of Art. (Photograph by Scurlock Studios, Washington, D.C.)

The conditions of slavery made it impossible for Black craftsmen to express themselves in a truly personal manner. The slave craftsman's principal function was to produce works that satisfied the needs and European tastes of the colonists.

Thus, though the slaves' creativity and African remembrances found outlets in many objects of high aesthetic quality, there is little evidence of art forms produced by slaves solely in response to their own expressive needs. Most Black artists in the eighteenth and early nineteenth centuries were saddled with European aesthetic concepts; however, there were a few, such as Moorhead, Hobbs, and Simpson, who found it possible to document the lives of the first Black American leaders and their roles in the search for freedom.

Emancipation and Cultural Dilemma

1865-1920

Until the mid-nineteenth century, survival was the primary concern of Blacks in the United States. With the post–Civil War era came different burdens, among them the problem of finding employment. Because of the lack of opportunities, few Blacks of this period became trained artists; however, many Blacks sought to express themselves creatively. This effort was of primary importance to their continued aesthetic and physical survival.

Two major approaches to artistic expression were demonstrated among Blacks during the post–Civil War period. One of these accepted the artist's environment and experiences as major factors in the creation of works of art, while the other favored the abandonment of Black values and the substitution of European tastes and aesthetics. Usually the latter approach prevailed. Since the quality of an artistic work was measured by its adherence to simulated European cultural traditions, Black artists generally avoided Black themes. Among some of their white contemporaries, moreover, disparaging portrayals of Blacks were becoming increasingly popular. Nineteenth-century American painting frequently depicted Blacks as clowns, simpletons, and creatures expressing all manner of inhuman qualities. The brush and canvas became aids in the creation of symbols that would for decades influence American racial values.

Black artists in the mid-nineteenth century found themselves in a world in which their art forms were judged inferior and their cul-

tural roots discredited. In every way possible, Blackness was held to be invalid. The only means to artistic acceptance required a commitment to white middle-class values and the rejection of everything Black. This circumstance caused much frustration for Black artists, and many, as a result, became individuals without a culture. Moreover, even those Black artists who refused to identify with the Black world were rejected by white society.

This generation of Black artists did, however, develop in a social climate less provincial than that of their predecessors. In addition to changes in the general social and political climate, cultural opportunities sponsored by abolitionists helped make meaningful careers possible for a number of promising Black artists.

THE FIRST MAJOR LANDSCAPE PAINTER

ROBERT STUART DUNCANSON (1821–72), benefiting from an abolitionist group's award, was one of the few Black artists to visit Europe. The son of a Scots-Canadian and a free Black woman, Duncanson spent his early years in Canada and later moved with his mother to Mount Healthy, a small Ohio community about fifteen miles north of Cincinnati. A border city between the North and the South, Cincinnati in the early 1880s was a center of controversy over slavery and the rights of Blacks who had escaped from southern states. Ohio's Black Laws, passed in 1804, prohibited settlement in the state without proof of freedom; however, repressive measures resulting from these laws did not directly affect resident Blacks, nor prevent those in Cincinnati from sharing in the city's program of fine arts for the masses.

Duncanson resided in the Cincinnati area at a time when art was promoted there as an important aspect of education. This frontier city was a prosperous one, and it maintained a society in which Black and white artists mingled freely and shared ideas about their work.

By 1842 Duncanson was apparently exhibiting in the Cincinnati area, for the catalog of an exhibition sponsored in that year by a local group (the Society for the Promotion of Useful Knowledge) listed three of his works: *Fancy Portrait*, *Infant Savior*, and *The Miser*. The other artists in the exhibition were primarily local residents who painted in the style of the Hudson River school, the romantic-naturalistic tradition of which Duncanson was to become a follower. During the subsequent years, references to Duncanson's

work appeared in numerous newspaper reviews and articles. Among these, the *Detroit Daily Advertiser* (2 February 1846) made reference to Duncanson's work and described him as a portrait painter who had "designed and finished several historical and fancy pieces of great merit."

Though officially a Cincinnati resident, Duncanson had a long association with artistic activities in Detroit. Among the commissions he completed while active in that city were portraits of the Berthelets, one of its most prominent families during the early 1800s; of Lewis Cass, Michigan's abolitionist senator; and of James G. Birney, editor of the *Philanthropist*, an abolitionist newspaper. None of these portraits were of high technical or aesthetic quality; they were executed, it seems, chiefly for monetary reasons. Duncanson's abilities as an artist were better demonstrated in landscape painting, in which he excelled and in which he was probably influenced by several outstanding American landscape artists, among them Thomas Cole and Asher B. Durand. Duncanson's landscape style exhibits the broad range of atmospheric and emotional elements typical of works of the Hudson River school. It often utilizes such striking atmospheric effects as wind and rain storms to give increased drama to the work; at other times, however, it very effectively conveys the qualities of a calm pastoral setting. Whatever their mood, Duncanson's paintings, like Durand's, involve a more intimate scale than do the paintings of Cole and many comparable landscape artists.

During the years 1845 to 1853, though active primarily in Cincinnati and Detroit, Duncanson traveled throughout New England and portions of the Appalachians. *The Blue Hole, Flood Waters, Little Miami River* [*Illus.* 11] and *View of Cincinnati, Ohio, from Covington, Kentucky* [*Illus.* 12] are two important examples of Duncanson's work during this period. The latter is one of the rare examples of a nineteenth-century portrayal of an American city. It is also an impressive display of the artist's ability to deal with space by means of aerial perspective. In *The Blue Hole, Flood Waters, Little Miami River*, Duncanson effectively captures the placidity of the scene and smoothly integrates the human element and the unspoiled natural environment. The figures of the three fishermen, though dwarfed by the grandeur of the landscape, are a center of visual interest by virtue of their placement. Upon close scrutiny, however, it becomes apparent that Duncanson's ability to depict the human figure lacks the sophistication so evident in his renderings of the countryside and other natural settings.

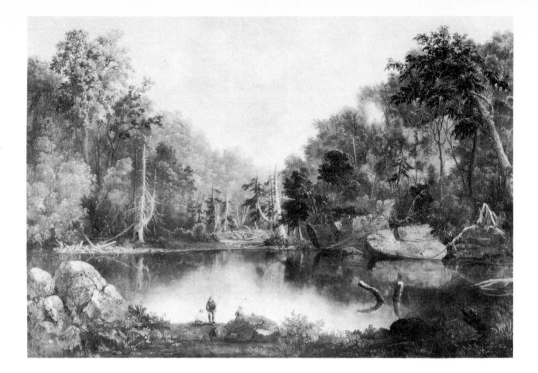

11 Robert Stuart Duncanson, *The Blue Hole, Flood Waters, Little Miami River*, 1851. Oil on canvas, 29¼″ x 42¼″. The Cincinnati Art Museum (gift of Norbert Heerman).

12 Robert Stuart Duncanson, *View of Cincinnati, Ohio, from Covington, Kentucky*, 1848. Oil on canvas, 25″ x 36″. Original in Cincinnati Historical Society.

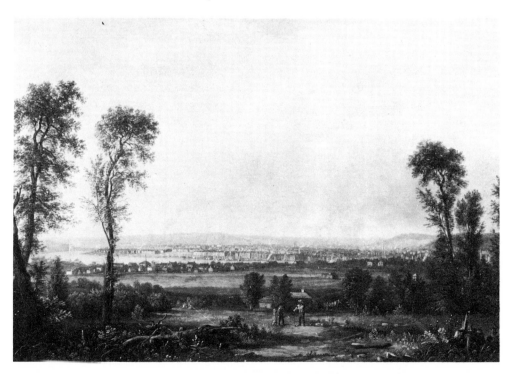

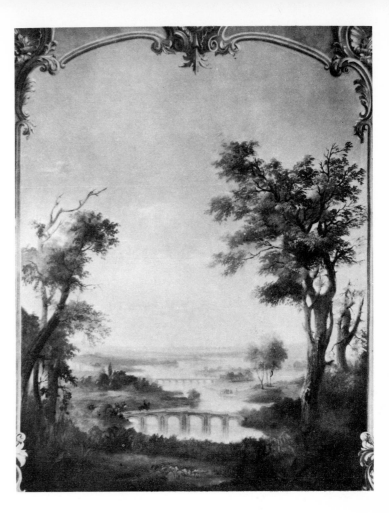

13 Robert Stuart Duncanson,
untitled mural, ca. 1848.
Oil on plaster, 109⅜″ x 91⅜″.
The Taft Museum, Cincinnati, Ohio.

Cincinnati directories of the early 1850s also list Duncanson as a daguerreotypist. A photographic process invented in the late 1830s, by midcentury daguerreotype had become the means by which many landscape artists recorded different views of their intended subjects, thus partially eliminating the need for sketching. As a daguerreotypist, Duncanson was associated with and at one time employed by J. P. Ball, also a Black photographer and a highly successful figure in the city of Cincinnati.

In 1848 Nicholas Longworth, a lawyer turned realtor, commissioned Duncanson to do a series of murals for his Cincinnati residence. (This house, an excellent example of nineteenth-century American architecture, had been purchased by Longworth in 1829 and is now the Taft Museum.) Completed over the next two years, the series consists of eight compositions that, because of their highly poetic quality, suggest the traditions of French landscape painting rather than the detailed style of Duncanson's contemporaries in the United States [*Illus.* 13].

The only known painting by Duncanson in which the special concerns of Blacks are the central subject matter is one that illustrates an incident from *Uncle Tom's Cabin* (1852), by Harriet Beecher Stowe [*Illus.* 14]. In this composition, Uncle Tom and Little Eva, like the people in other Duncanson paintings, suffer from the artist's depiction of the human figure. This consistent weakness on Duncanson's part is probably due simply to a lack of proficiency, but it may be related to Puritan attitudes prevalent in America at the time, which discouraged glorification of the human form.

14 Robert Stuart Duncanson, *Uncle Tom and Little Eva*, 1853. Oil on canvas, 27¼″ x 38¼″. Courtesy of The Detroit Institute of the Arts (gift of Mrs. Jefferson Butler and Miss Grace R. Conover).

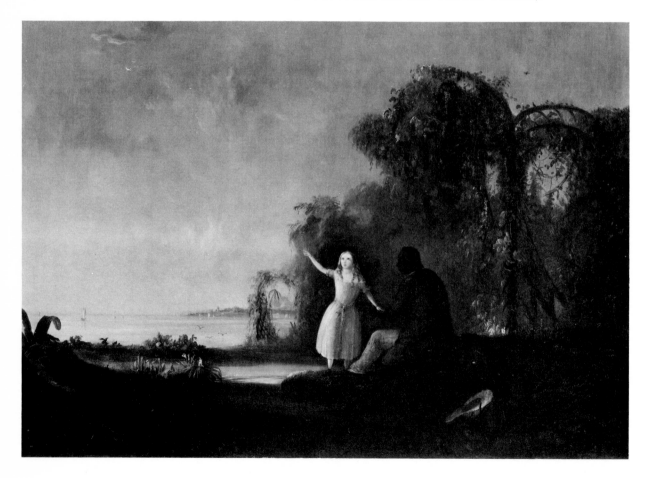

Only Duncanson's portrait of Richard Sutton Rust, the first president of Ohio's Wilberforce University, is an exception to this tendency. Painted in 1858, it displays a more sensitive treatment of the human figure than was usual for Duncanson. The artist and Rust are believed to have been personal friends, and their relationship may account in some measure for the greater strength of expression in this portrait.

Duncanson's success grew steadily throughout the 1850s, for his works were being purchased by many of Cincinnati's socialites. In 1861 he completed *Land of the Lotos Eaters*, which, when exhibited in Cincinnati during that year, received high praise from the critics. Beginning with this painting, an ability to combine reality and imagination gave a new and interesting dimension to Duncanson's work.

Duncanson is thought to have returned to Europe in 1863; the absence of his name in Cincinnati directories from 1864 to 1866 supports the belief that he remained in Europe during those years in an attempt to escape the increased racism in the United States brought about by the Civil War. However, in 1867, less than two years after the end of the war, Duncanson's name reappears in the Cincinnati directory, indicating his return to the United States. During his later years, as Duncanson vacillated between the Hudson River style of painting and one more faithful to the classical and romantic traditions, his works sold for prices as high as five hundred dollars and enjoyed great public favor, especially in Cincinnati and Detroit.

Duncanson lived in a period of great change and, being mulatto, undoubtedly faced many social and professional disappointments. His racial background probably discouraged his recognition as a major contributor to American art; yet there can be no doubt that, with the development of his mature style, Duncanson brought to American art a personal style high in aesthetic value.

THE DIVERSE SEARCH FOR PROFESSIONAL STATUS

EUGENE WARBURG (1825–67) and his brother Daniel were—according to Rudolph Desdunes' chronicle of Black life in New Orleans, *Nos Hommes et Notre Histoire* (1911)—among the few Black natives of that city in the mid-nineteenth century who were seriously involved in art. Eugene's interest was sculpture, and Daniel was an engraver and stonemason.

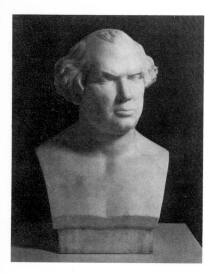

15 Eugene Warburg, *John Young Mason*, ca. 1853. Marble, 23″ x 9⅛″ x 7¾″. Reproduced through the courtesy of the Virginia Historical Society.

Free-born, Eugene Warburg is reported to have been apprenticed at one time to a French artist known as Gabriel. The Warburg brothers eventually shared a studio in New Orleans' French Quarter, and it is possible that they worked together on many commissions. Primarily involving portrait busts, religious statuary, and gravestones, the numerous commissions received by the artists were rumored to have aroused the envy of local white artists, some of whom made it uncomfortable for the brothers to remain in their New Orleans studio. Whatever the reason, Eugene departed for Europe in the 1860s and remained there until his death. While abroad, Warburg was commissioned to create a series of bas-reliefs illustrating episodes from *Uncle Tom's Cabin*, that popular source of artistic subjects. But the only existing sculpture by Warburg is a portrait bust of John Young Mason [*Illus.* 15], which was probably done in Paris between 1853 and 1859, while Mason was United States minister in France.

EDWARD MITCHELL BANNISTER (1828–1901) was born in St. Andrews, New Brunswick, Canada, his mother's birthplace; his father was from the West Indies. In his youth Bannister worked as a cook on a coastal trading vessel, and later much of his leisure time was spent sailing Narragansett Bay and studying its waters and cloud formations.

In the early 1850s Bannister settled in Boston, where he studied art at the Lowell Institute under the supervision of S. L. William Rimmer, a noted sculptor. To finance his studies, Bannister worked as a maker of solar prints. His decision to study and settle in Boston may have been based on its reputation as a city with an intellectual, liberal atmosphere. By 1855 Bannister had produced his first commissioned work, *The Ship Outward Bound*, and he was fast becoming the first Black artist to earn recognition as an American regionalist painter. He was also soon to marry Christiana Cartreaux, of Rhode Island, reportedly a descendant of Narragansett Indians.

In 1871 Bannister and his wife left Boston for Providence, Rhode Island, a city not then known as an artistic center. Active in the cultural life of his adopted city, Bannister became one of the three founders of the Providence Art Club, which later inspired the Rhode Island School of Design. He is believed to have been greatly affected by a statement printed in 1867 in the *New York Herald* which claimed that "while the Negro may harbor an appreciation of art, he is unable to produce it." Indeed, his work during the late

1860s and 1870s suggests that Bannister accepted the statement as a personal challenge.

In 1876, at the Centennial Exhibition in Philadelphia, Bannister received national recognition when he was awarded a bronze medal for a painting titled *Under the Oaks* (1875). (When he arrived to accept the award, however, the artist was refused admission to the galleries because of his race.) This prize-winning painting, which has since disappeared, was purchased by a Boston collector for $1500, a price then considered above average for the work of a living American artist. Following his first national success, Bannister won several other significant medals and was favored with numerous commissions.

By the time of the Centennial, Bannister had achieved his mature style, one in which different features of nature are fused in a tranquil and straightforward manner. Thus his later compositions effectively include animals, people, and landscape without allowing one element to overpower the others, and his impasto brushstrokes give added movement to the subtle treatment of the subjects. Throughout his career, he was principally a landscape artist, one whose style ranged from the lyrical to the expressionistic. In *Approaching Storm* [*Illus.* 16] Bannister expresses the excitement of nature through a clean, brisk, honest style; this treatment of an atmospheric disturbance is similar to those created in the seventeenth century by Jacob van Ruisdael and other "little Dutch masters." The figure located in the middle of the composition struggles against the wind and thus serves to heighten the drama of the work. Though small, he does not seem overwhelmed by the forces of nature.

Driving Home the Cows [*Illus.* 17] reveals another aspect of Bannister's painting style—an interest in the picturesque. All intentional suggestions of grandeur and drama have been avoided in the choice of subject matter: the work depicts a simple, intimate scene and suggests calm and tranquility. As is usual in Bannister's paintings, the figures are placed directly in the middle of the composition; the white cow emerging from the shadows is the composition's pivotal point. The patch of light sky, diagonally above the cow, serves as an effective balance to the mass of the animal.

Bannister, a religious man said to be a student of the Bible—and of Shakespeare, English literature, the classics, and mythology—died in January 1901 while attending an evening prayer meeting. Five months later a memorial exhibit of his works was held at the Providence Art Club in which 101 of his paintings were displayed.

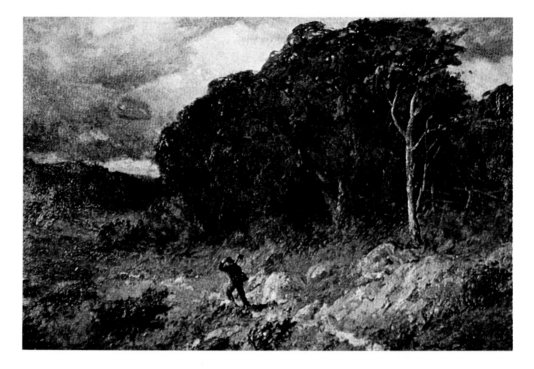

16 Edward Mitchell Bannister, *Approaching Storm*, 1886. Oil on canvas, 40″ x 60″. Museum of African Art, Washington, D.C.

17 Edward Mitchell Bannister, *Driving Home the Cows*, 1881. Oil on canvas, 32″ x 50″. Frederick Douglass Institute, Miller Collection, Museum of African Art, Washington, D.C.

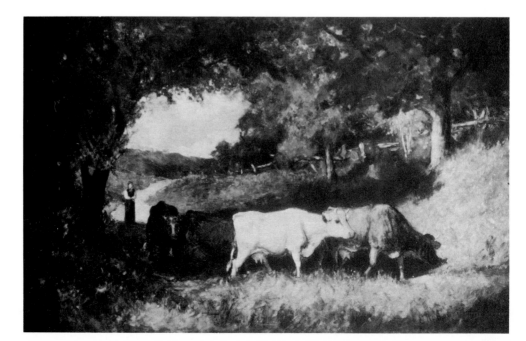

18 Edward Mitchell Bannister, *Street Scene*, ca. 1895. Oil on panel, 8⁹/₁₆″ x 5¾″. Museum of Art, Rhode Island School of Design (bequest of Isaac C. Bates).

All but two had been borrowed from leading private collectors in the Providence area; the exceptions belonged to the artist's wife. Sixteen of Bannister's paintings are now in the collection of the museum of the Rhode Island School of Design, including some regarded by critics as among his most interesting works [*Ills.* 18, 19].

Bannister is not known to have identified with social causes, but his dedication to nature suggests a deep concern for the miracle of

19 Edward Mitchell Bannister, *Landscape*, 1882. Oil on panel, 16″ x 22″. Museum of Art, Rhode Island School of Design (bequest of Isaac C. Bates).

life itself. According to John Nelson Arnold, a fellow artist and personal friend:

> [*Bannister*] *looked at nature with a poet's feeling. Skies, rocks, fields were all absorbed and distilled through his soul and projected upon the canvas with a virile force and a poetic beauty.* [*Quoted in James A. Porter,* Modern Negro Art *(New York: Arno Press and The New York Times, 1969), p. 56.*]

GRAFTON TYLER BROWN (1841–1918) was born in Harrisburg, Pennsylvania, and is believed to have been the first Black artist to work in California. His activities during the 1850s were centered in San Francisco, where he lived in a boardinghouse known as the

What Cheer House and worked for the firm of Kuchel & Dressel, first as a draftsman and then as a lithographer. While with this firm Brown designed lithographs depicting such western towns as Santa Rosa, Fort Churchill, and Virginia City. In 1867 he founded his own business, G. T. Brown & Company, and, during the next few years, became well known for his handsome stock certificates and lithographs of California cities, including many views of San Francisco [*Illus.* 20]. Though he sold his San Francisco business to an employee in 1879, Brown maintained an office at its Clay Street address throughout the 1880s.

In 1882 Brown traveled to Victoria, British Columbia, where he became a member of the Amos Bowman party that was then conduct-

20 Grafton Tyler Brown / C. B. Gifford, *San Francisco*, ca. 1877. Lithograph, 27¾" x 35¾". California Historical Society, San Francisco.

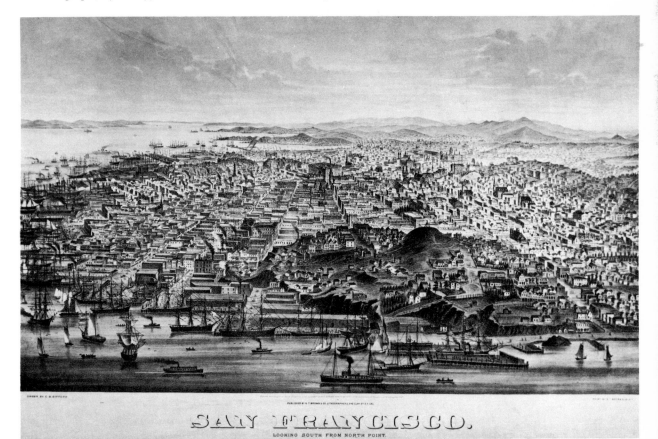

ing a geological survey for the Canadian government. He produced numerous pencil sketches during his travels with the expedition and, on his return to Victoria in the fall of 1882, developed many of the sketches into watercolors.

Because Brown had actually visited the locations they depicted, these paintings contain abundant detail, the sort that only an immediate observer could have reproduced. Fidelity to original scenes characterized the artist, for he always took great pains to make his works precise portrayals as well as good paintings. This reliance on sharp detail, probably the result of Brown's background as a lithographer and draftsman, has caused many critics to consider his works somewhat naive and underdeveloped.

Brown felt that the city of Victoria had much to offer, and during the next few years he held several exhibits there. After an exhibit in June 1883, a local newspaper praised him as "the originator of intellectual and refined art." Other critics described him as a great painter of realism and credited him with being the first artist to supply the young people of the city with the grand ideal of the "noble art."

From 1886 through 1890 Brown was among the artists listed in the city directories of Portland, Oregon, and there is reason to believe that he belonged to a Portland art club. Sketches made during those years suggest that Brown visited the area known today as Yellowstone National Park. *Grand Canyon of the Yellowstone from Hayden Point* [*Illus.* 21], one of the paintings Brown based on the sketches, bears the latest date of any of his known works. Effectively capturing the spirit of the site, this painting conveys much the same feeling for nature as was evidenced centuries earlier (960–1280) by the Northern Sung school of landscape painting. The craggy mountains and gnarled pines of *Grand Canyon* resemble characteristics of this Chinese school. One important difference between Brown's painting and the work of the Northern Sung artists, however, is Brown's use of an elevated vantage point; it is not a feature of most Sung paintings. Although not documented, his contact with Chinese art cannot be ruled out, having very possibly occurred in San Francisco and on government survey projects.

Brown lived next in St. Paul, Minnesota, where he was employed as a draftsman by the United States Army Engineers from November 1892 to November 1897. Though there is no evidence that his paintings were exhibited in St. Paul during this period, Brown was listed as an artist and draftsman in the city directories for the years 1897 to 1910. As of 1911 his name was no longer included in city

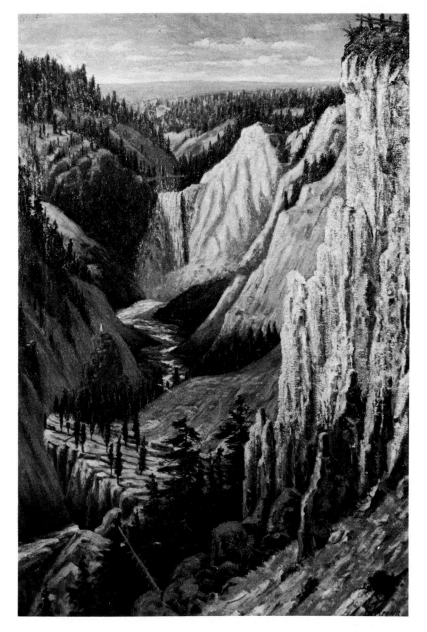

21 Grafton Tyler Brown,
*Grand Canyon of the Yellowstone
from Hayden Point*, 1891.
Oil on canvas, 24″ x 16″.
Collection of The Oakland Museum
(gift of The Oakland Museum
Founders' Fund).
(Photograph by V. Kriz.)

listings, and his endeavors in the following years are not documented. After an illness of about five years, Brown died on March 2, 1918, in a state hospital in St. Paul.

NELSON A. PRIMUS (1842–1916), born in Hartford, Connecticut, was a painter of portraits and religious subjects. In 1864 he moved to

37

Boston, where he resided for the next thirty years. While establishing himself in that city as a painter of portraits and carriages, he continued his association with artistic activities in Hartford. The *Hartford Daily Courant* (3 October 1867) cited him as having made a valuable addition to the year's county fair by means of four oil paintings. And years later the *Hartford Daily Times* (16 January 1877) reported that Primus had completed a fine portrait of "a little actress in Boston [Lizzie May Ulmer] and [that it had] received the highest praise from the critics of that city" [*Illus.* 22].

In numerous letters written to his family during the time he lived in Boston, Primus related many of his activities as an artist. For example, a letter to his mother (10 July 1865) expresses his disappointment in Edward Bannister (see page 30), whom Primus felt was in a position to help him with commissions:

> Mr. Ban[n]ister[, I] think[,] is a little jealous of me [sic] [H]e says that [I] have got great tast[e] in art, [b]ut does not try very hard to get me work. . . . Mr. Ban[n]ister has got on with the white people here[,] and they think a great deal of him. [H]e is afraid that I would be liked as much as himself. [*Primus Collection, Connecticut Historical Society.*]

A description of a genre scene painted by Primus is included in a letter to his father:

> I am busying myself in painting a small scene, called "Alone in the World." The design of the painting is a woman sitting on the stump of an old tree, with her right elbow resting on her knee, and her head upon her hand, her left hand is care[lessl]y drop[p]ed at her side, she is bar[ef]ooted, [and] is app[arently] feeling very sorry[,] as if she had lost all of her friends. [28 January 1866, *ibid.*]

Having sent many of his works back to Hartford in an effort to sell them, Primus often expressed disappointment with the lack of sales and finally concluded that he should concentrate on stores in Boston. But success there was also limited, and his primary goal, study in Europe, remained out of reach. To gain additional funds he tried bookselling, but found the work too dull. The following excerpt from a letter to his mother vividly expresses his frustration:

> Oh, I wish that [I] had money so [I] could go to Europe to study a couple of years [and] then [I] would ask the [odds] of none of the artists. I do not suppose that [I] shall be able to go. Boston trade is very dull[;] there is not anything a doin[g, and] people are not so ready to spend the money. The people on this way are tighter than on south [and] west. [22 March 1867, *ibid.*]

22 Nelson A. Primus,
Lizzie May Ulmer, 1876.
Oil on canvas, 27⅛″ x 22″.
Connecticut Historical Society.

Primus left Boston in 1895 and eventually settled in San Francisco, where he painted and worked as a model at the Mark Hopkins Institute of Art. Financially, San Francisco proved no better for him than Boston, but he found help and friendship in the Chinese community in which he lived.

Although an obituary written in 1899 on his mother's death refers to Primus as "now living in Seattle," recent research by the Oakland Museum indicates that he remained in San Francisco throughout the late 1890s and died there of tuberculosis in the early 1900s. *Oriental Child* [*Illus.* 23], a study of a distressed child standing in a street in Chinatown, is a provocative work that exemplifies the art created by Primus during his San Francisco period.

(MARY) EDMONIA LEWIS (1843–1900[?]), an exhibitor at the Centennial Exposition held in Philadelphia in 1876, was the first Black woman in America to gain widespread recognition as an artist.

23 Nelson A. Primus,
Oriental Child, 1900.
Oil on canvas, 10¼″ x 9″.
Collection of The Oakland
Museum (lent by Lora T. Scott).

She was also the first Black artist of either sex to gain a national reputation as a sculptor.

The available information regarding Lewis' life is scant, and it contains many gaps and conflicts; not even the place and date of her birth have been clearly established. Some records describe her as being from New York City, but it is generally believed that she was born near Albany, New York. It is also generally agreed that she was orphaned at an early age, and that her mother was a Chippewa Indian and her father a free Black; Edmonia's Indian name was Wildfire.

In the fall of 1856, with financial help from her brother and support from the abolitionist movement, Lewis entered the prepara-

tory department at Oberlin College, in northern Ohio. Though she underestimated herself as a student, she successfully followed the prescribed literature program at Oberlin, which included Greek and Latin. She was also a very popular student who enjoyed attention and maintained a good reputation among her teachers and fellow students—that is, until a peculiar episode affected both the course of her life and the moral fiber of the village of Oberlin, then regarded as a haven for Blacks.

This strange episode began on January 27, 1862, in the home of the Reverend John Keep, an elderly member of Oberlin College's board of trustees who, in 1835, had cast the deciding vote to admit Black students to the theretofore all-white institution. It was at the Keep home that Lewis roomed and boarded along with a dozen other girls, all of whom were white.

On the morning of January 27, while the college was in recess, two of the girls who had remained in the house with Edmonia were preparing for an outing with some male friends; their plan was to take a long sleigh ride to Birmingham, Ohio. As a preparation for the journey Edmonia supposedly invited the young women to her room for a drink of hot spiced wine, which medical testimony later indicated contained an aphrodisiac called canthardies.

During their journey, the two white girls suffered serious stomach pains. Following examinations by their doctors, it was assumed that they had been poisoned. Because she had been involved in a series of pranks in which the same two young women figured, and because she had served them the wine, Edmonia became the prime suspect.

When the news reached Oberlin, Edmonia was immediately accused of foul play. But because she was a student at the college and a ward of John Keep, she was not arrested. However, on leaving the Keep residence one night, she was abducted from the doorstep by vigilantes who dragged her to an empty field nearby and brutally beat her. The demands that she be punished for the alleged poisoning and the lack of effort to discover and reveal the identities of the self-appointed avengers almost wrecked the community, which prided itself on being a place where, as a college spokesman had noted in 1851, "mind and heart not color makes the man and woman too."

Edmonia was never brought to trial for the "poisoning," since a preliminary hearing deemed the evidence against her insufficient for prosecution. This decision was due primarily to the remarkable defense presented by her attorney, John Mercer Langston, a Black abolitionist leader and graduate of Oberlin College. Like Lewis,

Langston had ties to the American Indian civilization. Thus a feeling of kinship may have inspired his offer to defend her despite the advice of some Oberlin Blacks who felt that the involvement of so prominent a figure might undo the peace and harmony of the community.

The hearing lasted for several days and included an impressive array of witnesses for the state, among them the assumed victims. The critical testimony centered on the identification of the drug cantharides as poisonous. But since it was also known as a sexual stimulant of ancient origin, most people believed that, if Edmonia had in fact served the drug to the young women, her intent was more likely to promote sexual stimulation than to poison.

"At the conclusion of the argument," according to the *Cleveland Morning Leader* (3 March 1862), "the prisoner was ordered to be discharged, both justices concurring, as the evidence was deemed insufficient to hold her for trial."

After the hearing, Edmonia considered leaving white society to rejoin her mother's people in their less restricted way of life. But she chose instead to go to Boston and, on arriving there, studied for a brief period with Edmond Brackett, a local sculptor of some renown. Soon, with the proceeds from the sale of several of her works, Lewis opened a studio of her own; and among the pieces she produced there were a medallion of John Brown and a bust of Colonel Robert Gould Shaw, Civil-War leader of the Massachusetts Fifty-Fourth, an all-Black regiment. Funds from the sale of these two pieces and the patronage of the Story family of Boston later enabled her to study in Europe.

Lewis sailed for Italy in 1865 and settled in Rome, where she opened a studio and continued her studies. During her stay in Europe this self-taught artist was greatly influenced by Greco-Roman sculpture, and as a result her later works are strongly neoclassical.

On her return to the United States in 1874, Lewis was honored with receptions in both Boston and Philadelphia. She could count among her patrons prominent families on both sides of the Atlantic, and she was also the subject of much praise from the country's leading art critics. One of them, Henry Tuckerman, found her unquestionably the most interesting representative of the United States in Europe during her stay there, and urged other artists in America to follow her naturalistic style. However, Lewis' period of popularity proved to be brief, for she soon sank into obscurity. The reasons for this decline, like the date and circumstances of her death, are unrecorded.

24 (Mary) Edmonia Lewis,
Henry Wadsworth Longfellow, 1879.
Marble, 29″ x 15″.
Courtesy of the Harvard
University Portrait Collection.

Lewis' work is represented today by a bust of poet Henry Wadsworth Longfellow [*Illus.* 24], which, when completed (in the late 1870s), won both the poet's approval and the praise of critics. Other surviving works by Lewis include a bust of Abraham Lincoln (1870), that is currently in the Municipal Library at San José, California; and *Forever Free* [*Illus.* 25].

HENRY OSSAWA TANNER (1859–1937), according to an autobiographical sketch, was age twelve or thirteen when he saw his first artist at work, the discovery occurring during a walk with his father in Philadelphia's Fairmount Park. After this encounter, the young

25 (Mary) Edmonia Lewis, *Forever Free*, 1867. Marble. Howard University Gallery of Art. (Photograph by Scurlock Studios, Washington, D.C.)

Tanner attempted his own drawings and soon developed a desire to become a painter. His subsequent life illustrates many of the difficulties encountered by aspiring artists in nineteenth-century America.

Born in Pittsburgh into an "established" middle-class Black family, Tanner was the son of Sarah Miller Tanner and the Reverend Benjamin Tucker Tanner, a bishop of the African Methodist Episcopal Church.

When Henry was seven he and his family moved to Philadelphia. There, after developing an interest in art, he made frequent trips to Earle's Galleries on Chestnut Street, where he was particularly impressed by the seascapes of T. Alexander Harrison (1853–1930), a Philadelphia marine and figure painter. His exposure to Harrison's work prompted Tanner to concentrate on marine subjects. However, after learning from a friend that skilled painters of animals were rare in America, and feeling that he must become a "first" in some area in order to gain recognition, Tanner changed his specialty for a time to animal paintings.

It was not without difficulty that Tanner pursued his dream of becoming an artist, for his family had expected him to choose a professional career, preferably in the ministry. However, at age twenty-one, Tanner enrolled in the Pennsylvania Academy of Fine Arts. There his interest turned to landscapes and remained so until his teacher, Thomas Eakins (1844–1916), encouraged him to paint genre subjects. Eakins was himself noted as a genre painter, having produced many paintings of sports and recreational activities, home life, and, above all, the people of his native city; in 1900 Tanner would become the subject of an Eakins portrait. Eakins became a strong influence on Tanner during the young artist's two years at the Pennsylvania Academy, and under the guidance of this demanding and distinguished taskmaster, Tanner's skills as a painter developed appreciably.

In 1888 Tanner undertook a business venture that he hoped would provide him with the money and time needed to develop his art; he moved to Atlanta, where he opened a small photograph gallery. It is probable that whatever appreciation and knowledge of photography he possessed had been gained during his studies with Eakins, who was a photographer as well as a painter. In any case, unsuitable to its time and place, Tanner's photograph gallery proved unsuccessful.

During his stay in Atlanta, Tanner met Joseph Crane Hartzell, a white Methodist bishop, and Hartzell's associate, Bishop Daniel A.

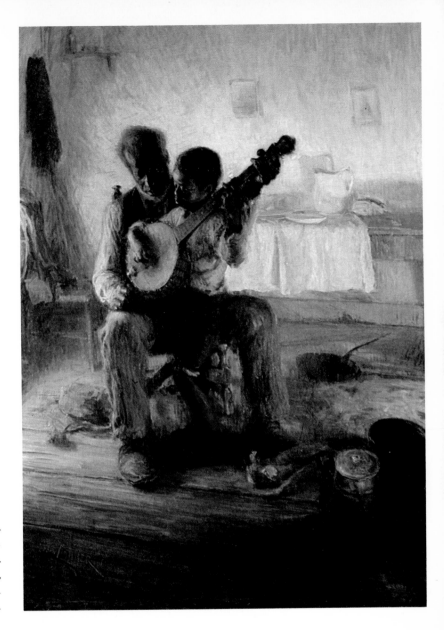

26 Henry Ossawa Tanner,
Banjo Lesson, 1893.
Oil on canvas, 35″ x 48½″.
Museum of African Art,
Washington, D.C.
(Eliot Elisofon Archives).

Payne, who gave him support and encouragement throughout the next few years. A trustee of Clark College, Bishop Hartzell also arranged for the school to employ Tanner as a part-time teacher of art. With this position promised for the fall, Tanner sold his photograph gallery in the summer of 1889 and traveled briefly in North Carolina, where he produced photographs, sketches, and paintings of its landscapes and a few portraits of its "back-country" people. Among the sketches were those for *Banjo Lesson* [*Illus.* 26], a portrayal of a man

45

fondly teaching a child the technique of fingering a banjo. By far one of Tanner's most appealing works and generally considered one of his best, *Banjo Lesson* has become one of the most famous American paintings of the period. The clarity and honesty of perception that distinguishes this work constitutes its most significant feature. A flood of light from an unseen fireplace throws the figures into bold relief against the simple background, a sparsely furnished cabin room. The colors are warm and dark, and the brushwork is controlled. The scene is depicted with great honesty, power of analysis, and strength of feeling. In an age when sentiment and preoccupation with style separated art from everyday life, Tanner had discovered a rich source of stimulation in the "back-country" environment.

On his return to Atlanta in the fall of 1889 Tanner started his art classes at Clark; his students were mainly fellow instructors. He remained in this teaching position for one year, supplementing his earnings by means of his portrait commissions. Late in 1890 the Hartzells added to Tanner's income by purchasing the collection unsuccessfully offered for sale earlier that year in a solo exhibition they had arranged for him in Cincinnati. The small sum paid for these works, a commission from a Philadelphia patron, and his savings provided Tanner with enough money to sail for Europe in January 1891. His interest in Europe had begun in his early youth, when he met and began to share the experiences of C. H. Shearer, a Philadelphia artist. Although white, Shearer apparently understood many of the problems Tanner faced as a young Black artist and counseled him in many of his depressed and anguished moments. Shearer's stories of European cities created in Tanner a desire to travel abroad.

The original destination of his first European trip was Rome, via Liverpool and Paris; but, on his arrival in Paris, Tanner fell in love with the city and decided to make it his home. Because of his exposure to the strong religious influences exerted by his father and friends, however, Tanner was to experience difficulties in adjusting to life in Paris. But, finding much of that life to his liking, he decided to enroll in the Académie Julien, a private art school whose staff included Jean-Joseph Benjamin Constant and Jean-Paul Laurens, both then among the most famous art teachers in France. Tanner remained at the Académie for five years, and during this time his painting style matured; it now combined the perceptual clarity of Eakins with compositional and color features of Rembrandt. His use of the light and dark qualities of Rembrandt mark Tanner as a nineteenth-century follower of the Caravagesque style. Along with these

elements, Tanner adopted the light colors of the Impressionists, becoming particularly noted for his use of luminous blues, which, subsequently, were often known as "Tanner blues."

After almost three years in France, during which he worked diligently at his art and tried to avoid what he felt were the less desirable practices of the French, Tanner returned to Philadelphia in 1893 to recover from an attack of typhoid and to secure additional financial backing. Part of the money that financed his second trip to Europe came from an exhibition of his works at Earle's Galleries, which he had so often visited as a boy. On his return to Paris in late 1893 Tanner resumed his work, and in 1894 he was among those whose paintings were accepted by the Salon. *The Thankful Poor* [*Illus.* 27], one of Tanner's paintings of this period, is very similar

27 Henry Ossawa Tanner, *The Thankful Poor*, 1894. Oil on canvas, 28″ x 40″. The Pennsylvania School for the Deaf, Philadelphia, Pennsylvania.

to *Banjo Lesson* in its concern with the everyday activities of ordinary people and in its tender use of light and shadow.

In 1895, Tanner produced *Daniel in the Lions' Den* [*Illus.* 28], his first major religious painting. Rekindling his early interest in animals as art subjects, Tanner prepared for this painting by working with French animal sculptor Emanuel Frémiet (1824–1910). The finished work keenly displays this training as well as Tanner's characteristic use of blues, the shades used here providing a feeling of coldness and isolation. This mood is reinforced by the separation of the prophet from the other figures in the painting; the strength of the lions contrasts sharply with the frail body of Daniel. The visible light source adds significantly to the pictorial drama. It illuminates the arms and robe of the prophet and the head and feet of the nearest lion, Daniel's head and the lion's body being allowed to retreat into darkness. In 1896, the painting was exhibited at the Salon, where it won Tanner the first official recognition of his career, an honorable mention.

A second major religious work, *The Resurrection of Lazarus*, was completed by Tanner in the summer of 1896 and in the following year, earned him a gold medal from the Salon. Purchased by the

28 Henry Ossawa Tanner, *Daniel in the Lions' Den*, ca. 1916. Oil on paper on canvas, 41¼" x 50". Los Angeles County Museum of Art.

French government, the painting hung for many years in the Lux-embourg Museum and then in the Louvre and was later placed in the Musée d'Art in Paris; it has since been lost. *The Resurrection of Lazarus* was so admired by Tanner's friend and patron Rodman Wanamaker, a member of a wealthy Philadelphia merchant family, that he agreed to send the artist to Egypt and Palestine to study the costumes and physical characteristics of the inhabitants.

In 1897, Tanner made a trip home to Philadelphia, and while there painted a portrait of his mother that is somewhat reminiscent of the painting known traditionally as "Whistler's Mother." This painting of Sarah Miller Tanner, which also recalls many portraits done by Eakins, seems to capture her emotional and psychological qualities. The colors are warm and dark, and both the light that illuminates the face of the subject and the drapery behind her chair give the illusion of great depth.

Financed by Wanamaker, Tanner made several trips to the Mid-dle East that proved important to his artistic development. A six-month exploration of Jerusalem and surrounding areas during one of these trips was particularly influential, for it resulted in his com-plete artistic dedication to religious subjects. Some of the resultant paintings include *Christ and Nichodemus* (1899), which won the Lippincott Prize from the Pennsylvania Academy of Fine Arts and in 1900 was added to the Temple University collection; *The Two Disciples at the Tomb* (1906); *The Disciples of Emmaus*, which was purchased in 1906 by the French government; and *Flight into Egypt* (1916).

During the war years 1914 to 1918 Tanner was involved in an agricultural project at a Red Cross camp near Paris. Under his supervision the vacant fields that surrounded the camp were used as gardens that helped to supply the facility with fresh vegetables. Tending these gardens also proved to be therapeutic work for many of the camp's wounded and shell-shocked soldiers as they neared recovery. Two paintings that now hang in the war museum of the American National Red Cross and a few sketches are the only works by Tanner known to exist from this period. Representative of them is the charcoal sketch *World War I Canteen* [*Illus.* 29], whose fig-ures, several refugee children and Red Cross workers, appear to be stolid and almost motionless, unlike the figures in Tanner's religious paintings.

Throughout his career, Tanner received many honors, including membership in the National Academy of Design and, in 1923, des-ignation as chevalier of the French Legion of Honor. He was also the recipient of hundreds of prizes from exhibitions held in the

United States and France. Despite this artistic recognition, however, Tanner experienced continuous financial problems. He was fortunate, though, in receiving the support of Atherton Curtis, another wealthy friend, who supplied Tanner with a monthly income for a great portion of the artist's life.

In spite of his personal experiences with racism in the United States, and his long friendship with W. E. B. Du Bois, Tanner does not seem to have been inspired by social or political causes. Throughout most of his career he remained dedicated solely to religious art, refusing the suggestions of friends that he return to the Black genre subjects of his earlier years.

The reason for Tanner's lack of interest in Black themes was probably twofold: first, he may have felt that paintings of Black subject matter would not sell as readily as those of religious themes; and, second, his personal life was characterized more by religious involvement than by commitment to racial issues. From a middle-class, churchgoing family, Tanner was sheltered throughout his youth from many of the hazards of Black life in America; and his fair skin also helped to spare him some of the daily frustrations

29 Henry Ossawa Tanner,
World War I Canteen, 1918.
Charcoal, 16″ x 14″. Collection
of Dr. and Mrs. Leon O. Banks,
Los Angeles. (Photograph
by Adam Avila.)

brought about by American racial bigotry. The major portion of his adult life, moreover, was spent in the relatively racially tolerant environment of Paris.

Thus Tanner suffered more from the economics of being an artist than from being Black. To him, race was a "ghetto of isolation and neglect," and he believed that Black artists would gain artistic freedom and recognition only after they had escaped from it. Though he supported such organizations as the National Association for the Advancement of Colored People and, on occasion, entertained Black artists visiting Paris, Tanner generally remained aloof from the causes and commitments of Black life in America; he considered himself an expatriate in search of aesthetic and artistic truth.

Tanner's approach to art was principally an academic one. He chose in his work to shut himself off from the artistic movements of his day and from the problems of the world. Concerning himself almost exclusively with subject matter expressive of his strong religious upbringing, he was careful to continue his studies of technique so as to sustain the quality of his work. He believed that

> many painters of religious subjects forget that their pictures should be as much works of art as are other paintings with less holy subjects. Whenever such painters assume that because they are treating a more elevated subject than their brother artists they may be excused from giving artistic value to their work or from being careful about a color harmony, for instance, they simply prove that they are less sincere than he who gives the subject his best attention. [From James A. Porter, Modern Negro Art (New York: Arno Press and The New York Times, 1969), p. 76.]

Throughout his mature artistic life Tanner steadfastly refused to compromise with aesthetic quality. The words of Thomas Eakins, his mentor at the Pennsylvania Academy, served as Tanner's motto for most of his life: "Get it, get it better, or get it worse. No middle ground of compromise." For Tanner his art—religious art—had to measure up to the requirements set for any good art if it was to be worthy of respect. Having spent his lifetime working for that respect, Tanner died on May 25, 1937, at his home in Paris.

WILLIAM A. HARPER (1873–1910), whom historian Alain Locke ("American Negro as Artist," in American Magazine of Art, no. 23 [September 1931], p. 132) cited as one of the finest artistic talents of the late nineteenth century, died at age thirty-seven; his death at so early an age must be considered a distinct loss for American art. Though born in Canada, Harper received most of his artistic training at the Art Institute of Chicago; and it was at the Institute that a

memorial exhibition of his works was held soon after his death. Only two exhibitions of Harper's works are known to have occurred in the United States during his lifetime, and records indicate that on both occasions the artist received great critical praise.

Although he studied briefly with Henry Tanner in Paris, Harper demonstrated an approach to art that was considerably different from Tanner's; Harper was less traditional in regard to form and content and much more influenced by the changing artistic concepts of his time. Primarily a landscape painter, Harper developed a style based largely on the traditions of France's Barbizon school, a group of landscape and figure painters who worked outdoors, in the Fontainebleau Forest near the village of Barbizon. The leading member of this group, Jean François Millet (1814–75), himself of peasant origin, produced paintings that sought to capture the dignity of the common people of France. The attention to detail characteristic of works by Millet and other Barbizon painters is evident in Harper's carefully conceived landscapes, and their poetic rendering of outdoor light and atmosphere reflects a Barbizon tradition that was later to influence Impressionism and Post-Impressionism.

MAY HOWARD JACKSON (1877–1931) was one of the first Black sculptors to reject popular European tastes and to deliberately use America's racial problems as a thematic source of their art. Born in Philadelphia, Jackson graduated in 1899 from the Pennsylvania Academy of Fine Arts. Unlike most recognized Black artists of the era, she did not think it necessary to study in Europe but relied instead on the academic training and experience available in the United States.

Active as an artist during a difficult social period in America, she enjoyed only sporadic success and, though of clear and solid objectives, was prevented by circumstances from realizing her full artistic potential. An interest in individual differences apparently led her to a deep awareness of social conditions, and she became particularly skilled at interpreting such differences in a manner that helped to dispel racial stereotypes. Many of her sculptures were portraitures, in which she emphasied characteristics of her subjects that she felt had their origins in social conditions.

After her marriage in 1902, Jackson became a resident of Washington, D.C., where she gained a reputation as a talented portrait artist, her sculptures of such notables as Paul Laurence Dunbar and W. E. B. Du Bois attesting to her technical proficiency. While these pieces were worthy of the praise they received, Jackson's strength is shown more fully in some of her other creations, those intended

as expressions of ideals. *Head of a Negro Child* (1916), for example, communicates more than just the innocence and charm of children: a hope for the future is an intangible part of the composition; for, despite the traditional handling of form, there is a quality that suggests unseen hope. Jackson also demonstrated her belief in the future by devoting much of her time to teaching art to young Black students.

META VAUX WARRICK (FULLER) (1877–1968), like Henry O. Tanner, was a Black Philadelphian who had the advantage of a middle-class family life. Her parents introduced her to art and made possible the training necessary to develop her talent. In the 1880s, for example, William Warrick frequently took his preschool daughter to the Philadelphia Museum and there introduced her to many of its collected works.

In 1894, on completion of her basic education, Warrick took an examination that earned her a scholarship to the Pennsylvania School of Industrial Arts. At her graduation from that school five years later, she was awarded a first prize for her metal crucifix of a tormented Christ and an honorable mention for a clay model she called *Procession of Arts and Crafts*.

As did most of America's professional artists in her day, Warrick soon sought further training in Paris, enrolling in 1899 at the Colarossi Academy. During her three years as a student there, she met such great sculptors as Augustus Saint-Gaudens (1848–1907) and Auguste Rodin (1840–1917); the latter, on viewing Warrick's sculpture *Secret Sorrow*, is purported to have said to her, "Mademoiselle, you are a sculptor; you have a sense of form" (Quoted in Benjamin G. Brawley, *Negro Genius* [New York: Dodd, Mead, 1937], p. 185).

Though some have felt that Warrick's works express too much pathos, most critics have found her sculptures to be inspired interpretations of humanity. James A. Porter provides an example: "Meta Vaux Warrick's early sculpture is a hymn to tradition expressed in forms which reflect the intense struggle of a soul with its own nature" ("One Hundred and Fifty Years of Afro-American Art," in *The Negro in American Art* [Berkeley and Los Angeles: University of California Press, 1966], p. 7).

It is true, however, that in her works most clearly inspired by Rodin, Warrick occasionally carried her interpretation of humanity's plight to extremes of despair, remorse, anger, and resignation. Certain of these expressions are subtle, and others are awkward; but all seem to be, in the main, sincere. In some ways, Warrick's art seems to echo the work of Edmonia Lewis, although Warrick's

brief sojourn in Europe resulted in the adoption of "impressionist realism" while Lewis was influenced by Europe's Neoclassicism. (Warrick and Lewis seem to have had somewhat similar personalities as well, both of them being unusually strong-willed and independent for women of their time.)

Exhibited at the Paris Salon, *The Wretched* (1903) marked Warrick as a sculptor of dynamic symbolism and originality. Her themes and the expressive manner in which she presented them were usually too serious to suit popular taste, but Warrick was able to exhibit and place a number of her works through the Art Nouveau Gallery. A description of *The Wretched* gives some idea of the vigor and power of the early works of Meta Warrick:

> *. . . seven figures, representing as many forms of human anguish, greet the eye. Above the others is that of the philosopher, who, realizing his powerlessness, sinks into the stoniness of despair.* [From Brawley, Negro Genius, *p.* 186.]

Warrick returned to America in 1904 and resumed her studies at the Pennsylvania School of Industrial Arts. During that year she was awarded the school's top prize for ceramics. In 1907, in connection with the Jamestown Tercentennial Exposition, she was commissioned to create a sculptural tableau illustrating the history of Blacks in America. For this project her style became more realistic, perhaps in order to satisfy the exposition's officials.

In 1909, after her marriage to Dr. Solomon Fuller, Warrick settled in Farmington, Massachusetts. Her subsequent artistic and civic activities were centered in the Boston area, where she became a member of the Boston Art Club, the Wellesley Society of Artists, the Women's Club, and the Civil League.

A disastrous fire in her studio in 1910 destroyed most of the pieces Warrick had produced during her stay in Paris. These are believed to have been the works in which she demonstrated her greatest emotional depth and concentration on the timeless themes of human anguish and despair. Among her extant works with sentimental and ethnic overtones is *Water Boy* [*Illus.* 30], and the sculptural monumentality she often achieved is exemplified in her portrait of actor Richard B. Harrison [*Illus.* 31].

The art of Meta Vaux Warrick provides us with insight into her concern for humanity. Although she lived during a time when it was neither common nor acceptable for middle-class Black women to involve themselves in social action, Warrick uninhibitedly nurtured an interest in social problems. Unfortunately, she was not fully ap-

31 Meta Vaux Warrick (Fuller),
Richard B. Harrison As "De Lawd",
ca. 1935. Plaster, 4½″ high.
Howard University Gallery of Art,
Washington, D.C.
(Photograph by Scurlock Studios,
Washington, D.C.)

30 Meta Vaux Warrick (Fuller),
Water Boy, 1914. Bronze.
Harmon Foundation Collection,
the National Archives.

preciated in her time; for the subject matter and emotional intensity
of this dynamic artist intimidated many of her contemporaries. A
transitional figure in the history of Black art, Warrick expressed
ideals that are more in accord with the Black Renaissance of the
generation that followed hers than with the prevailing artistic views
of her own period.

WILLIAM EDOUARD SCOTT (1884–1964), best known for his portraits and murals, was a product of the Art Institute of Chicago. After attending the Julien and Colarossi academies in Paris, Scott studied with Black expatriate Henry O. Tanner, who had gained a reputation in that city as an excellent art teacher and who proved a major influence on his pupil's early works. In 1912 one such work, *La Pauvre Voisine*, currently owned by the Argentine government, was accepted by the Paris Salon; and in 1913 Scott's *La Connoisseure* was exhibited at the Royal Academy in London.

A Rosenwald Foundation grant made it possible for Scott to visit Haiti in 1931; this trip brought about a drastic change in both his choice of subject and his artistic style. As the Indianapolis-born artist involved himself in Haitian life and painted extensive studies of the island's people, his palette became richer and his brushwork more expressive. During his short stay he produced 144 artistic works, the majority of which depicted ordinary people. That Scott was able to capture the essence of his new environment is suggested by the fact that a solo exhibit of his works held in Port-au-Prince was promoted by the Haitian government to show native artists, most of them accustomed to French art, that there was a wealth of subject matter at home; twelve of the paintings sold during the exhibition were purchased by the president of Haiti. *Haitian Fisherman* [*Illus.* 32] and *When the Tide Is Out* [*Illus.* 33] are examples of the style

32 William Edouard Scott,
Haitian Fisherman, ca. 1931.
Harmon Foundation Collection,
the National Archives.

33 William Edouard Scott,
When The Tide is Out, ca. 1931.
Harmon Foundation Collection,
the National Archives.

that Scott developed in Haiti and that later contributed to his effectiveness as a mural painter.

On returning to the United States in 1932, Scott received commissions to decorate the walls of many public buildings in his home state of Indiana. He also painted murals for New York's 135th Street YMCA and for buildings in Illinois and West Virginia. Scott's Haitian experience contributed greatly to his uninhibited use of color in these works. It also helped him to become one of the first Black painters in the United States to shake off the self-imposed yoke of European tradition.

LAURA WHEELER WARING (1887–1948), a painter, illustrator, and art teacher, was prominent among a school of painters who in the 1920s made notable contributions to the tradition of portraiture in American art. Born in Hartford, Connecticut, she attended schools in that state and, later, the Pennsylvania Academy of Fine Arts. Upon graduation from the Academy in 1914, Waring was awarded a scholarship to study in Europe; and from 1924 to 1925 she was a student at the Académie de la Grande Chaumière, a popular atelier in Paris. On her return to the United States she began a teaching career as an instructor at Cheyney State Teachers College in Pennsylvania.

The realistic style Waring exhibited in her portraits included aspects of Expressionism, but unrestrained in regard to structure and treatment of forms, it was most closely related to the work of the rebellious Romantics who painted in France during the 1920s. Yet, while her lyrical approach can be classified as Romantic, it did not include the "prettiness" common to the Romantic school. Her soft but contrasting portrait style also avoided the surface stillness characteristic of realistic painting of the time. *Frankie* [*Illus.* 34] and *Anne Washington Derry* [*Illus.* 35] provide excellent examples of Waring's approach to painting and illustrate the lifelike quality she was able to give her portraits.

34 Laura Wheeler Waring, *Frankie* (or *Portrait of a Child*), 1937. Oil. Harmon Foundation Collection, the National Archives.

35 Laura Wheeler Waring, *Anne Washington Derry*. Harmon Foundation Collection, the National Archives.

AMERICAN RELIANCE ON THE EUROPEAN ARTISTIC TRADITION

The efforts made by Black artists of the eighteenth century to establish themselves as significant contributors to American art were arduous but abortive. Working against cultural as well as economic odds, these artists, like their white contemporaries, generally developed styles that were provincial derivatives of the prevailing European mode. Thus, though the painters and sculptors themselves were often courageous, their achievements did not provide them recognition as distinctive artists, either Black or American.

Most Black American artists of the nineteenth century attempted to escape their country's prejudice and provincialism through study —and, in some cases, permanent residence—abroad. They usually found their way to one of the major European capitals, where, removed from American life and from the scenes of their early personal experiences, they sought to become internationally known. For some of these artists the flight from racial prejudice also included a complete avoidance of racial subject matter in their work. Thus, the Black artists of this period, with only rare exceptions, contributed little to the development of a consciousness of Black expression. Indeed, from the mid-nineteenth century to the turn of the twentieth, the majority of Black artists, whether living in the United States or abroad, sought to demonstrate their competence by means of the best artistic traditions and styles of Europe.

The celebration held in Philadelphia in 1876 to mark the centennial of American independence was the occasion for an art exhibit that offered most Americans their first opportunity to view a large number of works by American artists living abroad. So great was the subsequent national acceptance of European influence on art that painters and sculptors in the United States were fortified in their desire to study in Europe as a means to a successful career. Many Blacks, perhaps particularly students at the Pennsylvania Academy, were among the American artists caught up in the late–nineteenth-century fervor of "Europe first—then fame and fortune." The small number of American painters and sculptors who did resist the lure of Europe, however, could be encouraged by the strong individualistic stance of Thomas Eakins and Winslow Homer, for both these great American painters believed that their country needed to develop an indigenous art free of European sophistication and decadence.

Despite these prominent examples, however, most Black artists who could manage the expenses made their way to Europe; Tanner,

Harper, Lewis, Warrick, Scott, and Waring were but a few of the Black artists who flocked to the studios of Paris, Munich, and other European capitals. Black American artists might well have continued their nearly unanimous concentration on Europe had it not been for the call to Black awareness issued in the early 1920s by such scholars as Alain Locke, W. E. B. Du Bois, and Marcus Garvey. As the efforts of these men began to reestablish Africa as the cultural homeland of American Blacks, many Black men and women in various disciplines rediscovered ethnic roots that had been all but forgotten. For most of them the turn from Europe to Africa was not easily accomplished; and old habits being too powerful, there were those Blacks for whom the belief that "European is universal" persisted.

New Americanism and Ethnic Identity

1920-1945

Racial representation through art became the dominant issue for Black artists in the first quarter of the twentieth century. During this period, forces for self-expression, both internal and external ones, led them to greater ethnic awareness. Black artists generally had to decide whether to identify with their race, accepting and exploiting the Black heritage, or with the international art movement, accepting and exploiting the security of the European artistic tradition.

The Harlem Renaissance, a movement of the 1920s, marked the century's first period of intense activity by Black Americans in the fields of literature, art, and music. The philosophy of the movement combined realism, ethnic consciousness, and Americanism. Encouraged by the example of those established white artists (among them Thomas Eakins, Robert Henri, and George Luks) who had included Blacks in their paintings as serious studies rather than as trivial or sentimental stereotypes, Black artists of this period set about creating a new portrayal of Blacks and their lives in America. African-American artists began to assert themselves and, in doing so, developed self-reliance, self-respect, and self-pride. As they began to strive for social and cultural independence, their attitudes toward themselves changed, and, to some extent, other segments of American society began to change their attitudes toward them. Thus, though the Harlem Renaissance was a short-lived movement, its impact on American art was considerable.

Harlem was the capital of the movement. Black artists and intellectuals from many parts of the country had been attracted to this Manhattan neighborhood by the pulse and beat of its unique and dynamic culture. However, even in Harlem, the "mecca" for Blacks migrating from the South in the early 1900s, there were places that were off-limits to them. For example, the famous Cotton Club, the New York home of Black music, was then a place where Blacks were performers but not patrons. (By this time new stereotypes had been created about Blacks; members of white café society considered them primitive and exotic, and the Cotton Club had become a headquarters for whites who liked to go "slumming" and share in the "excitement" of Black life.)

In 1925 an issue of *Survey Graphic* magazine devoted exclusively to Harlem and edited by philosopher Alain Locke became the manifesto of the Black artistic movement. While accepting their Americanism, Locke encouraged all Blacks to take pride in their African ancestral arts and urged Black artists particularly to look to Africa for substance and inspiration. Far from advocating a withdrawal from American culture, as did some of his contemporaries, Locke recommended a cultural pluralism through which Blacks could enrich the culture of America. The African-American was urged by Locke to be "a collaborator and participator" with his fellow Americans in art, literature, and music; and, at the same time, to preserve, enhance, and promote his own cultural heritage.

Black artists who had left their homes in the South in search of new lives in northern cities experienced many common problems and found it necessary to unite for cultural and economic survival. From this unity came a new Black spirit and lifestyle, which, particularly in densely populated Harlem, was to result in greater group awareness and self-determination. Black artists took their place beside the poets and writers of the "New Movement" or "Harlem Renaissance" and carried on efforts to increase and promote the visual arts.

AARON DOUGLAS (b. 1899), the leading exponent of the visual arts during the Harlem Renaissance, grew up in Topeka, Kansas. He received a bachelor of fine arts degree from the University of Nebraska in 1922 and, later, a master's degree in fine arts from Columbia University.

Giving up a position as a high school art teacher, Douglas left Kansas in 1925 to settle in New York City, where he hoped to continue his studies in art. It was in New York that he met artist Winold Reiss, who later became his teacher and major artistic influ-

ence. Although Douglas had been trained in a strict academic tradition, his work in New York demonstrated a creative and individualistic flair; and he was challenged by his teacher, Reiss, to seek and accept his own cultural heritage as artistic subject matter. Douglas' subsequent combining of a knowledge of classical art and an interest in African art made him capable of an uncommon type and quality of artistic expression. One of the first American painters who can be considered an Africanist, Douglas, during the late 1920s, devoted much of his time to studying the African art then available at a few nearby institutions; the Barnes Foundation in Philadelphia was prominent among these. However, despite his great interest in African art and its cubistic forms, Douglas felt that his knowledge of Africa was too superficial to become the sole focus of his work. He preferred to dedicate himself to painting Black Americans, with a new measure of dignity and pride. Thus, as David Driskell of Fisk University has so aptly stated, Douglas was responsible for

a revolution in form which spoke succinctly against the accepted patterns of culture that labeled his people inferior. His art did this without the saccharine sweetness of some of the social protest art created during the same period. Each work that he created became a lesson in the heritage of the Black man culturally admonishing him to reject the falsities of the previous order. In so doing Douglas was able to expand upon his own vision through art and plant the seeds for the current aesthetics in Black Art. [From the Foreword to "Aaron Douglas Retrospective Exhibition." Catalog of an exhibition, 21 March–15 April 1971, at Fisk University.]

In the mid-1920s W. E. B. Du Bois invited the young artist to participate in the creation of visual symbols for the Harlem Renaissance. Douglas not only accepted Du Bois' invitation but provided direction and leadership regarding the visual aspects of the movement.

As one of the leading artists of the Harlem Renaissance, Douglas was responsible for many of the designs and illustrations in *The New Negro* (1925), a volume of literary works edited by Alain Locke. He also created illustrations for works by such well-known Black authors as Du Bois, Cullen, Hughes, and James Weldon Johnson. Douglas' series of illustrations for Johnson's *God's Trombones* (1925), a book of sermons projecting the character of early Black ministers, is regarded as one of his masterpieces.

After his early work as an illustrator, Douglas turned to painting panels and murals. Most of his first murals included stylized, geometric figures reminiscent of African sculpture. In murals for the

Countee Cullen Branch of the New York Public Library, Douglas illustrated the history of American Blacks [*Ills.* 36–39]. The elongation and angularization of the figures in these pieces are representative of his sophisticated style. Usually the sense of movement the figures provide is heightened by abrupt changes in the direction of line and mass; and the geometric forms that overlay the figures sometimes intersect, causing a change in value that makes the figures seem enmeshed in bands of fog. The themes of these panels have been described by Douglas in the following words:

> *The first of four murals . . . indicates the African cultural background of American Negroes. Dominant in it are the strongly rhythmic arts of music, the dance and sculpture—and so the drummers, the dancers, and the carved fetish represent the exhilaration and rhythmic pulsation of life in Africa.*

> Panel Two. *Exultation followed the abolition of slavery in America by the Proclamation of Emancipation (1 January 1863). Many Negro leaders emerged who are symbolized by the orator standing on a box. But soon a new oppression began in the South. The "hooded terror" of the Ku Klux Klan spread as the Union Army withdrew.*

> Panel Three. *Lynching was an ever present horror, ceaseless toil in the fields was the daily lot of the majority, but still the American Negroes laughed and sang and danced.*

36 Aaron Douglas, *Aspects of Negro Life:* Panel 1, 1934. Oil on canvas, 73″ x 80″. Collection of The New York Public Library (Astor, Lenox and Tilden Foundations).

37 Aaron Douglas *Aspects of Negro Life:* Panel 2, 1934. Oil on canvas, 59″ x 140″. Collection of The New York Public Library (Astor, Lenox and Tilden Foundations).

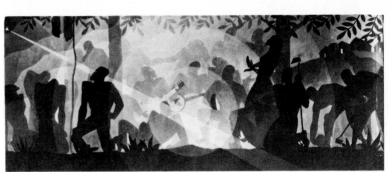

38 Aaron Douglas, *Aspects of Negro Life:* Panel 3, 1934. Oil on canvas, 59″ x 144″. Collection of The New York Public Library (Astor, Lenox and Tilden Foundations).

39 Aaron Douglas, *Aspects of Negro Life:* Panel 4, 1934. Oil on canvas, 96″ x 84″. Collection of The New York Public Library (Astor, Lenox and Tilden Foundations).

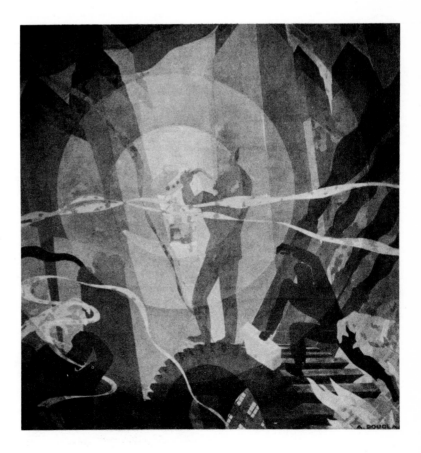

Panel Four. *A great migration, away from the clutching hand of serfdom in the South to the urban and industrial life in America, began during the First World War. And with it there was born a new will to creative self-expression which quickly grew in the New Negro Movement of the 'twenties. At its peak, the Depression brought confusion, dejection and frustration.* [Quoted in Cedric Dover, American Negro Art (*Greenwich, Conn.:* New York Graphic Society, 1960), *p.* 186.]

Other murals of importance by Douglas include those he executed for Fisk University, the Ebony Club in New York, and the Hotel Sherman in Chicago. The Ebony Club and Hotel Sherman murals have dance as their central theme, while those at Fisk University are devoted to Black history.

The numerous easel paintings for which Douglas is also noted are primarily portraits. They show none of the geometric patterning evident in his murals, but instead present their subjects with classically correct proportions. This is exemplified by his portrait of Mary McLeod Bethune [*Illus.* 40].

In 1939 Douglas joined the faculty of Fisk University; there he later became founder and chairman of an art department that would see many of its students become significant figures in American art. During the decades in which he held this teaching/administrative post in Nashville, Douglas continued his association with his academic and artistic friends in the Northeast, on occasion inviting them to address the students at Fisk. He also continued, until his retirement in 1966, to be active in expressing the aims of the Harlem Black Renaissance.

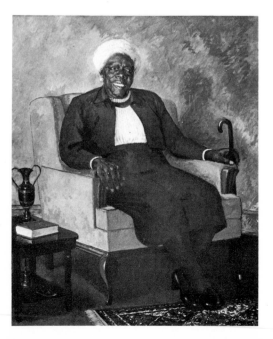

40 Aaron Douglas, *Portrait of Mary McLeod Bethune*, 1968. Oil, 58″ x 48″. Property of the Minneapolis Public Schools (gift of the John Cowles, Sr., family).

Harlem's artistic movement of the 1920s stimulated similar activity in other urban centers of the country. In Washington, D.C., in 1922 the Tanner Art League, a local organization named in honor of Henry O. Tanner, held an exhibition in which 112 paintings and 9 sculptures by Black artists were displayed; and, throughout the 1920s and 1930s, exhibitions of the same sort occurred in Chicago, Cleveland, and other large cities where Blacks formed a sizable portion of the population. These presentations of Black art laid the groundwork for a climate of artistic interest and support that would gain momentum and continue for many years.

In 1928 the Harmon Foundation, founded earlier in the decade by the philanthropist William E. Harmon to aid Black artists and extant until the 1960s, sponsored a New York exhibition that proved disappointing to its organizers in that most of its eighty-seven paintings reflected traditional European influences: one aim of the foundation had been to encourage Black artists to develop along a course more representative of their own culture. In this respect, subsequent foundation projects were more successful: a major exhibition in 1931 and the well-attended traveling exhibitions later sponsored by the foundation. Throughout the 1930s these exhibitions visited cities in over twenty-five states and were viewed by Blacks and whites in numbers totaling nearly one-half million. The artists involved in the traveling exhibitions included Sargent Johnson, Malvin Gray Johnson, Ellis Wilson, Richmond Barthé, Beauford Delaney, Meta Warrick Fuller, Hale Woodruff, William H. Johnson, Lois Mailou Jones, and William E. Artis.

The Harmon Foundation also encouraged the growth of art education programs in many Black institutions. Young Black artists competed for its cash awards, and its stipends enabled many of them to study at art schools and colleges. The foundation eventually became one of the major institutions involved in the perpetuation and preservation of Black art in the United States. Along with the Black Church, the major Black colleges and universities, and some historical societies, it served in the 1930s as a prime mover in the cultural life of Black Americans.

HALE WOODRUFF (b. 1900) is the creator of murals on Black history for the libraries of both Atlanta University and Talladega College, in Alabama. *The Amistad Murals*, his creation for Talladega's Savery Library, are powerful compositions that, in their debt to Diego Rivera and José Clemente Orozco, illustrate the influence

some of the Mexican muralists had on Black artists in the United States during the 1930s and 1940s.

Completed in 1939, the three panels represent different episodes related to the *Amistad* incident, the revolt of fifty-four Africans bound for slavery in Cuba aboard the Spanish ship *Amistad*. In the first panel, *The Mutiny Aboard the Amistad*, 1839 [*Illus.* 41], two triangular groupings of intertwined forms depict the violent struggle of the slaves to regain their freedom. Separated by the images of a dead slave and of a struggling white sailor, these figure groupings give the composition its great balance and visual stability. The focal point of the painting is an escaping sailor, who reappears in the second panel as the accuser.

The second panel, *The Amistad Slaves on Trial at New Haven, Connecticut*, 1840 [*Illus.* 42], offers a calm, orderly arrangement of figures. The faces of the defendants show the fright they feel in knowing their future is at stake. The three most important figures in the drama—Cinqué, the leader of the slaves; the judge; and the accusing sailor—are surrounded by more space and placed at a slightly higher level than the other participants at the trial. Cinqué, in an extremely immobile, steadfast pose, provides a strong vertical thrust that is symbolic of his confidence in his position. The arm of the sailor confronting Cinqué creates an opposing horizontal focus. The judge's desk repeats this emphasis and unites the two groups, while the wall panels define the opposing factions. The central figures create a circular motion that acts as a visual frame and calls attention to the "evidence of the mutiny."

The final panel, *The Return to Africa*, 1842 [*Illus.* 43], also utilizes a two-part arrangement. Central to this composition is a boatload of former slaves returning to their homeland in Africa; their jubilant faces show their emotional reaction. In the foreground, Cinqué gestures as if to deliver a proclamation, while a man to the right displays books and other material acquired during their involuntary stay in America.

Woodruff, a professor emeritus of New York University and a former organizer of the annual art exhibition at Atlanta University, was born in Cairo, Illinois. After a public school education in Tennessee, he attended the John Herron Art Institute in Indianapolis. On receiving a Harmon Foundation award in 1926, he was given an additional sum by a patron to enable him to study abroad. Leaving a YMCA position he had held for four years, Woodruff sailed to Paris in 1927 and began studies at the Académie de la Grande Chaumière. During the next four years in France, he assimilated much of the Impressionist style that marks his later works. Following his re-

41 Hale Woodruff,
The Mutiny Aboard the Amistad,
1939. Oil on canvas, 6' x 10'.
Savery Library,
Talladega College, Alabama.

42 Hale Woodruff,
*The Amistad Slaves on Trial at
New Haven, Connecticut*, 1840,
1939. Oil on canvas, 6' x 20'.
Savery Library,
Talladega College, Alabama.

43 Hale Woodruff,
The Return to Africa, 1842,
1939. Oil on canvas, 6' x 10'.
Savery Library,
Talladega College, Alabama.

turn to the United States in 1931, Woodruff became an art instructor at Atlanta University and later accepted a post in the education department at New York University.

The realistic style used by Woodruff in his early years does not characterize his later works. He has always been a versatile artist willing to use current art forms to update his own style. Originally a successful figure painter, Woodruff shifted to the Non-Objective school and later to Abstract Expressionism [*Ills.* 44, 45].

69

44 Hale Woodruff, *Leda*, 1961. Oil, 50″ x 60″. Courtesy of the artist.

45 Hale Woodruff, *Landscape with Green Sun*, 1966. Oil, 30″ x 42″. Collection of Ebony Magazine.

PALMER HAYDEN (1893–1973), one of the most influential Black artists to gain prominence during the 1920s, was born in Wide Water, Virginia, and was educated in the state's public schools. As an enlisted man in the armed forces during World War I, he enrolled in a correspondence school that provided his first formal training in art. After completing military service, Hayden went to New York, where he secured a part-time job in Greenwich Village and studied art with Victor Perard, then an instructor at Cooper Union.

46 Palmer Hayden, *Fétiche et Fleurs*, ca. 1933. Oil on canvas, 23″ x 28½″. Collection of Mrs. Palmer Hayden.

In 1926 Hayden won a Harmon Foundation award (four hundred dollars and a gold medal) for a painting of the Portland, Maine, waterfront. Exhibited at the Civic Club in New York City, the painting was one of those done by Hayden in 1925 while he was studying under Asa G. Randall at the Boothbay Harbor art colony in Maine. With a grant of three thousand dollars from a patron, Hayden was able to go abroad in 1927 to pursue his studies. Settling in Paris, he became the private pupil of Clivette Lefèvre, an art instructor at the École des Beaux-Arts.

It was during his stay in France that Hayden became interested in Black subject matter. His first paintings of Blacks were done in Europe and were part of the American Legion exhibition held in Paris in 1931. When he returned to the United States, Hayden's success continued. His works were included in several Harmon Foundation traveling exhibitions, and, in 1933, his *Fétiche et Fleurs* [*Illus.* 46] won the Mrs. John D. Rockefeller Prize for painting. This still life of an African sculpture and fabric and a vase of flowers was viewed by at least one critic as a "naïve response to Alain Locke's plea for a return to the ancestral arts." However, the composition represents a juxtaposition of objects that could be found in the home of many artists, and in no way is it any more naïve than many paintings of African subjects that were created by European artists at about the same time.

One of the most enduring and outstanding painters of Black images, Hayden was a productive artist through the years of the Harlem Renaissance up to the 1970s. Among the most significant contributions of his career is a series of twelve paintings depicting the life and death of Black folk hero John Henry [*Illus.* 47]. For Hayden, John Henry represented the struggle of Blacks to move from an agricultural to an industrial life. He hoped that this series, which he started in 1944 and completed in 1954, would serve as a symbol of ethnic greatness to a people struggling for economic survival.

Other important paintings by Palmer Hayden include *Mid-Summer Night in Harlem* (1936), *The Janitor Who Paints* (1937), and *The Baptizing* [*Illus.* 48].

Although he participated in many solo and group exhibitions, Hayden never received the strong support of a gallery, which is so often necessary if an artist is to enjoy good public relations and

47 Palmer Hayden, *John Henry on the Right*, *Steam Drill on the Left* (from the *John Henry* series), 1947. Oil on canvas, 30″ x 40″. Collection of Mrs. Palmer Hayden.

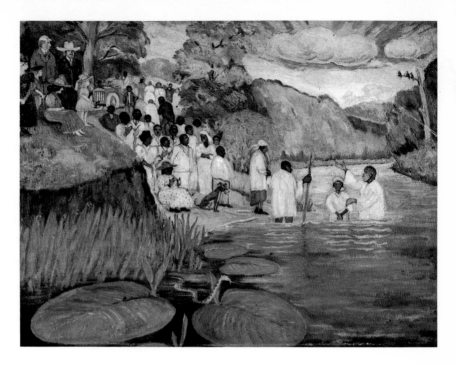

48 Palmer Hayden,
The Baptizing. Oil on canvas,
27⅞" x 34½". Collection
of Mrs. Palmer Hayden.

obtain the help of wealthy patrons. Like those created by many
other Black artists of his time, his images were unfamiliar to much of
the art world and unacceptable to most of the public. But in spite
of this lack of public support, Hayden continued to create primarily
genre scenes that record the flavor of Black life.

ARCHIBALD MOTLEY, JR., (b. 1891) focused on Black subjects in a
way unique among the artists of the Harlem Renaissance. To art
historian Alain Locke, Motley's work reflected "a broad, higher
keyed and somewhat lurid color scheme, with an emphasis on the
grotesque and genre side of modern Negro life" (*Negro Art Past and
Present* [Albany, N. Y.: Albany Historical Society, 1933], p. 69).
Motley did not attempt to glorify or idealize the activities of Blacks;
rather, he depicted his people as he often saw them in the urban
settings of the 1920s.

Born in New Orleans, Motley moved to Chicago as a young man
and worked there as a day laborer. Like most of his Black predecessors in the arts, he considered the stamp of European study a prerequisite to success as an artist. Thus, after winning a Guggenheim
Fellowship in 1929, he soon departed for France. *Old Snuff
Dipper* [*Illus.* 49], which won a Harmon Foundation award in the
late 1920s, illustrates the realistic style Motley employed during the
early part of his career.

A solo exhibition in New York City in 1928 revealed that Motley
had both a concern for the African consciousness and an interest in

49 Archibald Motley, Jr.,
Old Snuff Dipper, 1928.
Oil on canvas.
Harmon Foundation Collection,
the National Archives.

50 Archibald Motley, Jr.,
The Picnic in the Grass.
Howard University
Gallery of Art.
(Photograph by Scurlock Studios,
Washington, D.C.)

51 Archibald Motley, Jr., *Chicken Shack*, 1936. Oil on canvas. Harmon
Foundation Collection, the National Archives.

voodoo and other mystical powers. This artistic interest in the spirit world was not long-lived, however; he soon abandoned it for the life-oriented subjects of paintings such as *The Picnic in the Grass* [*Illus.* 50], an intimate view of people enjoying themselves. Filled with figures and movement, this composition effectively conveys the "good-timing" life to be found in urban areas of the period. With its lack of deep space or areas that allow the eye to rest, the painting is an intense experience full of nervous energy. In this regard it contrasts with *Mending Socks* (1924) and other examples of Motley's earlier subjective realism. Motley's studies of urban dwellers also include *Chicken Shack* [*Illus.* 51].

A painter of "people as scenes," Motley concentrates on actions rather than individuals. Activities of the Prohibition era, including illegal gambling and drinking, have been among his favorite subjects. But his "people-filled" cityscapes are less in accord with the racial identification of the Harlem Renaissance than with the concepts of the Ashcan school, a group of American artists and journalists who in 1908 rejected the Salon art of Europe and chose as their themes ordinary people engaged in ordinary activities.

A resident of Mexico since the early 1970s, Motley continues to accept the challenges of life and art. In April 1972, at a dinner given in his honor in Chicago at the annual meeting of the National Conference of Artists, Motley reaffirmed his dedication to art as a means of underlining the basic gaiety of everyday life.

MALVIN GRAY JOHNSON (1896–1934) was one of the most far-reaching and versatile artists of his period. He drew upon many stylistic sources and demonstrated the disciplined learning necessary for high levels of creative expression. While a student at the National Academy of Design, Johnson worked in the popular classical mode; but as he became familiar with the works of the Impressionists and the Cubists, his artistic style changed. Inspired by their individuality and freshness of approach, he developed a style that was a combination of the traditional mode and the new "Modern Art" nurtured in Paris.

Johnson later used his diverse artistic knowledge to create expressions of Black life and illustrations based on spirituals. In *Arrangement* [*Illus.* 52], for example, though his feeling for the traditional remains evident, the handling of the surfaces seems to foreshadow *The Elks* [*Illus.* 53], in which he definitely employs a planar style derived from Cubism. Johnson's handling of watercolor technique in *Woman Washing* [*Illus.* 54] combines all his prior styles. The subtle, expressionistic manner in which its cubelike shapes are ap-

52 Malvin Gray Johnson, *Arrangement*, ca. 1933. Oil on canvas, 20″ x 16″. Department of Art, Fisk University.

plied gives great dignity to this image of an ordinary woman engaged in a traditionally unheralded task.

When he died, at age thirty-eight, Malvin Gray Johnson had just begun to reach the goal he sought during most of his adult life: he was becoming an informed, sensitive communicator of Black images.

53 Malvin Gray Johnson, *The Elks*, ca. 1933. Oil on canvas, 15⅜″ x 18⅛″. Department of Art, Fisk University.

54 Malvin Gray Johnson, *Woman Washing*, ca. 1933. Watercolor, 11¼″ x 17″. Department of Art, Fisk University.

55　Ellis Wilson, *Harvest*.

ELLIS WILSON (1899–1977), one of the few Black artists whose father was also an artist, was born in Mayfield, Kentucky, and graduated from the Art Institute of Chicago. He later worked as an interior decorator and as a commercial artist. Wilson's interest in Black art was first rewarded when he won a prize for an African poster he made while a student. As this interest continued to grow Wilson became one of the most vigorous painters of subjects expressive of the Black experience. Particularly fascinated by Black life in Haiti, Wilson was a regular visitor to that country for many years. His affinity for the area and its people is reflected in the vitality of the art he created.

56　Ellis Wilson, *Bird Vendor*, 1953. Oil.

While a certain naïveté seems evident in both his landscapes and his figural compositions, Wilson always produced fully accomplished and sophisticated design patterns; the pattern of the greenery in *Harvest* [*Illus.* 55], for example, is quite intellectually resolved. Making bold use of color, his paintings reflect a coherent and personal style that combines aspects of Expressionism with contemporary Realism. His vigorous distortion of form, one of the aspects of Expressionism, is evident in such compositions as *Bird Vendor* [*Illus.* 56].

A longtime resident of New York City, Wilson was identified with the group of New York artists whose ingenuity and determination helped to make them early leaders of the Black art movement. Like them, he rejected the concept of a single aesthetic norm and sought to introduce and maintain Black subjects as a significant part of American art.

SARGENT CLAUDE JOHNSON (1887–1967), a Boston-born sculptor, studied the artistic styles of many different cultures. African and Mexican styles were his principal interests, but his subject matter and definition of shape were thoroughly international. His immensely sophisticated style transcended time by capturing basic truths deeply rooted in human experience.

The media in which Johnson worked were as varied as his themes and styles. Known principally as a sculptor, he was also a graphic artist, painter, enamelist, and ceramist. *Forever Free* [*Illus.* 57], one of Johnson's most popular works, is a monumental and majestic figure of a mother fashioned in lacquered wood. Incised in the lower portion of her tubular body are the figures of two children playing happily in her protective presence. The African-inspired, realistic head and the abstract cylindrical body give dignity and strength to the mother figure; these qualities are also evident in *Negro Woman* [*Illus.* 58].

His creation of a protective mother figure may have reflected a psychological need on Johnson's part. Orphaned in 1902, he spent a portion of his early life in foster homes, including the Washington, D.C., home of his uncle, a high school principal, and his wife, the sculptor May Howard Jackson (see p. 52); it is possible that Johnson's introduction to sculpture was the result of this contact with Jackson. Johnson and his five brothers and sisters later moved to the home of their maternal grandparents, in Alexandria, Virginia, but were subsequently separated. The girls were sent to a school in Pennsylvania, while the boys were enrolled in a school run by the Sisters of Charity, in Worcester, Massachusetts. After Johnson left the school, he lived briefly in Chicago, then moved in 1915 to San Francisco. There he attended the A. W. Best School of Art and the California School of Fine Arts and also studied privately with Beniamino Bufano, a well-known sculptor.

Johnson first gained public notice in 1925 as a result of a San Francisco exhibit that included his *Elizabeth Gee*, a ceramic bust reportedly "after the manner of Bufano"; in 1928 *Sammy*, another ceramic bust, was entered in a Harmon Foundation exhibit and also won the Otto H. Kahn Prize. In 1935 Johnson participated in a three-man exhibition held in New York City under the sponsorship of the Harmon Foundation. Malvin Gray Johnson and Richmond Barthé were the other participating artists.

A Johnson statement that appeared in the *San Francisco Chronicle* (6 October 1935) remains one of the strongest and most impressive statements by a Black artist on his craft:

57 Sargent Claude Johnson, *Forever Free*, 1933. Lacquered cloth over wood, 36″ x 11½″ x 9½″. Collection of the San Francisco Museum of Modern Art (gift of Mrs. E. D. Lederman). (Herrington-Olson photography.)

I am producing strictly a Negro Art, studying not the culturally mixed Negro of the cities, but the more primitive slave type as existed in this country during the period of slave importation. Very few artists have gone into the history of the Negro in America cutting back to the sources and origins of the life of the race in this country. It is the pure American Negro I am concerned with, aiming to show the natural beauty and dignity in that characteristic lip and that characteristic hair, bearing and manner; and I wish to show that beauty not so much to the White man as to the Negro himself. Unless I can interest my race, I am sunk, and this is not so easily accomplished. The slogan for the Negro artist should be "Go South, young man." Unfortunately for too many of us it is "Go East, young man." Too many Negro artists go to Europe and come back imitators of Cézanne, Matisse, or Picasso; and this attitude is not only a weakness of the artists but of their racial public. In all artistic circles I hear too much talking and too much theorizing. All their theories do not help me any, and I have but one technical hobby to ride; I am interested in applying color to sculpture as the Egyptian, Greek, and other ancient people did. I try to apply color without destroying the natural expression of sculpture, putting it on pure and large masses without breaking up the surfaces of the sculpturesque expression. I am concerned with color, not solely as a technical problem, but also as a means of heightening the racial character of my work. The Negroes are a colorful race; they call for an art as colorful as can be made.

58 Sargent Claude Johnson, *Negro Woman*. Lacquered cloth over wood, 28″ x 12¼″ x 11″. San Francisco Museum of Modern Art (gift of Albert M. Bender).

Sargent Johnson's concern with the origins of Black Americans is illustrated by his masks and studies of heads. The copper masks in *Illustrations* 59 and 60, clearly derivatives of western Africa's Baule culture, show his interest in the beauty of African forms. The head *Negro Woman* (1933) is another notable example of his interest in the "pure American Negro."

As an employee of the Federal Arts Project in the late 1930s, Johnson held a number of general and administrative positions, ranging from staff artist to unit supervisor. During this affiliation he produced several monumental works, among them a large redwood screen carved in 1937 for the organ at the California School for the Blind, in Berkeley. The government project also gave Johnson the opportunity to create a mural for the Maritime Museum in San Francisco's Aquatic Park. With this assignment, for which he acquired his first well-equipped studio, Johnson began to express himself in a new medium. His mural for the museum is a mosaic that depicts human and marine life.

59 Sargent Claude Johnson, copper mask, 1935.
13¾" x 7" x 2½".
San Francisco Museum of Modern Art (gift of Albert M. Bender).

60 Sargent Claude Johnson, copper mask, 1935.
11" x 8¾" x 2½".
San Francisco Museum of Modern Art (gift of Albert M. Bender).

61 Sargent Claude Johnson, sculpture of Incas, 1939. Stone, 8′ high.

Johnson believed that governmental assistance was necessary to the development and maintenance of the creative forces that characterize a vital community. Shortly before his death, he recalled the close friendships he had made as a result of his government-project associations and lamented the fact that today's artists, Blacks in particular, did not have similar opportunities.

The Golden Gate International Exhibition of 1939 provided an opportunity for Johnson to produce large-scale sculpture. Home life, agriculture, and industry were the themes of three works he created for the Exhibition's Alameda–Contra Costa County Fair Building. Two other monumental works, eight-foot stone sculptures of Incas seated on llamas, were made by him for the Court of Pacifica and still stand on the site today [*Illus.* 61].

81

In 1940 the San Francisco Art Commission asked Johnson to execute an athletic frieze for the city's George Washington High School. The large relief sculpture by Johnson that serves as part of the retaining wall at one end of the school's football field was completed in 1942. This massive project offered many technical challenges, and the artist was able to solve them with no sacrifice of aesthetic concerns. The simplicity of his forms and figures aided his efforts in this regard [*Illus.* 62].

Concurrent with his involvement in sculpture was Johnson's work in graphics. In 1940 he produced the lithograph *Singing Saints*

62 Sargent Claude Johnson, athletic relief sculpture, 1940–42. Stone, 12' x 181'. George Washington High School, San Francisco. (Photograph by Robert Cheung.)

[*Illus*. 63], whose musical theme he would continue to employ. *Lenox Avenue* [*Illus*. 64], an earlier lithograph, also reflects the interest Johnson retained in music long after he had studied it as a child. The flowing curves of the work's simply stated forms express elements of design that are fundamental to both music and art. The framework of the composition is achieved through line; however, additional interest is created through the use of shapes and textured surfaces that support and give variety to the forms.

Traveling throughout Mexico in the 1940s, Johnson visited the states of Oaxaca and Yucatán, where he assimilated ideas and techniques that influenced his future art. In 1958, with the assistance of a

63 Sargent Claude Johnson, *Singing Saints*, 1940. Lithograph, 12′ x 9¼′. Collection of The Oakland Museum (gift of Mr. Arthur C. Painter). (Photograph by T. S. Leong, Oakland, California.)

64 Sargent Claude Johnson, *Lenox Avenue*, 1938. Lithograph, 15″ x 10½″. Collection of the San Francisco Museum of Modern Art (on extended loan to The Oakland Museum). (Photograph by T. S. Leong, Oakland, California.)

benefactor, he was able to take an extended trip to Japan—an experience he had anticipated for many years. Johnson's interest in different lands and cultures helped to make him an artist whose works reflected a wide range of stylistic tendencies. Expressing strength and elegance, his forms were always clean and simple and never needed the support of decorative accessories.

From the 1920s to his death in 1967 Johnson remained a master artist and a master craftsman. That this professional excellence was matched by excellence of character is suggested in the following statement by Clay Spolin, a painter and contemporary of Johnson's:

> [Sargent Johnson] was one of the few persons I have ever known who seemed perennially happy, joyous; exuberant in living, working—being with people and being a help to people regarding his knowledge of artistic crafts, or in any other way he could. For he really had the love of life and was always willing to share his enthusiasm with others. Consequently, he received the same in return. Never can I recall an occasion when he was not happy or joyous in spirit, thereby making others feel the same. [From "Sargent Johnson: Retrospective." Catalog of an exhibition, 23 February–21 March 1971, at the Oakland Museum.]

AUGUSTA SAVAGE (1900–62), an important figure in the history of Black art, has not been adequately appreciated by critics. Born in Florida, she was the seventh of fourteen children in the family of an impoverished Methodist minister. Despite strenuous opposition from her father, she began modeling clay figures when she was only six years old. Later, because of her unusual talent, she was allowed to teach clay modeling to students at a secondary school while still a student there herself. Planning to enter the teaching profession, she enrolled at the Tallahassee State Normal School (now Florida A and M University), but her desire for more intensive art training soon took her to New York's Cooper Union. Admitted in October, 1921, she was one of the first women to study sculpture at that institution.

Poverty almost forced Savage to drop out of art school, but instructors who recognized the quality of her work convinced the board of trustees to give her financial support. At about the same time a librarian for the New York Public Library, where Savage had been studying African art, heard of her plight and suggested to friends of the library that the young artist be commissioned to execute a portrait bust of W. E. B. Du Bois. Savage's completed bust of Du Bois is considered to be the finest portrait in existence of this Black leader. Commissions for portraits of other Black leaders followed, one of the most significant being of Marcus Garvey.

In 1930 Savage won a scholarship from the Julius Rosenwald Fund, which made it possible for her to study in France; the award was a direct result of *Gamin* [*Illus*. 65], her sculpture of a Black youth of Harlem. While in France Savage studied at the Académie de la Grande Chaumière under the guidance of French artist Félix Bueneteaux. On returning to the United States in 1932 she began teaching art classes in Harlem, and her Savage School of Arts and Crafts soon won a fifteen-hundred-dollar grant from the Carnegie Foundation for the provision of tuition-free classes for young children. Among the students who came to her studio were William Artis, Norman Lewis, and Ernest Crichlow, all later major contributors to Black art.

In the mid-1930s Savage helped many Blacks enroll in the art project of the Works Progress Administration, despite the reluctance of its officials. Aided by the Harmon Foundation files, she and other Black artist-educators were able to document the accomplishments of many talented Black artists and thus to secure WPA commissions for them. She was also instrumental in making it possible for Black artists of superior talent and training to become project supervisors in the WPA.

In 1938 Savage was commissioned to do a sculptural grouping for the 1939–40 New York World's Fair. Inspired by a song written by the brothers Rosamund and James Weldon Johnson, she produced *Lift Every Voice and Sing* [*Illus*. 66], a composition that featured a

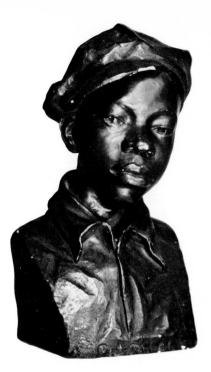

65 Augusta Savage, *Gamin*, ca. 1930. Plaster, 18″ high. Collection of The New York Public Library (Astor, Lenox and Tilden Foundations). (Photograph by Lynda Gordon.)

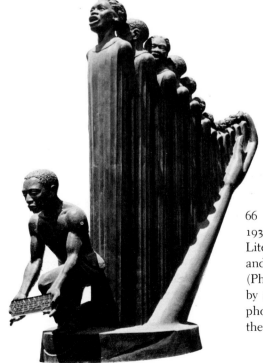

66 Augusta Savage, *Lift Every Voice and Sing*, 1939. Cast plaster. Collection of American Literature, The Beinecke Rare Book and Manuscript Library, Yale University. (Photograph by Carl Van Vechten; reproduced by special permission of Saul Mauriber, photographic executor of the Carl Van Vechten estate.)

group of singers placed in a harplike arrangement and a kneeling youth displaying a bar of musical notes. This latter figure and his offering have been considered symbolic both of the musical gifts of Black Americans and of the African background of Black American music. The singing figures, clad in what appeared to be choir robes, seemed to march in procession from the outstretched hand that formed part of the harp's frame. The work was done in cast plaster and finished to look like black basalt. The money needed to have it cast in bronze was unavailable, and the composition was destroyed soon after the close of the World's Fair.

Augusta Savage was a forceful and talented woman who, overcoming the difficulties of racism and sexism, was responsible for many of the advancements made by Black artists during the Depression. The generous donations of her time on behalf of Black art undoubtedly limited her own personal contribution as a sculptor, which might otherwise have brought her greater success and critical praise.

RICHMOND BARTHÉ (b. 1901), a former student of the Art Institute of Chicago and of the Art Students League in New York City, is an important artist who confines his work to sculpture. Born in Bay St. Louis, Mississippi, Barthé has enjoyed a long and prolific career in the United States and the Carribean.

The first public showing of Barthé's work was in 1927 at a Chicago Women's City Club exhibition. Fame came to him some years later, hastened by the Whitney Museum's 1935 purchase of several of his sculptures, including *Blackberry Woman* [*Illus*. 67] and *African Dancer* (1933). Barthé popularity continued throughout the thirties and forties, during which he created works based on both racial and nonracial idioms. Fascinated by the theater, he sculpted portrait busts of such acting luminaries as Katharine Cornell and Laurence Olivier. In 1943, the Metropolitan Museum of Art in New York purchased Barthé's *The Boxer* (1943), and the continuing interest shown in his work by museums and private collectors attests to the quality of his art.

Barthé's characteristic elongation of form can be seen most clearly in such works as *Blackberry Woman* and *Wetta* [*Illus*. 68], a rendering of an African woman paused in the midst of a dance. The suspended-action stance of this figure, with its slightly raised left foot and firmly planted right one, makes the viewer unsure of the action to follow and thus creates strong visual tension. The S-curve of the dancer's lithe, sensual torso is reminiscent of European classical works; but the graceful positioning of the arms, which draw

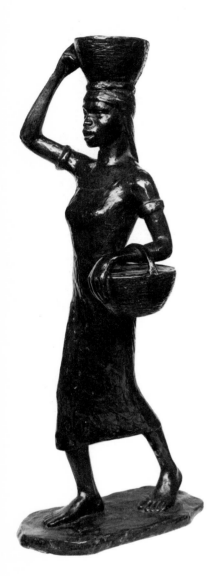

67 Richmond Barthé, *Blackberry Woman*, 1932. Bronze, 34″ x 11½″ x 14″. Collection of the Whitney Museum of American Art. (Photograph by Geoffrey Clements, New York City.)

the eye of the viewer around the figure, is more African than it is Greek or Roman. The long, sweeping curves of the body are clearly illustrative of Barthé's strong interest in dancers and the theater. Barthé's sculptural figures transcend time and give evidence of forms that relate to many artistic styles.

Barthé is without question the Black sculptor born in the early twentieth century who has most successfully bridged the gap between the interests of his race and those of most professional critics. His sculptures of Blacks have been uniquely acceptable to white institutions and individual purchasers, and, at the same time, they have been symbols of dignity and strength for his Black audience.

WILLIAM HENRY JOHNSON (1901–70) was born in the small town of Florence, South Carolina, which, like most places in the South around the turn of the century, offered its Black residents no opportunity to make their way in art. The son of a Black woman and of a white man who was reportedly of significant economic standing, Johnson did not share in his father's world but was left instead in the care of his mother. Soon after William's birth, she married a Black man by whom she was to have two sons and two daughters. When her husband became crippled, Johnson's mother became the sole support of the family of seven, and, as the eldest child, William helped her with the housework and in the fields. After she found salaried employment at the local YMCA, William was obliged to remain at home to take care of the younger children. As a result his formal education was delayed and sporadic.

On one of the rare occasions when William was able to attend school, his creativity was observed by a teacher who, after watching the youngster draw in the dirt with a stick, gave him the pencils with which he would draw his first permanent original portraits and copies of newspaper cartoons. By age seventeen Johnson had saved enough of his earnings to pay his fare to New York City, where he sought work that would allow him to support himself and to subsidize his family. But he found only the kinds of jobs available to him in the South—stevedore, cook, and porter—and at disappointingly low wages.

In 1921, after three years of hard work and saving, Johnson began studies at the National Academy of Design. His teacher and chief mentor at the Academy, Charles Harthorne, arranged for him to spend the summers of 1923 to 1926 at the Cape Cod School of Art in Provincetown, Massachusetts. The work scholarship that Johnson received exchanged the cost of his enrollment at Harthorne's summer school for his care of the school's tennis courts.

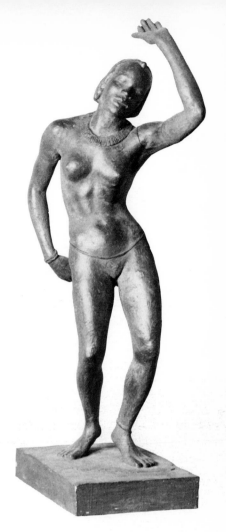

68 Richmond Barthé, *Wetta*. Harmon Foundation Collection, National Archives.

69 William Henry Johnson, *Cagnes-sur-Mer*, 1928–29. Oil on canvas, 23⅜″ x 28½″. Courtesy National Collection of Fine Arts, Smithsonian Institution.

While attending the National Academy of Design, Johnson earned several of its highest awards; in 1923 he won the Hallgarten Prize and in 1925 and 1926 the coveted Cannon Prize. Eight such prizes had been awarded to him by the time of his graduation in 1926. In that year, mainly through the efforts of Charles Harthorne, money was collected to pay Johnson's travel expenses to Paris. As it did for many American artists, living in Paris seemed to offer Johnson a new life in which he could explore a kind of freedom he had never before experienced. The paintings he produced in Paris reflected his new enthusiasm and, owing their greatest stylistic debt to Cézanne and Chaim Soutine (1894–1943), provided a strong contrast to his earlier academic style.

While in France, Johnson visited Henry Tanner at his home in Trépied. Though Johnson enjoyed meeting Tanner, their paths proved too distant to permit any real communication. The strongest artistic influence Johnson encountered during this period was Soutine, one of the most vigorous Expressionist painters then active in Europe. It seems apparent that for over a half-dozen years Johnson modeled some of his compositions on Soutine's works. Following the path of Soutine, he left Paris in 1928 for Cagnes-sur-Mer, where, like the French painter, he used "topsy-turvy" forms in depicting the local landscape. The exciting use Johnson made of shape and contour in such works as *Landscape Cagnes-sur-Mer* [*Illus.* 69] seems to have suited his need for strong emotional expression.

70 William Henry Johnson, *Landscape with Sun Setting*, Florence, N.C. Howard University Gallery of Art. (Photograph by Scurlock Studios, Washington, D.C.)

Also in Cagnes, Johnson met Holcha Krake, a Danish designer, weaver, and ceramist whom he later accompanied to Denmark and married. Before their marriage, however, he returned to the United States and resided briefly in New York City. There, throughout the winter, he rented a cheap loft in Harlem and spent his time painting. The resultant six paintings were entered in a Harmon Foundation exhibition in 1930 and earned him the show's gold medal and a cash award of four hundred dollars. The distinguished jury's announcement of their selection included the following statement:

> We think [William Johnson] is one of our coming great painters. He is a real modernist. He has been spontaneous, vigorous, firm and direct. He has shown a great thing in art—it is expression of the man himself. [Quoted in National Collection of Fine Arts, William H. Johnson, 1901–1970 (Washington, D.C.: Smithsonian Institution Press, 1971), p. 14.]

71 William Henry Johnson, *Minnie*, 1930. Oil on Canvas, 17" x 12⅛". Courtesy National Collection of Fine Arts, Smithsonian Institution.

Encouraged by this success and now having the funds for the trip, Johnson soon visited his family in South Carolina. During his stay, he employed his newly acquired "modern European style" in paintings of the local residents and terrain; *Landscape with Sun Setting*, Florence, S.C. [Illus. 70] and *Minnie* [Illus. 71] are examples of his work during this period.

Johnson's joy in being home was to be short-lived, however; for, one day as he stood in the street painting a brothel known to him only as the Jacobia Hotel, he was arrested and jailed. That the paint-

ing was not confiscated (though confiscation was customary in such cases) suggests that it was not so much the subject of the work that offended the local constabulary as it was Johnson himself—a Black man who felt free enough, or was insane enough, to openly spend time painting pictures in the streets of Florence, South Carolina [*Illus*. 72]. The experience so embittered Johnson that he did not return to the South again for fourteen years. However, before he left Florence after the Jacobia incident, an impressive exhibition of his works was held at the local branch of the YMCA, where his mother was still an employee. The local newspaper's announcement of the exhibit read, "William Johnson, Florence man, to show 135 paintings"; and, in an effort to validate the artist, added:

> *Alice Johnson having been rendering faithful service for the past 12 years, her husband a cripple, she has been the sole support of her two girls and three boys. The public is generally invited to inspect the work of this humble Florence Negro Youth whose real genius may some day make the city of his birth famous.* [*Quoted in National Collection of Fine Arts*, William H. Johnson, 1901–1970, *p.* 14.]

Particularly after his run-in with the law, this billing must have seemed painfully ironic to a man who had found a "breath of freedom" in Europe and some recent promise of success in New York. Although, as the birthplace of Johnson, Florence, South Carolina, may have hoped to achieve fame through him, during his stay the town proved a patronizing and humiliating host.

72 William Henry Johnson, *Jacobia Hotel*, 1930. Oil on canvas, 19⅛″ x 23⅛″. Courtesy National Collection of Fine Arts, Smithsonian Institution.

On his return to Denmark, Johnson married Holcha Krake, and settled in the small fishing village of Kerteminde. He enjoyed the simple life of the villagers, and they made him feel like one of them. His portraits of the Kerteminde fishermen, and his harbor and village scenes, evidenced a new vigor and sparkle and a quality reminiscent of the Expressionist brushstrokes of van Gogh.

In 1932 Johnson and his wife visited North Africa; the way of life of its inhabitants impressed him as being closer to art than that of the so-called cultivated societies of Europe. He later reflected that he had learned more from the fishermen of Denmark and the Arabs of North Africa than from any other peoples. And he added, "I myself feel like a primitive man, like one who is at the same time both a primitive and cultured painter" (quoted in National Collection of Fine Arts, *William H. Johnson*, 1901–1970, p. 14).

That the excitement of such places as Tunisia was suited to his emotional personality was evident in the vivid watercolor scenes Johnson painted while in North Africa; not surprisingly, he found the return to the quiet village of Kerteminde rather disappointing. Holcha and William Johnson soon decided to travel to Norway, where he hoped to sell some of his works. He may also have been hopeful of meeting Edvard Munch (1863–1944), a Norwegian painter and graphic artist whose work he admired. Johnson was himself a graphic artist, and Munch's influence was obvious in his style.

A continuing need for money forced Johnson to attempt to exhibit and sell his paintings in the United States. Both Alain Locke and the staff of the Harmon Foundation acted on his behalf in this regard; however, the museums they contacted were not responsive, and commercial galleries would pay only minimal prices for Johnson's work. Disappointed and offended, the artist wrote the following in a letter to a Harmon Foundation representative:

> I must say that you shall demand a higher price for my painting for I am no ordinary American Negro painter or no ordinary American painter. I am recognize [sic] by known Americans and Europeans as a painter of value so I must demand respect. [William Johnson to Mary Brady, 24 September 1937, quoted in National Collection of Fine Arts, William H. Johnson, 1901–1970, p. 16.]

In November 1938, in response to their financial situation, the approaching war in Europe, and William's desire to again be with and paint his own people, the Johnsons moved to New York City. For a time the outside employment that Johnson sought was not

73 William Henry Johnson,
Lamentation, ca. 1939.
Oil on board, 29⅛″ x 33¼″.
Courtesy National Collection
of Fine Arts, Smithsonian
Institution.

74 William Henry Johnson,
Going to Church. Silkscreen,
12½″ x 17½″. Courtesy of
Contemporary Crafts, Los Angeles.

forthcoming, and painting at home remained his major preoccupation. *Lamentation* [*Illus.* 73] and the other religious works he painted during this period represent a complete change in his subject matter. Although not outwardly religious, Johnson poured into these works recollections of the Bible stories and Black spirituals he had heard in church during his childhood in South Carolina. Beautifully formulated, his religious designs are marked by simplicity and warmth and represent the peak of his artistic expression. They are also convincing chronicles of Black life, for their everyday scenes provide an authoritative record of the basic joys and struggles of Black Americans.

Johnson's productivity continued, and in the early 1940s he obtained employment as a mural painter for the WPA. The many works he exhibited between 1941 and 1944 mark the development of his last style. New York's major art critics were impressed by these new works; and, though some insisted on labeling him a prim-

itive, many of them recognized that his simple flat shapes represented a sophisticated contemporary style.

A number of versions of a single genre subject depicted by Johnson during this period were executed in various sizes and media. He learned silkscreening while working on WPA projects, and later used it as a convenient medium for producing a large number of prints. *Going to Church* [*Illus* 74], one of his many silkscreens, is a work that illustrates Johnson's habit of dealing with serious subjects in a "humorously serious" way. Much the same can be said of his treatment of war and poverty and of his unusually large canvas called *Chain Gang* (1939), which was chosen for exhibition at the 1939–40 World's Fair in New York. The massive forms and strong patterns of this huge painting also illustrate Johnson's exceptional ability to control motion through organized design.

During the early 1940s, Johnson taught at the Harlem Community Art Center. His impressions of life in the neighborhood of the center are depicted in serigraphs (original color prints made by silkscreening) of such compositions as *Jitterbugs* [*Illus*. 75] and *Street Musicians* [*Illus*. 76].

75 William Henry Johnson, *Jitterbugs*. Silkscreen, 17½″ x 12½″. Courtesy of Contemporary Crafts, Los Angeles.

76 William Henry Johnson, *Street Musicians*. Silkscreen, 17½″ x 12½″. Courtesy of Contemporary Crafts, Los Angeles.

In January 1943 Johnson's wife died, and thereafter the artist suffered continuing mental deterioration. Following a trip to South Carolina, where he spent a few months visiting his mother, he returned to New York and tried to resume work. As his style reverted to one more closely related to German Expressionism in combination with other styles of his former periods, Johnson struggled to carry out his ambition to express Black life and history. Records indicate, however, that he had all but lost his sense of composition. In 1946 he sailed for Denmark and lived in Copenhagen for six months with his wife's family. Because his faculties showed a serious decline, he was sent back to New York in the summer of 1947 and committed to a mental hospital on Long Island. He remained there until his death, twenty-three years later, in April 1970.

JAMES LESESNE WELLS (b. 1902) is a successful printmaker and designer who was for many years associated with Howard University. Armed with the solid academic training he obtained at Lincoln University in Missouri and Columbia University and at the National Academy of Design, this native Georgian was a pioneer

77 James Lesesne Wells, *African Fantasy*, 1929. Woodcut. Afro-American Collection, Fisk University.

78 James Lesesne Wells,
Primitive Girl.
Afro-American Collection,
Fisk University.

of many modern methods of teaching art to all age groups. As a young man he was an instructor in the art workshop of the Harlem Library Project for Adult Education, a job that afforded him some of the varied experience on which he later based his teaching theories.

In the 1940s James Wells gained a reputation as an excellent graphic artist. Utilizing several media—mainly block printing, etching, and lithography—he produced many compositions on African themes, of which *African Fantasy* [*Illus.* 77] and *Primitive Girl* [*Illus.* 78] are typical examples. Since 1931 he has also become known as a painter. His painting *The Wanderers* (1934) is a symbolically rich interpretation of three female migrants. Its rich color and interpretative quality reflect a highly imaginative expressionistic vision. An earlier work on the same subject, *The Wanderer* (1931), is even more symbolically evocative as the animal, human, and landscape elements merge with a distinctive abstract design. Many other paintings by Wells were exhibited in the 1930s at the

95

Phillips Memorial Gallery in Washington, D.C., in the Harmon Foundation traveling exhibitions, and in museums and galleries throughout the New York metropolitan area.

In 1933 Alain Locke described Wells as a successful ultramodernist but found that

> *while ultra-modern in composition and color scheme, many of his paintings have also an unusual mystical quality like* The Wanderers, *which reveal[s] to some eyes a typical Negro note; which in his own words, he attempts to express, "not in that sensational gusto so very often typified as Negroid, but as that which possesses the quality of serenity, has sentiment without sentimentality and rhythmic flow of lines and tones in pure and simple forms."* [From Negro Art Past and Present, *p. 76.*]

BEAUFORD DELANEY (b. 1901) grew up in Knoxville, Tennessee, but moved to Boston while still a teenager. There he studied at the Massachusetts Normal Art School, the South Boston School of Art, and the Copley Society, although it is unlikely that he was registered at any of these institutions. Perhaps it is for that reason he considers himself self-taught; however, his associations with teachers and professional artists and writers have no doubt contributed to his artistic experience.

On leaving Massachusetts, Delaney moved to New York's Greenwich Village, where he lived on Greene Street, which he painted time and again. For a while during his early days in New York, Delaney worked as a telephone operator at the Whitney Museum, where, by the beginning of the 1930s, some of his compositions would be on exhibit. Early scenes by Delaney were also shown in the Harmon Foundation exhibition of 1933 and in exhibitions at the 135th Street and 42nd Street branches of the New York Public Library. Over the next decade Delaney also painted portraits, including those of such notables as Henry Miller, Marian Anderson, and Al Hirschfeld. These commissions helped him overcome some of the hardships of artists living in New York, which in Delaney's case included the maintenance of a studio and the cost of expensive paints required in lavish quantities by his budding interest in Abstract Expressionism.

In 1954 Delaney traveled to Paris for a short visit, but he was so pleased with the life he found there that his stay has not yet come to an end. Now considered the dean of Black American artists living in Europe, Delaney does not claim that he was driven from the United States; he lives in Paris because it is where he feels he belongs.

JOSEPH DELANEY (b. 1904), like his brother Beauford, attended elementary schools in Knoxville, Tennessee, and, following his graduation from high school, left to seek his fortune in cities in the North. He lived briefly in Cincinnati, Detroit, Pittsburgh, and Chicago, where, employed as a waiter in the famous "Loop," he met the many jazz musicians who became subjects for some of his paintings. He moved to New York at the beginning of the Depression and enrolled in the Art Students League, where he studied with the famous regionalist Thomas Hart Benton (1889–1975). Also enrolled in Benton's class was Jackson Pollock (1912–1956), the painter who was to become America's leading Abstract Expressionist. A combination of regional realism and expressionism, Delaney's style owes much to both Benton and Pollock.

The recipient of many fellowships and awards, Delaney is represented in permanent collections throughout the United States—most of these in universities and libraries—and his works have been shown in most of the leading museums in New York City. For several days each year over the past few decades Delaney has exhibited his works in Greenwich Village at the annual outdoor art show held near Washington Square.

LOIS MAILOU JONES (b. 1905) has been a strong force in the teaching and promoting of Black art:

> I believe it is the duty of every Black artist to participate in the current movement which aims to establish recognition of works by "Black Artists." I am and will continue to exhibit in "Black Art Shows" and others, works which express my sincere creative feelings. Whether or not these works portray the "Black Experience," or "Heritage," or are purely abstract is immaterial—so long as the works meet the highest standards exemplified in modern world art. The major focus is to achieve for Black Artists their just and rightful place as American artists in the mainstream of the art world. [Personal communication with the author.]

Born in Boston, Jones was among the first Black graduates of the Boston Museum School of Fine Arts; she has also studied in New York at Teachers College and, in 1937, attended the Académie Julien, in Paris. Her artistic style and purpose have been enriched by contact with several cultures—French, Haitian, African, and American. A professor of design and watercolor painting at Howard University for the past forty years, Jones has played a major role in guiding young students to artistic maturity; many of the artist-

teachers who are currently contributing to the Black art movement have been her students.

Jones' own record as an artist is one of consistent development and spirit. In the 1920s she created compositions that are predominantly realistic in style, their interpretation of the human figure always imparting a great sense of dignity [*Illus. 79*]. The landscapes of Paris she painted in the 1930s are similarly impressive and serve as reminders of Cézanne's strong influence on Western art. The explosions of color and use of geometric shapes in her more recent works bring together aspects of the two earlier periods.

The artistic work of Lois Mailou Jones has also progressed through several distinct cultural stages, all aimed at expressing the form and spirit of the Black heritage. Her developed Parisian style

79 Lois Mailou Jones, *Negro Boy*, 1935. Watercolor, 19″ x 16″. Courtesy of the artist.

80 Lois Mailou Jones, *Marché Haiti* (*Haitian Market*), 1963. Acrylic on canvas panel, 24″ x 20″. Courtesy of the artist. (Photograph: M. Grumbacher, Inc., from "21 Paint in Hyplar," Traveloan Exhibition.)

was related to African sculpture; and the more Cubist style that followed resulted from contact with Haiti, an island whose culture, though outwardly French, has its roots in Africa [*Illus.* 80]. In her recent works Jones has returned to purely African forms, the source of Cubism, and combined them with her knowledge of the African-American experience. Her *Ubi Girl from the Tai Region* [*Illus.* 81] is an exciting example of composite forms; through her traditional treatment of the lower portion of the mask, she combines a

99

81 Lois Mailou Jones, *Ubi Girl from the Tai Region*, 1972. Acrylic, 60" x 43¾". Courtesy of the artist.

82 Lois Mailou Jones, *Moon Masque*, 1971. Acrylic collage, 41" x 29". Courtesy of the artist, © SEMA.

sense of realism with a dominant Cubist tone. Also characteristic of this stage of Jones' career is her interest in Black symbolism, such paintings as the *Moon Masque* [*Illus.* 82] expressing this aspect of her style: their language is unmuddled; their forms are strong and quite bold; and their direct and sure tones sound a call to world Blackness.

JAMES A. PORTER (1905–70), the author of *Modern Negro Art* (1943), influenced the Black art movement in the United States both as an artist and as an educator. Graduated from Howard Uni-

100

versity in 1926, he also worked toward a degree at Teachers College and was later enrolled at the Art Students League. He received a scholarship at the Institute of International Education in 1935 and was the recipient of a Rockefeller Foundation grant that allowed him to study art in Belgium, Holland, Germany, and Italy. In 1937 he was awarded a master's degree in art history from New York University. Numerous solo exhibitions and group shows, in the United States and abroad, characterized his subsequent career; and in 1953 he was appointed head of the art department and director of the art gallery at Howard University, the first major gallery established at a Black institution in the United States.

As an artist, Porter was a sensitive interpreter of both Black character and the human form—as is evident in such works as *My Mother* [*Illus.* 83]—and, primarily between the years 1954 and 1964,

83 James A. Porter, *My Mother*. (Photograph courtesy of the National Archives.)

he executed several works based on African themes and on the lives of Black Americans. As an art historian, Porter recorded the activities of Black artists who lived during his time and researched the work of those who had preceded him. The magnitude of his sense of history was unique, and his personal knowledge of art provided insights offered by few art historians. Talented and dedicated as an artist, as a teacher, and as a scholar, James Porter, like Alain Locke, played a vital role in the early accreditation of Black American art.

WILLIAM E. ARTIS (1919–77), a sculptor who received a great deal of coverage in such publications as *Time*, the *Christian Science Monitor*, and *Sculpture Review*, remained decidedly unaffected by his publicity. He spoke about art mainly through his works, which demonstrate not only that "Black is beautiful" but that it is sensitive, concerned, and humane.

A native of Washington, North Carolina, Artis received his artistic training at several schools, including the Art Students League, Alfred and Syracuse universities in New York State, and Pennsylvania State University. Throughout a long teaching career, he was also a prolific artist and the recipient of numerous artistic awards and honors. An exhibition sponsored by the Harmon Foundation in 1933 was the first one in which Artis participated, and his association with many of the foundation's subsequent projects gave them a different perspective.

Artis' compositions reflect his personality. They are not political or social, nor do they express current problems of any kind; rather, they are profound statements of human aspirations. A deep concern for human beings is seen, for example, in his sensitive treatment of form: his sculptures seem to breathe, and the essence of gentle life flows from each base through to the highest point. *Supplication* [*Illus*. 84], a large figure composition, is an example of Artis' magnificent handling of modeled form. His approach to sculpture was an additive one, and each segment of a work comprises the same sense of life exhibited by the whole.

SELMA BURKE (b. 1901) is an active sculptor who resides in Pittsburgh, where an art center has been named in her honor. Though not a participant in the Harmon Foundation exhibitions of the 1930s, she was one of those who provided other Black artists with needed aid and encouragement during the lean days of the Depression. The record of her personal achievements and direct contributions to Black art is also exemplary.

84 William E. Artis, *Supplication*, 1971. Terra cotta, 40″ high. Courtesy of the artist.

85 Selma Burke, *Peace*, 1972.
Italian alabaster, 24″ high.
Presented to
Winston-Salem State University
by the Winston-Salem
Alumnae Chapter
of Delta Sigma Theta, Inc.

She received her first training as a sculptor at Columbia University and later studied with Maillol in Paris and with Povoley in Vienna. Among her most notable works are *Falling Angel* (1959), a highly decorative floating sculpture of a figure in supplication, and *Peace* [*Illus.* 85]. An earlier work, *Lafayette* (1938), is a fine example of Burke's skill in portraiture, in which she gives the French patriot a strong and vigorous nobility.

THE SELF-TAUGHT INDIVIDUALISTS

Self-taught artists are often well into adulthood when they begin to concentrate on their artistic careers. Having reached their middle years, many of them bring to their work valuable practical knowledge and a wide perspective gained from everyday living. Rather than attempting to imitate their environment, they tend to express through personal imagery their faith in and love of life.

WILLIAM EDMONDSON (1882–1951) and HORACE PIPPIN (1888–1946), two such self-taught artists, shared the same approach to art. To them the academic circles frequented by many of their contemporaries were of little interest; both men chose to avoid the company and advice of other, more established artists and relied instead on their own knowledge, abilities, and insights. Thus, much like the folk artists of nineteenth-century America, Edmondson and Pippin were able to maintain their artistic freedom. In this they set themselves apart from the majority of early twentieth-century artists, who, in exploring art, found it necessary to join popular movements.

In his forties when he completed his first composition, Pippin painted most of his works from memory, tapping childhood and war experiences and other events of his life as sources of subject matter. Edmondson, on the other hand, maintained that his subject matter, most of it religious, came to him through divine inspiration and vision. Whatever the case, both he and Pippin demonstrated an intuitive feeling for design. The direct and uninhibited statements apparent in their art provide a vitality and freshness that place these artists among the best of their day.

Born in Davidson County, Kentucky, Edmondson for many years produced compositions that went unnoticed. During this time he was employed principally as a stonemason, and his experience in that occupation contributed to his strong, compact solutions to sculptural problems. Edmondson achieved major recognition, finally, in May 1938 when a solo exhibition of his works was held at the Museum of Modern Art in New York, shortly after they had come to the attention of Meyer Dahl Wolfe, a friend of the museum.

Edmondson's sculptures have a monumental impact. Representing both humans and animals, they exhibit economy of detail and fluidity of form and show the artist's strong sense of invention in such details as eyes, noses, and mouths; yet his interpretations of these facial features are similar to those seen in the stylized sculptures of numerous African cultures. Most of the sculptures created by Edmondson prior to his 1938 exhibition were made for Black patrons and intended for use as gravestones. Among these early sculptures is *Mother and Child* [*Illus.* 86], a small stone piece that depicts the spirit and beauty possible in the relationship between a mother and her offspring.

86 William Edmondson, *Mother and Child*. Stone, 11½″ x 5¾″ x 6″. Barbara Johnson Collection.

Horace Pippin, like Edmondson, was a self-taught artist who found much of his subject matter in personal experience. He be-

lieved, in the words of the artist John Kane (1860–1934), that "you don't have to go far to find beauty . . . all you need is observation" (quoted in "Hicks–Kane–Pippin." Catalog of an exhibition, 21 October–4 December 1966, at the Museum of Art, Carnegie Institute, Pittsburgh). Born in West Chester, Pennsylvania, Pippin grew up in Goshen, New York, where he and his parents had moved when he was three years old. The death of her husband, in 1898, made it necessary for Pippin's mother to work, as a domestic, to support her son. He found part-time work at age fourteen and was forced to leave school at fifteen to support his ailing mother.

In 1917 Pippin enlisted in the army. During his twenty-two months of military service, most of which he spent as a corporal in a Black regiment, he saw battle in Europe and, wounded by a sniper, permanently lost the use of his right arm. Soon after his return to the United States and his army discharge in May 1919, Pippin met Jennie Ora Featherstone, with whom he married a year later and settled in West Chester. He supported himself and his family through various odd jobs and a small disability pension that supplemented the meager income of his wife.

Because of his handicap Pippin did not begin to draw or paint again until 1929, when he accidentally discovered that he could draw by applying a hot poker to a wood panel; seventeen drawings done in this manner soon followed. These early works often had no color other than the white of the wood surface and the black of the charred areas. Whether he worked on wood or on canvas, Pippin's laborious technique made large compositions impractical; thus his works are seldom more than two-by-three feet.

Though he began late in life and was disabled, Pippin produced a great number of paintings in his short career, seventy-five in his last six years. His first completed painting, *The End of War: Starting Home* (1931), communicates his deep emotional involvement with memories of war—even the painting's carved frame features objects of battle. The somberness of the dark colors that predominate in the work is only partially relieved by the red of flaming planes, bursting bombs, and bleeding soldiers. Such horrors of war are not presented in a moralizing manner, however; they are employed merely to re-create an actual experience vividly remembered.

In 1937 a painting by Pippin placed in the window of a shoe repair shop in West Chester attracted the attention of two passers-by— Christian Brinton, an art critic, and N. C. Wyeth, the illustrator. By the summer of that year, Brinton had arranged to have Pippin's works presented in a solo exhibition at the local community center; afterward, the artist's popularity grew rapidly. In 1938 four works by

Pippin were included in a Museum of Modern Art exhibit called "Masters of Popular Painting"; and in 1940 Robert Carlen, a Philadelphia art dealer, was so impressed with Pippin that he presented his work in a solo show. Prior to the opening, Albert C. Barnes, a philanthropist and influential collector, purchased three of the exhibit's paintings and insisted on writing an introductory note to the exhibit catalog, in which he said of Pippin:

> It is probably not too much to say that he is the first important Negro painter to appear on the American scene and that his work shares with that of John Kane the distinction of being the most individual and unadulterated painting authentically expressive of the American spirit that has been produced during our generation. [Quoted in "Hicks–Kane–Pippin," p. 82.]

Invited by his admirer to visit the art collection at the Barnes Foundation's headquarters in Merion, Pennsylvania, Pippin was able to view the foundation's array of works by Cézanne, Matisse, Picasso, Renoir, and others. Of the artists whose works he saw, he was most affected by Renoir—not because of the French artist's technique but because of the remarkable bodies of his female subjects. About this time Pippin also began to attend classes sponsored by the Barnes Foundation; but, since he had little regard for formal art instruction, his attendance soon ceased.

A close observer of nature, Pippin had a special feeling for winter landscapes, which he demonstrated in such works as *Buffalo Hunt*

87 Horace Pippin, *Night Call*. Oil on canvas, 28″ x 32″. Museum of Fine Arts, Boston.

88 Horace Pippin,
The Holy Mountain II,
1944. Oil, 22″ x 30″.
Private collection.

(1933) and *Night Call* [*Illus.* 87]. Viewing *Night Call* one can almost feel the cold force of the blowing snow, and the skeletal trees, dark sky, and snow-covered road all convey the bleakness of the landscape. Among his other important paintings are *John Brown Going to His Hanging* (1942), *Domino Players* (1943), *Mr. Prejudice* (1943), and four versions of the one subject that are known as *The Holy Mountain* series [*Illus.* 88]. Each of the versions suggests that the artist was familiar with Edward Hicks' series of the same name in the Carlen Gallery; they have been explained by Pippin as a response to war. In Pippin's series the murky forest and its shadowy figures seem to be an allusion to the forces of hatred and war. The background is a direct contrast to the peaceable assemblage of animals and people: the shepherd watches over lions, lambs, wolves, leopards, and bears—all living in peace. The bright green grass, jewellike flowers, and calmly posed animals all convey a feeling of peace and tranquility.

Painting eventually brought Pippin financial stability, but it had an unsettling effect on his marriage. He quarreled with his wife, who he felt neither understood nor trusted his art, and because of their difficulties, began to drink heavily and spend much of his money on a mistress. These factors no doubt contributed to the breakdown experienced by his wife, who spent her last months in a mental institution, dying there two weeks after her husband's death, by stroke, on July 6, 1946.

1940-1960

Any analysis of the arts on the basis of time periods is necessarily arbitrary. Artistic movements generally blend imperceptibly into one another; and, as we have seen in the works of Edmondson and Pippin, art sometimes belongs to no specific period of time. The accomplishments of the Harmon Foundation, the Harlem Renaissance, and the WPA continue to influence the course of Black art. The artists who benefited from these organizations were free of sponsor-established limitations and thus were able to produce works of significant value. They did not seek the approval of their peers or other rewards for their creativity but instead expressed themselves as individual participants conscious of their role in society.

The dearth of information regarding the past accomplishments of African-Americans is largely responsible for the negative attitudes toward their artistic contributions. Additionally, some historians and art critics have erroneously assumed that Black artists are unfamiliar with the formalized techniques of Western aesthetics. Until recently, this assumption contributed to the long-lived absence of serious historical investigation into the African-American aesthetic. Perpetuating another stereotype, some cultural powers have believed that the relatively spontaneous arts, music, and dance, are better suited to Black expression than are the more deliberate forms. This view ignores the many skillful designs in sculpture,

weaving, pottery, and architecture that are part of the African tradition and a prevailing influence in the culture of Black Americans.

MURAL ART AS CULTURAL AND SOCIAL COMMENTARY

Mural art is a major aspect of the African architectural tradition; the exterior walls of buildings that surround many villages and compounds in Africa today display a variety of decorative patterns and symbols that have cultural significance for their communities. It was Mexico, however, that provided the examples that inspired most of the first professional Black American muralists.

The period of Social Realism that flourished in Mexico after the revolution of 1910 to 1920 had great impact on mural painting in the United States in the following decades. Black American artists especially were impressed with such Mexican muralists as Diego Rivera and David Alfaro Siqueiros, two of Mexico's greatest muralists. Mexico was one of the few nations then using large-scale murals to decorate public buildings, and, not relying on traditional fresco techniques, the Mexican muralists had developed new mural painting methods and materials based on modern technology. Advocates of social change and champions of the politically, economically, and socially disadvantaged, the Mexican muralists conveyed messages easily understood and embraced by Black artists in the United States. This rapport was nourished as well through direct contact, for many Mexican muralists were commissioned to work in the United States. Thus, Miguel Covarrubias, for example, was an early associate of the Black muralist Charles Alston and his contemporaries in Harlem.

CHARLES ALSTON (1907–77), who grew up in North Carolina, taught at the City University of New York and at the Art Students League. Alston's early compositions were displayed by the Harmon Foundation in 1935, and his works have since figured in many major museum shows throughout the United States; they are included in the permanent collections of the Butler Art Institute, in Youngstown, Ohio; the Detroit Institute of the Arts; the Metropolitan Museum of Art; and the Whitney Museum of American Art, in New York.

Trained in art at Columbia University in the late 1920s, Alston had a unique figurative Cubist style, which he first demonstrated in such works as *Magic and Medicine* [*Illus.* 89], a mural executed for the Harlem Hospital in 1937. The work shows two distinct Black lifestyles—the African and the American. African life is charac-

89 Charles Alston
Magic and Medicine (detail),
1937. Oil. Works Projects
Administration Collection; the
National Archives.

terized as fluid and nature-oriented, while American environments are depicted as rigid and tense, with mechanical products dominating and destroying nature. Humanity stands as the victim in American urban and rural communities.

Alston's expression of the human condition through art was a response to the injustices and indignities experienced daily by many of his fellow citizens. Since he believed firmly in the basic ideals on which the nation was founded, Alston felt that he had an obligation to aid in the fulfillment of the American dream.

A commission Alston shared with Hale Woodruff (see page 67) produced two outstanding examples of the Social Realism of Black muralists in the late 1930s and 1940s. Designed for the Golden State Mutual Life Insurance Company of Los Angeles and unveiled in 1949, the adjacent murals produced by Alston and Woodruff were meant to document the participation of Black settlers in the founding of California. The Alston panel is called *Exploration and Colonization* (1537–1850) [*Illus.* 90], and Woodruff's panel is *Settlement and Development* (1850–1949) [*Illus.* 91]. About them a catalog issued by the insurance company proclaimed:

More than mere murals . . . these priceless panels incorporate documentary material, much of which appears in no annals of American history. These murals, although native in scope, are also reflective of other states and Negroes who were prominent in their development. As such they are a tribute to these men.

The murals offer an extensive range of color as well as expressive forms interwoven in overlapping triangular patterns. Still, each his-

111

90 Charles Alston, *Exploration and Colonization* (1537–1850), 1949. Oil on canvas, 111¼″ x 198″. Collection of the Golden State Mutual Life Insurance Co. (Photograph by Howard Morehead.)

91 Hale Woodruff, *Settlement and Development* (1850–1949), 1949. Oil on canvas, 111¼″ x 198″. Collection of the Golden State Mutual Life Insurance Co. (Photograph by Howard Morehead.)

torical event is easily seen as a separate part of the total composition. The artistic foundations of both Alston and Woodruff, secure artists with great skill in formal organization, are demonstrated by their control over the dramatic shapes in these two compositions. Each artist obviously made an effort to adjust his painting to the setting, each panel being a harmonious part of the architectural whole. It is also obvious that the artists used the challenge of the structure as a guide in organizing the historical message of the murals. Both the Alston and Woodruff murals fulfill their purpose admirably, each telling a story from a point of view that is interesting and readily understandable. Thus they prove the great capabilities of their respective artists in handling the expressive and technical challenges demanded by the subject and the setting.

NORMAN LEWIS (b. 1919) is one of the few native New Yorkers to gain early prominence in art as an interpreter of Black life in Harlem. A WPA project participant, Lewis attended Columbia University and studied privately with Augusta Savage (see page 84). His WPA assignment with the Harlem Art Center brought him into contact with many of the other Black artists who became leading contributors to American art.

In the 1940s Lewis was interested in geometric depiction of the human figure. *Yellow Hat* [*Illus.* 92] is an excellent example of his early semi-abstract style, for it is direct, powerful, and geometrically composed. In the mid-1960s, as a member of the Spiral Group, an organization of artists committed to documenting the essence of the Civil Rights movements, Lewis produced designs done principally in black and white. *Processional* [*Illus.* 93], one such work, is a direct, powerful statement that expresses the unity of the marchers who characterized the movement.

In later works of the same period Lewis shifts from his Cubist style toward Abstract Expressionism. More spontaneous, his later brush technique creates soft textural patterns that are organic in shape; and, although specific subject-matter forms are avoided, the overall meaning of each pattern is clearly projected. *Ovum* [*Illus.* 94] is one of the works of this period in which Lewis combines the

92 Norman Lewis, *Yellow Hat*, 1936. Oil on canvas, 36″ x 26″. Courtesy of the artist. (Photograph by Rudolph Burckhardt.)

93 Norman Lewis, *Processional*, 1965. Oil on canvas, 38″ x 58″. Courtesy of the artist. (Photograph by Rudolph Burckhardt.)

113

94 Norman Lewis, *Ovum*, 1961. Oil, 50″ x 71″. Collection of Ellen Ruhm, New York. (Photograph by Geoffrey Clements, New York City.)

geometric style of his early career with the more lyrical treatments of Abstract Expressionism. The painting's small geometric shapes, sometimes evocative of animal and human forms, create a visual texture that emerges from a foglike atmosphere. The bright central section of the composition seems to glow, radiating life and energy.

In 1971 while a teacher at New York's Art Students' League, Lewis worked with Ernie Crichlow and Romare Bearden in the founding of the Cinque Gallery. The special concern of this gallery became the exhibition of works by young minority-group artists.

ROMARE BEARDEN (b. 1914), while still a college student, voiced dissatisfaction with the activities of the Harmon Foundation. He criticized the foundation's exhibitions and accused its officials of patronizing mediocrity. Bearden believed that many of the artists who participated in the Harmon shows were merely duplicating art forms from Europe rather than expressing personal experiences. A longtime Harlem resident, Bearden became acquainted with many of the writers and artists of the Harlem Renaissance during

his youth, when his mother headed the New York office of the *Chicago Defender*, a Black newspaper.

Bearden has developed his approach to artistic expression over a period of years and through experimentation with a variety of art forms and styles. Always careful to rely on his own cultural heritage, he feels that subject matter is of little importance unless the artist is able to transform it into something unique. Such a transformation is seen in his paintings of the early 1930s, which in their Social Realism also reflect his interest in the works of José Orozco, Rufino Tamayo, and other modern Mexican masters.

Between 1945 and the late 1950s Bearden's work underwent a gradual stylistic transition. His paintings began to exhibit a more limited use of color, an increasingly shallow space, and a more developed planar surface. By 1961 a reappearance of figural elements could be seen in his work, and it was at about this time that he began to experiment with collage. His materials were photostated, enlarged, cut out, and reassembled in a manner suited to his creative imagination; the use of photography added to the "reality" of his works.

In 1963 Bearden, along with Norman Lewis, helped found the Spiral Group. These artists, who originally planned to limit their palettes to black and white as a symbol of the racial conflict, held their first member show in 1965 in their Greenwich Village gallery. The compositions created by Bearden since 1967 represent successive increases in size and brilliance of color. Like his earlier ones, these works are figural abstractions of Black subject matter; but they are more sophisticated and exhibit an increasingly fluid handling of form.

An enthusiasm for Cubism, nourished by associations with such modernists as Stuart Davis, has led Bearden to attempt greater structural organization in his work. His artistic growth is also indebted to his post–World War II involvement with the Kootz Gallery in New York and his resultant associations with Hans Hofmann, Robert Motherwell, and other noted gallery members. In 1950, a study trip to Paris allowed Bearden to add to his collage style the benefit of contacts with many distinguished European artists, including Georges Braque, Constantin Brancusi, and Fernand Léger. But though Bearden has had an international array of stylistic influences, his thematic focus has remained as it was in the 1930s. He still creates art in which the human image is defined in terms of the Black experience, presenting Blacks in a believable reality rather than as abstract, unknown quantities. Familiar with

95 Romare Bearden,
The Prevalence of Ritual:
Tidings, 1967. Collage,
36″ x 48″. Courtesy of the
Cordier and Ekstrom Gallery.

96 Romare Bearden,
The Prevalence of Ritual:
Baptism, 1964. Collage on board,
9″ x 12″. The Hirshhorn Museum
and Sculpture Garden,
Smithsonian Institution.
(Photograph by Geoffrey Clements,
New York City.)

the works of contemporary Black writers, Bearden seeks to establish
a visual counterpart to their literary contributions by creating a
language of lively pictorial images that express their own logic.

The Prevalence of Ritual: Tidings [*Illus.* 95] represents the most
recent phase of Bearden's long artistic career. This collage com-
bines a number of diverse objects, all seemingly out of context, in a

116

manner reminiscent of both Cubism and Surrealism; ambiguities of location and of time are thus created. The face of an angel resembles an African mask and, though treated cubistically, has a penetratingly naturalistic eye. The Virgin, who holds a rose rather than the customary lily, has a somewhat more realistic face than the angel, but their bodies are broken into cubelike planes in very much the same way. The structure behind the figural grouping seems to be composed of a sharecropper's shack and a post and scrollwork from a Victorian mansion. The landscape, a strange combination of drawings, paintings, and photographs, introduces a disquieting element to the work. Similarly, in Bearden's *Prevalence of Ritual: Baptism* [*Illus.* 96] the central figure in the composition is expressed through symbols that combine the past and the present. The upper portion of the face of the convert is the image of an African mask, while the lower portion is a photographic image that reflects the average and the contemporary; the spirit of the ceremony is thus both ancient and modern. The small church in the background borders railroad tracks that symbolize the social place and status of the participants, while the great size of these constructed figures attests to their human importance. With *Mysteries* [*Illus.* 97], from his projection series, Bearden continues his use in collages of photos of such substances as pavement and marble for faces, eyes, and hands. But whatever the makeup of his figures, Bearden always manages to elevate their depressed and frequently oppressed conditions.

97 Romare Bearden, *Mysteries*, 1964. Photomontage, 6′ x 8′. Courtesy of the artist.

HUGHIE LEE-SMITH was born in 1914 in Eustis, Florida, far away from the lonely urban ghettos he paints. His youth (he was more fortunate than most Black artists in that his parents encouraged his early interest in art) was spent in Cleveland, where he moved with his family as a small child. While a teenager he studied at Cleveland's now famous Karamu House, a community center with an exceptional art program; after graduation from high school he was able through several scholarships to earn a bachelor of science degree. A romantic realist, he has been described as "an artist whose dignified, isolated men and women have a surrealistic touch expressing man's lonely and confused condition in a complex technological age" (Carroll Greene, Jr., "Afro-American Artists: Yesterday and Now," in *The Humble Way*, Humble Oil & Refining Co. Bulletin, vol. 7, no. 3 [Houston, 1968], pp. 10–15). Through his paintings, Lee-Smith gives the viewer an opportunity to see commonplace experiences in a new way; for, when applied to even he simplest of these experiences, his poetic technique intensifies one's understanding of the dimensions of human existence. His painted environments demonstrate a keen feeling for space. Sensitive but unemotional, his handling of his subjects conveys their desolation and alienation and, while prompting neither excitement nor sympathy, tends to lead the viewer to greater empathy and understanding. In *Slum Song* [*Illus.* 98], for example, by setting a mood, evoking an image, and causing an idea to form, Lee-Smith makes a statement about much that is happening in contemporary life—loneliness in the midst of many and poverty in the midst of prosperity—and seems to suggest music as a weapon against the attendant fears.

ELDZIER CORTOR (b. 1916), an easel painter with the WPA in 1937, was born in Richmond, Virginia, but spent the majority of his early years in Chicago. His associations with Black artists and writers in the Chicago area, his experiences as a young teacher at the South Side Community Art Center, and his years as a student in one of the most complex cities in the United States all influenced the development of Cortor's eclectic artistic style.

Cortor began to take serious interest in art while he was a high school student in Chicago, his concern with political and historical events prompting him to draw cartoons of these subjects. Following his graduation from high school he enrolled at the Art Institute of Chicago, where his studies introduced him to non-Western art and inspired his many visits to the city's Field Museum to sketch sculptures in its African collection. It was also at the Art Institute that

98 Hughie Lee-Smith,
Slum Song, 1962.
Oil on canvas, 27½" x 30".
Collection of the
Golden State Mutual
Life Insurance Co.

Cortor began to paint, and his first paintings earned him a Rosen-
wald Fellowship that enabled him to work and study in the Sea
Islands, which lie in the Atlantic off the coasts of South Carolina,
Georgia, and northern Florida.

On his return to Chicago, Cortor experienced yet another influ-
ence on his art; he saw a group of French paintings—including
works by Corot, David, and Delacroix—that were on exhibit at the
Art Institute and immediately thought he recognized a weakness in
his own technique and composition; in analyzing these paintings
by the "French Masters" he had seen an "epic" style not present in
his own work. Realizing his need for further study, he went to New
York, where he found personal satisfaction and greater professional
advantages.

In some of his early works Cortor used settings that provide a
semisurrealistic flavor, for he often combined the elegance of his
figures with a kind of "deprived environment." The use of such a
combination in his *Room* series, Cortor has said, is meant to express
the overcrowded conditions of those who are obliged to carry out
their daily activities in the confines of the same four walls and in

119

99 Eldzier Cortor, *Room No. V*,
1948. Oil on board, 37″ x 27″.
Collection of
Mr. and Mrs. Richard Rosenwald.
(Photograph by Jeanne Siegel,
New York City.)

the utmost poverty. *Room No. V* [*Illus.* 99], a part of this series, shows a room whose peeling walls bear a "collage of pages from magazines and newspapers and provide a backdrop for a once elegant chest. A cat and the elongated figure of a woman share a quality unaffected by their sordid surroundings, and hairpins, a chipped cup, and a burning cigarette are so carefully placed that they appear to be ceremonial objects. The reflection of the "feline woman" in the mirror is both disquieting and surreal.

A more recent example of Cortor's style is *Classical Study #34* [*Illus.* 100], in which a meditating head shows the same detachment as the woman in *Room No. V*. The artist has omitted the surrealistic symbolism and has concentrated instead on the mood of his subject. Through his sensitive handling of form and emotional qualities, Cortor has made this study a tribute to the Black woman.

JACOB LAWRENCE (b. 1917), one of the Harlemites who benefited from WPA aid in the 1930s, is one of America's best-known contemporary artists. As a young man Lawrence worked at a number of community workshops, eventually becoming associated with one called Utopia House, where he studied with Charles Alston and

120

100 Eldzier Cortor,
Classical Study #34, 1971.
Oil on canvas, 22″ x 26″.
Courtesy of the artist.

began to record in his unique fashion the Harlem he knew. In the late 1930s, visits to the studio of sculptor Augusta Savage enabled Lawrence to meet Alain Locke, Aaron Douglas, Claude McKay, Countee Cullen, and many of the other artists and writers who were involved in the Harlem Renaissance. Lawrence gives much of the credit for his successful career to Augusta Savage, for he feels her determination helped him obtain his first WPA assignment.

Even before he was twenty-one, Lawrence had made a name for himself as an artist. In 1939, on the eve of his twenty-first birthday, his series of panels of the Haitian general Toussaint L'Ouverture was shown in an exhibit of Black artists co-sponsored by the Harmon Foundation and the Baltimore Museum of Art; the sixty 11-by-19-inch tempera paintings that make up the series proved to be the main attraction of the exhibit. These celebrated biographical compositions were soon followed by Lawrence's portraits of the abolitionists Frederick Douglass and Harriet Tubman, and by his impressive series *Migration of the Negro*, about which he has commented:

> *I started working on the series in 1939 and completed it in 1941. Perhaps you would like to know how I came to do the series. In the Harlem community, as in many communities throughout the country, there was a great interest in Negro history. I guess this was during the Marcus Garvey period. We had teachers in the community and afterschool Negro history clubs. I used to go to them. We had Negro history sessions at the YMCA and I became fascinated with Negro history. I guess it was part of*

121

my search for an image. One of the first series that I did was the
Toussaint L'Ouverture. . . . *The* Migration *series grew out of that. I*
would like to think that I was representing a certain history of the Negro
in America as seen through the migration.

The series especially pertains to the Negro migration from the South to
the North after World War I. The great influx of people that came, the
tribulations of the people, the reasons they left the South in such
large numbers may be regarded as world history. People are always
trying to better their social condition and the Negro is no exception.
The Black man in America is always trying to better his condition and
the conditions of his children. However, the series shows that the con-
ditions that they met in the North were similar to those that they had
known in the South. [Personal communication with the author.]

Poverty and prejudice encouraged Blacks to flee from the "semi-
feudal cotton economy" of the South to the industrial cities of the
North. When the first wave of migrants arrived between 1916 and
1919 there were jobs available for them because of the labor short-
age caused by the war. When news of the success of the early
migrants reached the South, other Blacks followed; the second wave
came between 1921 and 1923, after the immigration laws had cur-
tailed the European labor supply. In these periods the Black popu-
lation of the major Northern cities increased 100 percent [*Illus.*
101]. Not long after the war, however, Blacks began to realize that
in the North as well as in the South they were not welcome in
peacetime as neighbors and co-workers. *Illustration* 102, another
panel in the Lawrence *Migration* series, takes its theme from the
resultant racial strife.

101 Jacob Lawrence,
The Migration of the Negro,
Panel 1: "During the World
War there was a great
migration North by
Southern Negroes," 1940–41.
Tempera on masonite,
12″ x 18″.
The Phillips Collection,
Washington, D.C.

102 Jacob Lawrence, *The Migration of the Negro*, Panel 50: "Race riots were very numerous all over the North . . . ," 1940–41. Tempera on composition board, 18″ x 12″. Collection of The Museum of Modern Art, New York (gift of Mrs. David M. Levy).

A painter of remarkable personal vitality, Lawrence has a strong command of pictorial organization and uses primary colors with extreme simplicity. His approach to painting thus resembles a printmaking method. For example, in creating panels for a series, he pencils in each scene and then applies each color in turn wherever it is called for throughout the series. This means that all panels are in progress simultaneously and all are completed at roughly the same time. Lawrence developed this approach to painting as a youngster, when his mother's oriental rugs so fascinated him that he duplicated their geometric patterns in drawings, using this color-by-color method.

Lawrence represents with distinction the first generation of recognized artists nurtured by the Black experience: his community was Black, his early teachers were Black, and his first encouragement came from Blacks. He is a social artist of great of great ability who speaks loudly and clearly through his works. As important as the fact that Lawrence is probably the best-known, most published, and most influencial living Black American artist is the fact that he is a humble man of great personal stature.

123

CHARLES WHITE (b. 1918) emerged in the late 1930s as in interpreter of Black life by depicting idealized Black heroes and the struggling Black masses. As quoted by Louie Robinson in an article for *Ebony* magazine (July 1967), James Porter has said that White

> has found a way of embodying in his art the very texture of Negro experience as found in life in America. Charles is an artist steeped in life; and his informal artistic vision conduces to an understanding of vivid pictorial symbols which, though large as life itself, are altogether free of false or distorted ideas or shallow and dubious emotion. [P. 28]

One of White's early works, *Five Great American Negroes*, a mural completed in 1940 for the Chicago Public Library, is a tense, emotional expression of persecution and struggle. Another early composition by White, *Contribution of the Negro to American Democracy* [*Illus.* 103], is a tempera mural completed for the Hampton Institute. This strong pictorial expression focuses on the heroic contributions of such major Black historical figures as Crispus Attucks, Nat Turner, Denmark Vesey, Booker T. Washington, and George Washington Carver. There is a graphic quality in the handling of shapes, and White's powerful forms move in and out in a dynamic geometric progression. Over the years, White's figures have become less geometric and have taken on a more realistic posture. He has also shifted from groups to individual subjects and from murals to drawings and prints. A comparison of his portrayal of Frederick Douglass [*Illus.* 104] and the rounded forms of *In Memoriam* [*Illus.* 105] shows the changes that have taken place in White's portrayal of the human form.

103 Charles White, *Contribution of the Negro to American Democracy*, 1943. Tempera, 12″ x 18″. Collection of Hampton Institute (reproduced by courtesy of Heritage Gallery).

104 Charles White, *Frederick Douglass*,
1950. Lithograph, 26″ x 20″. Collection
of Samella Lewis.

105 Charles White, *In Memorium*, 1965.
Ink and collage, 52″ x 40″. Collection
of Naomi Caryl, Los Angeles.

ELIZABETH CATLETT (b. 1919), a sculptor and printmaker, has a
strong academic background and an imaginative command of the
principles and techniques of Western aesthetics. She is dedicated to
visual communication and to the promotion of ideas through art,
especially those related to the struggle of human beings to improve
their economic, political, and aesthetic lives. Catlett's early involve-
ment in the Civil Rights movement, both as a student and as a
teacher, contributed to her philosophy of art and life, which she
describes in the following statement:

*Art must be realistic for me, whether sculpture or printmaking. I have
always wanted my art to service Black people—to reflect us, to relate to us,
to stimulate us, to make us aware of our potential. . . . Learning how to
do this and passing that learning on to other people have been my goals.
I have learned from many people: from the restlessness and inquisitive-
ness of the young, from my mother, from other Black people who have
struggled to better themselves—from childhood right on up to now. It has
taken a long time to find out that technique was the main thing to learn*

125

from art schools. It's so important—technique—how to do things well. It's the difference between offering our beautiful people art and offering them ineptitude. They deserve the very best and we have to equip ourselves to give them our very best. You can't make a statement if you don't speak the language.

The search for learning took me to Mexico, to the Taller de Gráfica Popular, where we worked collectively, where we had strong artists and weak artists, and each one learned from the other. Everybody offered something—and when you saw the product, even if you were weak, you saw a collective product that you had helped form. It makes a difference in your desire to work and your understanding of what you're doing. And at the same time we did individual work. I would say it was a great social experience, because I learned how you use your art for the service of people, struggling people, to whom only realism is meaningful.

I try to keep away from galleries; they flatter you, seduce you, they buy and sell you. While the Popular Graphics Workshop lasted, it was really worthwhile. Among other things, I learned that my sculpture and my prints had to be based on people's needs. The needs of whomever I'm creating for determine what I do. Some artists say they express themselves; they just reflect their environment. We all live in a given moment in history, and what we do reflects what level we are on in that moment. Whether you are in the white man's game, which is competition, and fighting to get to what's called the top; or whether you're really with the people trying to get everybody to the top or at least see that everybody has a chance to keep on living; or whether you're in limbo, creating art for art's sake—you have to consciously determine where your level is. I de-

106 Elizabeth Catlett, *Black Unity*, 1968. Cedar, 20½″ x 24″. Courtesy of the artist and Contemporary Crafts, Los Angeles.

107 Elizabeth Catlett,
Negro es Bello
(*Black is Beautiful*), 1968.
Lithograph, 8″ x 11″.
Collection of Samella Lewis.

*cided a long time ago that mine is with the only people in the United
States that call each other "brother" and "sister," and with the Mexicans
who are trying to get food and freedom for everybody—so that the way one
is going to live or lose his life is not predetermined by somebody's greed.
What comes out in my sculpture or prints can only reflect this level.
It's not possible for me to work within what's called the Universal, or
Modern Art, movement. I can't do what white people with money want at
the same time I'm doing what Black people need. Trying to bring these
two extremes together only creates chaos.*

*. . . if we can just get away from what's supposed to be the way of doing
things, of doing the same fads in art and taking it to the galleries and
charging higher and higher prices and creating less and less. And trying
to be different, superficially, and ignoring our people, saying, "We are
artists, first, and then Black."*

*I think we have to find a way, collectively—not working alone. I think we
have to find it with our people, and according to their needs. That's the
art that's going to be part of us, coming out of our lives. That's the art
that's going to carry over to other people throughout the world. It might
not win prizes and it might not get into museums, but we ought to stop
thinking that way, just like we stopped thinking that we had to have
straight hair. We ought to stop thinking we have to do the art of other
people. We have to* create an art for liberation and for life. [Personal com-
munication with the author.]

Among the many distinguished sculptures by Catlett is *Black
Unity* [*Illus.* 106], a provocative symbol of Pan-Africanism and its
spiritual implications for global Black unity. Her lithograph *Negro
Es Bello I* [*Illus.* 107] is a strong yet tender rendition of the pro-

file of a Black child. Through the qualities of the lithographic stone and through Catlett's deep understanding of her subject and her materials, the myriad shapes of the work combine to form a clear, precise statement of the qualities of childhood.

Another work by Catlett is the prizewinning linocut *Malcolm Speaks for Us* [*Illus.* 108], which is part of her series on Black heroes. A combination of four blocks, three of which are repeated several times, this color linoleum print demonstrates Catlett's technical ability in the placement and registration of images; its color and value changes were achieved through separate inkings and printings.

JOHN WILSON (b. 1922) is a painter and printmaker whose works are representative of the social consciousness in art. Although he has long been associated with artists who were at one time employed by the WPA, Wilson himself was too young to participate in the Federal Arts Project; the support that allowed him to become a working artist came from scholarships and fellowships given by educational institutions and foundations.

Even though his development as an artist did not coincide with the Harlem Renaissance or the WPA period, Wilson nevertheless

108 Elizabeth Catlett,
Malcolm Speaks for Us, 1969.
Linocut, 37″ x 27½″.
Collection of Samella Lewis.
(Photograph by Armando Solis, Los Angeles.)

represents both of them in his philosophy and style. His works affirm racial pride and, at the same time, respond meaningfully to social and political problems. The racism in the Boston area in which Wilson grew up intensified his feeling for justice and equality; and Carl Zerbe, his teacher and advisor at the Boston Museum School, encouraged his resultant interest in social art. Studying the works of artists Daumier, Rouault, Shahn, Grosz, Rivera, and Orozco, and of writers who were also concerned with social and economic injustices, further inspired Wilson to make his art an expression of his reactions to oppression. Accordingly, he has shown particular admiration for the Mexican muralists. *Incident*, one of his first fresco murals, was painted in the suburbs of Mexico City in 1952 as a part of a student project. On the instructions of David Alfaro Siqueiros, it was later ordered preserved for permanent display.

Roz [*Illus*. 109], a pastel and charcoal drawing of a deeply pensive figure, shows the classical aspect of Wilson's style. He uses light and shadow to create the solid oval shape of a head that, emanating from a tubular neck, recalls the ancient Ife terra cottas of Nigeria. *Trabajadores* [*Illus*. 110], a colorful Wilson composition, uses simple geometric shapes as a background for three construction workers. Dramatic verticals and horizontals create a rigid structural pattern that is effectively complimented by the use of primary colors, which also serve to heighten the dark massive quality of the figures.

109 John Wilson, *Roz*, 1972. Pastel and charcoal, 24″ x 19″. Courtesy of the artist.

JOHN BIGGERS (b. 1924) is another artist whose early career was dominated by mural painting. While a student at the Hampton Institute in the 1940s, Biggers watched Charles White paint his mural *Contribution of the Negro to American Democracy* (see page 124) and soon began to paint his own murals, under the guidance of Viktor Lowenfeld, then chairman of the art department at Hampton and an important figure in art education throughout the 1940s and '50s. One unique work by Biggers was painted in 1944 for the United States Naval Training School at Hampton. Most of his early murals were painted directly on the walls of buildings that have since been destroyed.

An example of Biggers' work on a smaller scale is provided by *Washer Woman* [*Illus*. 111], a drawing completed in 1945. The woman in this composition seems rooted to the ground by her huge immobile feet, above which her body must bend and sway in the rhythm of her task. She attends a washboard and a steaming pot, the tools of her trade and, for many years, symbols of the life of many Black American women.

129

110 John Wilson,
Trabajadores, 1973.
Oil, 46″ x 34″.
Courtesy of the artist.

More recent works by Biggers show a concentration on subtle value changes and, thematically, an informed interest in the Black heritage. *The Time of Ede, Nigeria* [*Illus.* 112], one of three related works, is among the paintings Biggers has created as a result of his study trips to Africa.

The WPA period saw a resurgence of participation by Black artists and craftsmen in the mainstream of American life. Although their formal training was usually in teaching or community service, many Black artists were able to function successfully as weavers, graphic artists, photographers, or architects. Unlike the "modernists" of the time, most of the more representational Black artists did not claim to work for themselves but devoted their art to social and humane needs. Feeling a growing need to influence and affect the thoughts and behavior of other Black Americans, these artists created for Blacks rather than for white critics. They used their art forms to describe significant individual and collective experiences—experiences that would later contribute to the reemergence of Black consciousness in the 1960s.

111 John Biggers, *Washer Woman*, 1945.
Pencil drawing, 24″ x 18″.
Collection of Samella Lewis.

112 John Biggers, *The Time of Ede*, *Nigeria*,
1964. Conti crayon, 6′ x 4′. Collection of
Dr. and Mrs. J. J. Kimbrough, San Diego.

Political and Cultural Awareness

1960-1970s

The Harlem Renaissance of the 1920s offered Black artists the patronage of foundations controlled by interested whites. The Depression of the 1930s continued a measure of support to artists through the establishment of federal programs, which were also controlled by whites.

Following World War II there developed an intense struggle by Black Americans for equal rights in all aspects of American life. In the course of this struggle for equal economic, political, and social opportunity, Black artists embraced the concept of self-determination through self-expression, which involved the demand that Blacks formulate their own aesthetic principles. As this demand became a dominant theme of the 1960s, Black artists, writers, musicians, and dancers joined together, as they had during the Harlem Renaissance, to formulate new ideological directions. Barriers caused by differences in age, economic standing, and sociopolitical conviction gave way to a new group feeling. With this new unity and dedication, the role of Black art had been transformed: from fulfilling the needs of the traditional African community to fulfilling the needs of the contemporary African-American community.

In the midst of the aggressive social activity of the past two decades, many young Blacks have been attracted to art as a profession that offers them experiences capable of counterbalancing the chaos and uncertainty of Black life in the United States. The combina-

131

tion of a new outspoken expressiveness and a new knowledge of Black historical deeds has produced a climate in which the Black artist can work with a new sense of dignity and pride.

Contemporary Black artists do not hesitate to use diverse ideas and techniques in the production of art forms that speak to Black people. Their techniques are derived from a variety of civilizations and are expressed in Social Realism, Surrealism, Abstract Expressionism, Conceptual Art, or any of the other popular styles. Subject matter and philosophical orientations are also diverse, though for many Black artists in America, Africa serves as the principal source of creative inspiration. The result of this new consciousness is an art in the process of realization, a process in which the single most important aesthetic principle to emerge is that differences are valid.

PAINTING

ADEMOLA OLUGEBEFOLA (b. 1941) reflects the spirit of those artists who hold strong visual and spiritual ties to Africa. Born in St. Thomas, the Virgin Islands, he migrated to New York City with his family when he was four years old.

Olugebefola's dynamic sense of movement in form and color has been enriched by his professional experience in music and drama. A double-bass player, he developed a desire to create visual sounds, and while working in New York City as director of the Jazz Art Development, executed paintings for the *Blues for Nat Turner Jazz Suite*. This experiment in the fusing of poetry, music, and art recalled the ceremonial traditions of African celebrations in which the visual, auditory, and literary arts are integrated.

A member of the Harlem-based Weusi Nyumba Ya Sanaa Gallery and the Academy of African Arts and Studies, Olugebefola believes that he is not creating art as an individual but rather reflecting organic parts of an evolution. His primary aim is to reach beyond pictorial surfaces by spiritually expressing space, shape, and color. He views his art as visual equations created to awaken individuals to a higher potential and to bring out the Africanisms in them.

In 1964 Olugebefola responded to the call for unity and positive direction in the arts of ethnic minorities by joining a group called the Twentieth-Century Creators. This group brought him into full participation in the development of its philosophy: Black Art—for Black People.

Expressing contemporary manifestations of traditional lore and art forms, Olugebefola believes that the role of the Black visual art-

113 Ademola Olugebefola, *Shango*.
Construction with shells.
Courtesy of Contemporary Crafts,
Los Angeles.

ist is to provide the proper guideposts for Black people; he notes that the struggle is not so much a war of guns but a war of minds. His concept of racial power is reflected in images such as *Shango* [*Illus.* 113], in which the god of thunder and lightning expresses the "regality of our blood." Olugebefola's rendition of Shango is a mystical construction in which the color blue is used spiritually as an expanse of space. A double-headed ax bears leaves that are nourished and strengthened by a line of shells suggesting a continuous inner flow of life from roots that are firmly planted. This combination of forms expresses both stability and energy, while visually depicting the sensitivity and productivity of the Yoruba god.

HERMAN ("KOFI") BAILEY (b. 1931) also exemplifies the new dimensions of Black art. With Pan-Africanism as his philosophy, he gains inspiration and motivation from a direct involvement in the social and political life of the international Black community. His associations with W. E. B. Du Bois, Kwame Nkrumah, and Martin Luther King, Jr., have placed him at the heart of some of the century's most potent Black social and political movements. His participation in public matters has not kept Bailey from becoming a highly productive and expressive artist, however. The numerous works he has created employ both geometric and figurative elements and, while including aspects of character common to all mankind, usually speak directly to Black people.

133

114 Herman ("Kofi") Bailey,
Hausa Boy. Charcoal and wash,
30″ x 20″. Courtesy of
Contemporary Crafts, Los Angeles.
(Photograph by Armando Solis,
Los Angeles.)

Like numerous other Black Americans, Bailey has established a cultural base in Africa; and his works are nurtured by the powers and sensitivities he has absorbed from "his mother continent," especially from Ghana. Bailey's strong figurative style speaks to Black people throughout the world, of birth, life experience, and death. Combining both geometric and figural elements, he often uses massive shapes to surround the sensitively rendered figures that serve as focal points in most of his compositions. The geometric elements are usually utilized as background forms that subtly emerge from space.

Bailey's *Hausa Boy* [*Illus*. 114] is a tender rendition of a child who, in a meditative stance, is peering into the distance. The figure is not static but seems to be intently concentrating on something that will affect his immediate course of action. The lone figure needs little background to define his situation, and what is required the artist leaves to the creativity of the viewer. The subtle, economical handling of light and shade expresses a completeness of form and benefits from the artist's strong foundation in draftsmanship and his understanding of human sensibilities and emotions. An effective charcoal-and-wash drawing, *Hausa Boy* is a finished composition, not a sketch for a more detailed work.

The majority of his compositions are done in charcoal or conté crayon (made of graphite and clay), but Bailey also works in oil, acrylic, and several other media. Indeed, his technique relies heavily on a combination of substances; he sometimes uses three or four in a single composition. And because Bailey employs primarily earth tones, color is always a secondary factor in his work; the graphic qualities of his compositions supply the visual impact.

Birth [*Illus*. 115], through its effective combination of symbolism and realism, shows another characteristic of Bailey's style. The background and foreground are interrupted geometrically, sometimes subtly with wash and at other times dramatically with lines; this treatment effectively combines both subjective and objective use of form. The circle in the background and the corresponding implied circle in the foreground create a figure eight that relates the two areas. A dramatic composition that demonstrates Bailey's compassion, the work is a rare example of strength and sensitivity.

Unity [*Illus*. 116] a mixed-media painting by Bailey, has notable political and social implications. A single figure is juxtaposed against subtle forms emerging from the swirling lines of the background. The heroic presence reaching for the star and crescent, symbols of Black unity, creates a strong visual movement toward these goals. The "all-seeing eye," the eye of Black unity, overlooks all.

134

115 Herman ("Kofi") Bailey, *Birth*.
Mixed media, 40″ x 30″. Courtesy
of Contemporary Crafts, Los Angeles.

116 Herman ("Kofi") Bailey, *Unity*, 1961. Mixed
media, 40″ x 30″. Collection of Samella Lewis.
(Photograph by Armando Solis, Los Angeles.)

RAYMOND SAUNDERS (b. 1934) is an artist whose works reflect a
vigorous marriage of figurative, geometric, and calligraphic styles.
Margery Aronson, formerly associated with the Museum of Modern
Art, has said of Saunders and his works:

> I like Saunders because nothing about him is artificial. I like his art
> because it is a personal and exuberant visual diary which takes me beyond
> the confines of my experience and opens my eyes to the work, labor and
> effort required for the creative process. These are living works—real—not
> static. The works and their creator make me aware and glad to be alive.
> ["Artists' Biographical and Publicity Information." Terry Dintenfass
> Gallery, New York, October 1972.]

In his African Series, Saunders uses colored pencils and a highly
fluid sense of line to delineate aspects of life viewed during the
several months he spent in Africa in 1970. In one sketch his lively
approach to design results in geometric African "fabric patterns,"
which, repeating the movements of figures in the lower portion of

135

117 Raymond Saunders,
Page from an African Notebook, 1970.
Colored pencil, 8½″ x 6¼″.
Courtesy of the artist.

118 Raymond Saunders, *Jack Johnson*, 1971. Oil on
canvas, 81¾″ x 63½″. Pennsylvania Academy of the
Fine Arts (purchased through the aid of funds
from the National Endowment for the Arts,
the Pennsylvania Academy Women's Committee,
and an Anonymous Donor, 1974).

the composition, form the headdress for a massive human head
[*Illus*. 117]. Upon careful examination it is apparent that the large
human presence is also a combination of two profiles; the realistic
figures of an African mother and child appear in the center of the
work in front of a billboardlike environment. While smaller in scale,
the figure of the woman repeats the overlapping triangular forms
evident throughout the composition.

Saunders' enthusiastic style is equally evident in his handling of
portraiture. His *Jack Johnson* [*Illus*. 118] combines painting, draw-
ing, and collage techniques to present an image of the Black cham-
pion, with such items as tickets and adhesive tape documenting
his role in the world of prizefighting.

136 LUCILLE MALKIA ROBERTS (b. 1927) has traveled extensively in
Africa, Canada, Europe, Mexico, and the Far East, but it is clear

119 Lucille Malkia Roberts,
Natural Woman, 1972. Acrylic,
50″ x 36″. Courtesy of the artist.

that Africa has had the strongest impact on her work. Though her painting style is indebted to several sources, she generally finds her subject matter in African culture. Her travels in Africa have also affected her palette: "Now I find myself painting in the rich luminous colors of the landscape of the people." Roberts also manages to capture the spirit of the African people and their environment. In *Natural Woman* [*Illus.* 119] Roberts combines an awareness of negative space—a traditional Far Eastern concern—with an expressive use of color; she also dynamically blends the spirits of African, Asian, and African-American imagery.

A native of Washington, D.C., Lucille Roberts received a bachelor's degree from Howard University and a graduate degree from the University of Michigan. She has also done postgraduate work at the Catholic University of America, in Washington; at New York University; at the Académie de la Grande Chaumière, in Paris; and at the University of Ghana, in Legon. At present Roberts is a faculty member at Howard University.

137

120 David Driskell, *Shango Gone*, 1972. Egg tempera, 24″ x 18″. Courtesy of the artist.

DAVID DRISKELL (b. 1931) is Professor of Art at the University of Maryland and winner of the 1962 Museum Donor Award presented by the American Federation of Art. Represented in many public and private collections, he is also an articulate spokesman for Black art. In 1969 and 1970 Driskell served as a visiting professor at the Institute of African Studies of the University of Ife, Ile Ife, Nigeria. His experiences there differed from those of most other Black American artists visiting Africa in that his academic position provided unusual opportunities to exchange ideas with some of Africa's best-known artists.

Driskell's recent works show the influence of his African experience, and such titles as *Nok Honoring Walter* (1972) and *Shango Gone* [*Illus.* 120] are obvious remembrances of Nigeria. With geometric principles underlying the basic structure of *Shango Gone*, its pictorial space is organized through conformity to rectilinear patterns. The frontal approach of the figure suggests Driskell's interest in African sculpture. A simplified statement, *Shango Gone* exhibits a lighter palette than do most of Driskell's other works. Somber in tone, the architectonic quality of this painting is expressed primarily through line and shape rather than through color.

121 David Driskell, *Gabriel*,
1965. Oil on canvas, 48″ x 36″.
Courtesy of Contemporary Crafts,
Los Angeles.

In *Gabriel* [*Illus.* 121], an earlier work, Driskell adhered to a sim-
ilar geometric plan. Its semiabstract forms are enriched with expres-
sionistic effects that resemble modern graffitti. *Gabriel* is related to
Shango Gone in structure, spirit, and design; and its suggestion of a
double-headed ax, a tool and symbol clearly depicted in *Shango
Gone*, gives the two compositions a thematic resemblance as well.
 Driskell has described his art in the following manner:

> *Art is the fulfillment of my human desire to be at peace with myself, my
> fellow man and my environment. If the world of experience does not
> provide the model for this fulfillment, then my art seldom imitates literal
> life, but it does imitate the ways of life.* [*Quoted in "David C. Driskell:
> Watercolors and Prints." Catalog of an exhibition, 6–17 March 1972, at
> Scarrit College for Christian Workers, Nashville, Tenn.*]

FLOYD COLEMAN (b. 1937). The works of art created by Floyd Cole-
man prior to 1970 are devoid of representational elements; his early
painting *Yellow Square* [*Illus.* 122] achieves its complex relation-
ships through a combination of lively color and calligraphic mark-
ings. In more recent works, Coleman's style has become less paint-
erly and increasingly more graphic. The exuberance of his early

139

123 Floyd Coleman, *One Common Thought*, 1972.
Colored ink, paint, graphite, 29½″ x 41½″.
Courtesy of the artist.

122 Floyd Coleman,
Yellow Square, 1967.
Mixed acrylics, 48″ x 36″.
Courtesy of the artist.

work is replaced by an evocative lyrical expression in which each
shape is carefully and simply defined. His style, though more figura-
tive than it once was, now incorporates patterns created by the
interaction of advancing and receding planes. Using color only as
an undertone, Coleman emphasizes cross-hatched lines and highly
textured surfaces as principal structural elements in his compositions.

Coleman's visit to Africa in 1971 resulted in extensive changes in
both the subject matter and style of his work. *One Common
Thought* [*Illus*. 123], his sequence of three "stills" in which different
attitudes of the same figure are presented, makes obvious refer-
ence to African sculpture in its use of the symbolic circular eye.
Less colorful than his earlier works, this and Coleman's other re-
cent compositions balance their loss of intense color with an in-
crease in textural complexity.

PAUL KEENE (b. 1920) is the product of a strong traditional educa-
tion; he attended the Philadelphia Museum School of Art, the Tyler
School of Arts, the Académie Julien, and Temple University. A
master colorist with a fine sense of design, Keene has for many years
concentrated on themes of Black life. Some of his works are *The
Cabinet of Doctor Buzzard* [*Illus*. 124], *Death Calls on the Root Man*
(1969)—both from *Root Man Series #2*, which features subject
matter related to voodoo—and *Garden of Shango* (1969), inspired by
the ancient Yoruba deity. In *Garden of Shango* one experiences a
variation on geometric shapes in which design plays an essential
role. The dynamism inherent in traditional African sculpture is
felt in the pulsating motion created by the arrangements of shape

140

124 Paul Keene, *The Cabinet of Doctor Buzzard* (from the Root Man Series), 1968. Acrylic, 50″ x 60″. Courtesy of Contemporary Crafts, Los Angeles.

and color. The life-giving force generated by the circular symbol penetrates every area of the composition, thereby creating a strong sense of energy. Keene's use of color and shape in this work produces a dynamic, spiritual environment suitable for Shango, the god of thunder.

ARTHUR CARRAWAY (b. 1927). While many Black American artists have been attracted to West Africa, the region of many of their ancestors, Arthur Carraway, an experienced merchant seaman, has spent considerable time in several regions of the continent. He maintains that his travels in Africa have had great impact on his art:

> *I was in Africa for two years under the auspices of the United Nations. Though I traveled through the west, north, and south of Africa, I spent one year in east Africa—Dar es Salaam, Tanzania; and Mombasa, Kenya. It was there that I became acquainted with Makondo sculpture by touring the museums and art shops. The work was most impressive. Through exposure to Makondo sculpture, different forms and ideas began to take shape in my mind. These ideas were to lead me to a new and positive approach to painting closely related to my own cultural direction and development. This direction is not yet clearly defined. [Personal communication with the author.]*

In his *Fetish Form Series II* [Illus. 125] Carraway presents a figure from which vibrations appear to flow. The monochromatic ground and shifting effects of light and shadow give an impression of changing space and continuous motion.

125 Arthur Carraway, *Fetish Form Series II*, 1968. Oil, 49½″ x 30″. Collection of The Oakland Museum (gift of the Art Guild, Oakland Museum Association).

126 Mikelle Fletcher, *Guardian*,
1971. Acrylic, 48″ x 36″.
Courtesy of the artist.

MIKELLE FLETCHER (b. 1945), one of the fascinating young painters to emerge in recent years, derives her visual expressions from both Africa and America. The symbols in her *Guardian* [*Illus.* 126], for example, suggest that the cooperation of these two areas is necessary for the protection of the Black race. The most important symbol protecting the painting's Black Madonna and child is the *aunkh*, an African emblem of life and prosperity. Also among the guardians are a jackal, the Black liberation flag, and a small outline of the African continent. Encircled by these protectors, the figures of the mother and child are depicted in a style that seems to combine fantasy and reality. The interplay of these clearly defined shapes suggests movement, and the rhythmic quality is increased through the use of irregular shapes in contrasting colors, which extract a maximum decorative effect from each object or space.

Viewing the work of Mikelle Fletcher provides a powerful emotional experience. Because they reflect concepts and attitudes relevant to several Black cultures, her paintings can be regarded as visual expressions of Pan-Africanism. This is in keeping with Fletcher's belief that Black art must be functional:

> One picture is worth one thousand words!! That's an old cliché. Our role as Black artists is to provide that direction needed by our people through art, through "pictures." We cannot afford to relegate ourselves to art for art's sake. Throughout our history, from Egypt, the great empires of Benin, Ife, and Nok, to traditional Black African art, our art has been functional *and created by our people for a* purpose: *for ceremonies, for celebration of birth, to mourn death. . . .*

> In our struggle for liberation, Black artists play a very crucial role. Because of our ability to express, in a picture, a thousand words, those words should be in some way functional, words relevant to educating our people to the need for liberation. Our art can begin to educate, to teach the three R's, but the three R's that are relevant to us now: Redefine, Reeducate, Redirect. [*Personal communication with the author.*]

VARNETTE HONEYWOOD (b. 1950) is a Los Angeles artist whose experiences in the South as a student at Spelman College in Atlanta reinforced her feeling for Black life and inspired her portrayals of Blacks. An impressive genre painter whose works are reminiscent of the early Archibald Motley portrayals of Blacks of the 1920s (see page 74), Honeywood approaches her subjects with empathy that stems from deep-seated spiritual convictions and also manages to capture both the serious and humorous aspects of a situation. In *Gossip in the Sanctuary* [*Illus.* 127] she finds far-reaching social implications in the concept of gossip:

127 Varnette Honeywood,
Gossip in the Sanctuary, 1974.
Acrylic on canvas, 24" x 30".
Courtesy of Contemporary
Crafts, Los Angeles.

Gossip in the Sanctuary *is one in a series of paintings in which I try to
illustrate the strong, reassuring, and free expressions of proud Black peo-
ple. The expressions of self-esteem, power, and self-determination were
instilled in many of our leaders through the Black Church. Many experi-
enced their first feelings of dignity and worth which fostered desires to
keep the "faith torch" lighted as they led the way to the outside world so
full of prevailing forces. In church, they felt free to dream, to hope, and to
show all the human instincts . . . even to gossip.* [Personal communica-
tion with the author.]

BENNY ANDREWS (b. 1930) produces art that is uniquely his own, for
it evolves from his deep concern for the people he considers fre-
quent victims of society. His primary commitment is to the reshap-
ing of society through the creation of art that will call attention to
social evils and raise issues the viewer will, it is hoped, be encour-
aged to resolve.

Andrews has a representational style that avoids the modeling of
form; he relies instead on drawing, creating bulk by suggestion
through the proper combinations of lines and voids. An example
of this technique is provided by *Put Up* [*Illus.* 128], in which the
artist's economy of line forces the viewer to concentrate on the

143

subject's battered visage. Through his gestures, the scarred fighter seems to cry out for sympathy. Andrews also demonstrates his sensitive handling of line in *Nice and Easy* [*Illus.* 129], in which the meditative face of a musician expresses his preoccupation with the production of music, a mood reinforced by the detailed reproduction of the player's hands and banjo.

In its use of the collage technique, *War Baby* [*Illus.* 130] represents still another dimension of Andrews' creative ability. This work, in which the limp body of a dead child is held by a sunken-eyed soldier, also reflects Andrews' desire to project in visual form the evil forces that confront humanity. Committed to social-protest art, Andrews is a leader of the Black Emergency Cultural Coalition, an organization of Black artists dedicated to the elimination of racism in the arts, and the National Prison Art Movement.

128 Benny Andrews, *Put Up*,
1971. Ink drawing, 20″ x 16″.
Courtesy of Contemporary
Crafts, Los Angeles.

130 Benny Andrews, *War Baby*, 1968.
Oil collage, 35″ x 25″.
Courtesy of
Contemporary Crafts, Los Angeles.

129 Benny Andrews, *Nice and Easy*,
1970. Ink drawing, 20″ x 16″.
Collection of
Mildred Mosier, Los Angeles.

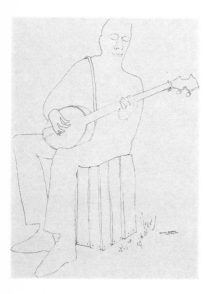

REGINALD GAMMON (b. 1921), possessor of an intense interest in the African-American past, often chooses as artistic subjects individuals who have figured dramatically in the making of Black history. One dynamic commentary by Gammon deals with the much publicized Scottsboro case, in which a group of Black men were charged with rape. His gothic *Scottsboro Mothers* [*Illus.* 131] depicts grief-laden figures in poses that convey strength and aristocratic stamina. Highly formal in style, these geometric figures are echoed in the door and other background shapes. The composition suggests that unity brings strength, even to those who are seemingly helpless.

In *Freedom Now* [*Illus.* 132] Gammon is also concerned with unity, but his style is different. *Freedom Now* takes its spirit from the 1960s, in which the oppressed sought to become aggressive seekers of freedom. The expressionistic technique used by the artist suggests the vitality and inspiration of the Civil Rights movement.

131 Reginald Gammon, *Scottsboro Mothers*,
1970. Arcylic on canvas, 30″ x 22″.
Courtesy of the artist.

132 Reginald Gammon, *Freedom Now*,
1965. Acrylic on board, 40″ x 30″.
Courtesy of the artist.

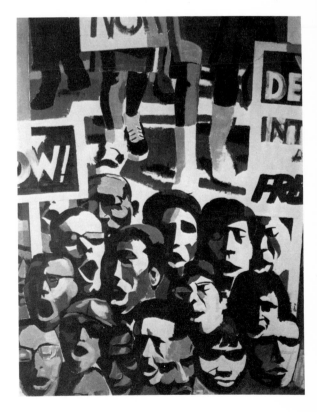

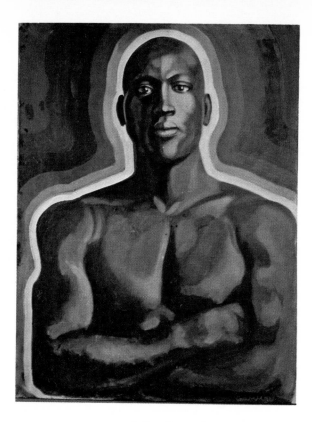

133 Reginald Gammon,
The Young Jack Johnson, 1967.
Acrylic on canvas, 32" x 24".
Courtesy of the artist.

Like *Scottsboro Mothers* and *Freedom Now*, *The Young Jack Johnson* [*Illus.* 133], one of Gammon's hero portraits, has a highly emotional impact. Standing proud, Johnson is portrayed as a robust and challenging figure, velvet skin effectively displaying the muscular forms of his body. Radiant bands of color surrounding the fighter add to the impression that he is a powerful Black machine capable of standing against all challengers.

FAITH RINGGOLD (b. 1934) is an artist interested in capturing "the conceptual visions of the Black image inherent in the sculpture and masks of African art." In her projection of Black faces and body images, she struggles to free herself from what she considers the "yoke" of light and shadow. Since 1967 she has been using a unique style she terms "black-light painting," which abandons the traditional approach to lights and darks—the value scale—in favor of contrast based on the intensity scale. Along with this color style and in order to liberate her works from the traditional up-and-down visual pattern, Ringgold employs "poly-rhythmical space based on ancient African design," which, she hopes, will stimulate the viewer to look at her work from a multitude of directions and levels.

Admitting that "black" painting is not new, Ringgold maintains that she first became aware of it through the works of Abstract Ex-

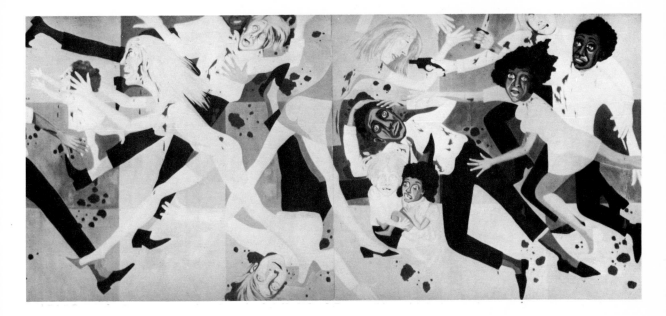

134 Faith Ringgold, *Die*, 1967. Oil on canvas, 6′ x 12″.
Courtesy of the artist.

pressionist Ad Reinhardt (1913–1967). She adds, however, that her
concept of black light differs from Reinhardt's in that she "uses
black as a symbol for humanity rather than as an abstraction of
color vision or design." In such works as *Die* [*Illus.* 134] she ex-
presses the emotional tension of ethnic struggle and violence.
Though the composition is subjectively expressed, the shapes com-
prising it project abstract qualities. Subject-matter areas that are
emotionally explosive are held in context through the artist's keen
sense of design.

Ringgold has long been involved in the struggle for equality for
women, and she feels that her most profound artistic contribution
has been in "women's art": "My art is for everyone but it is about me
(my sisters)." In *Aunts Edith and Bessie* [*Illus.* 135], from her *Fam-
ily of Women* series, Ringgold shapes soft, pliable materials into life-
sized human figures; the open mouths of these two subjects are
meant to symbolize the need for women to speak out for themselves.
Ringgold's interest in women's rights has not lessened her concern
about the continuing racial oppression in the United States: "As long
as sixty percent [the female sector] of the Black population con-
tinues under [its] double oppression, Black people will not be free."

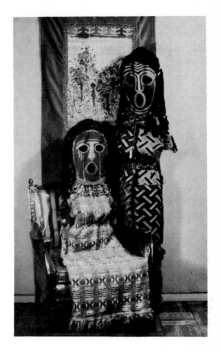

135 Faith Ringgold,
Aunts Edith and Bessie, 1974.
Mixed media, life size.
Courtesy of the artist.

THE FLAG: A SYMBOL OF REPRESSION

During the late 1960s, there arose in the United States a reaction on the part of many Black artists against what they viewed as institutional racism. In an effort to focus public attention on this evil, a great number of these artists began to use the national flag as a visual symbol of their disappointment over the country's lack of social justice.

CLIFF JOSEPH (b. 1927), who believes that "the power of art belongs to the people," makes racism, war, and sexism his principal pictorial concerns:

> *My art is a confrontation. Among the many realities of art expression, this remains the most constant purpose of my aesthetic. It is, of course, a social art, based on my "gut" perceptions of our worldly conditions; but it draws upon each viewer to confront himself in consideration of his role in affecting those conditions. As long as these conditions remain, I must continue to move between analysis, militant pride, and revolutionary suggestion in my search and struggle for true humanity.* [Personal communication with the author.]

Co-chairman, with Benny Andrews, of the Black Emergency Cultural Coalition, Joseph is an artist who is highly conscious of the social and political problems of the modern world. His *My Country Right or Wrong* [*Illus.* 136] portrays Americans who, blinded by an inverted flag, stand oblivious to the skeletons of those fallen around

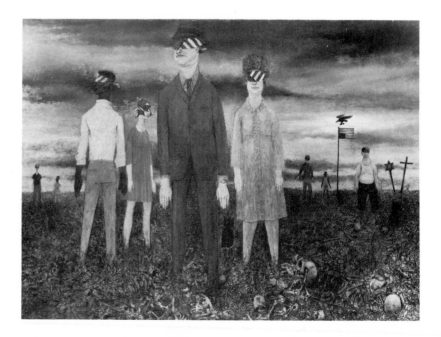

136 Joseph Cliff, *My Country Right or Wrong*, 1968. Oil on masonite, 32" x 48". Courtesy of the artist. (Photograph by Eric Pollitzer, Garden City, New York.)

them. This eerie, surrealistic comment on the destruction committed in the name of patriotism is meant to arouse feelings of indignation and to have a macabre effect on all who view it.

DAVID BRADFORD (b. 1937), in *Yes, LeRoi* [*Illus.* 137], provides a penetrating example of the use of the flag as a symbol of social and political repression. The dramatic horizontal stripes of the banner become symbols of environmental conflict when Bradford makes them a backdrop for his composition's humble figure. Joseph's *My Country Right or Wrong* depicts the flag as a source of blindness; *Yes, LeRoi* associates it with a penal environment.

BERTRAND PHILLIPS (b. 1938), a Chicago painter and graphic artist, is another whose work projects anger over the broken promises of the flag. In his *Stars, Bars and Bones* [*Illus.* 138] jagged, brittle lines heighten the composition's emotional energy and express an intense reaction to death and destruction perpetrated under the guise of patriotism. An extraordinarily dynamic artist, Phillips has explained his work by saying:

> My objective as an artist is to portray in my work symbols and forms related to the history, experience, and aspirations of working people, Black people, and other suppressed people. It is important that the manner in

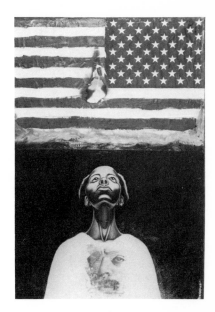

137 David Bradford,
Yes, Leroi, 1968.
Oil, 36″ x 30″.
Courtesy of Contemporary
Crafts, Los Angeles.

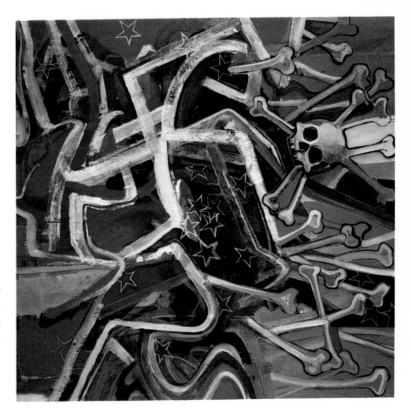

138 Bertrand Phillips,
Stars, Bars and Bones, 1970.
Oil on canvas, 4′ x 4′.
Courtesy of the artist.

which these portrayals are done be contemporary, but a favorable reaction from the viewer needn't follow. My art is done for the people. It is not void of figurative subjects or social and political concepts. It is dedicated to the freedom and liberation of humanity.

As an artist and a sensitive Black human being whose historic roots bear witness to America's genocidal atrocities, I will not fall victim to the myth that art should not concern itself with social and political problems facing America and the world. [Personal communication with the author.]

MANUEL HUGHES (b. 1938) provides another example of the Black artist's use of the flag. His painting *The Chitlin Eater* [*Illus.* 139] shows a flag bearer—a self-portrait of Hughes—who seems to question the awkward position in which he finds himself. The partially unfurled flag appears to be a burden to him, and his eyes stare in frustration and dismay. While motion is suggested, it is left to the imagination of the viewer to determine whether the figure is moving forward or hesitating.

139 Manuel Hughes,
The Chitlin Eater, 1970.
Oil, 3' x 3'.
Courtesy of the artist.

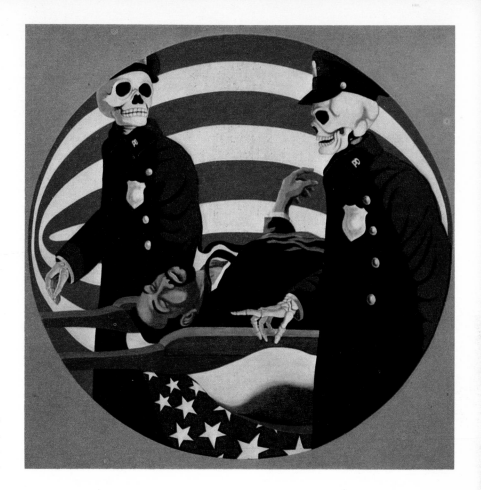

140 Phillip Lindsay Mason,
The Deathmakers, 1968.
Acrylic on canvas, 49¾″ x 50¾″.
Courtesy of the artist.

PHILLIP LINDSAY MASON (b. 1939) has a distinctly personal painting style based principally on a unique use of color. His content ranges from themes of tender love and fertility to biting social and political commentaries like that of *The Deathmakers* [*Illus.* 140], which recalls the assassination of Malcolm X. In this painting Mason points an accusing finger at the Establishment while it, represented by skeletal policemen, points an accusing finger at the fallen Malcolm. Prominent among the bright, primary colors that make up this tense scene is the chrome yellow of the field, a pictorial frame that alternately advances and retreats, depending on the colors that touch it. Figures are realized through abrupt value changes in shape rather than through the use of light and shadow. The dramatic bars of the American flag serve as a bull's-eye backdrop that further intensifies the death scene.

Mason's *Woman as Body Spirit of Cosmic Woman* [*Illus.* 141] is a predominantly cool composition that imparts a mood of serenity and meditation. The central sun disk radiates warmth and provides a contrast to the large, flat, light blue area of the frame and the

151

141 Phillip Lindsay Mason,
Woman as Body Spirit of Cosmic Woman.
60″ x 37″. Courtesy of the artist.

142 Dana Chandler,
4(oo) *More Years*, 1973.
Acrylic, 75″ x 35″.
Courtesy of the artist.

bright blue of the background. The cosmic body serves as a backdrop for a rose floating in space. Contrasting colors and textures and a surrealistic treatment of space all contribute to this tribute to Black womanhood.

DANA CHANDLER (b. 1941) sees his role in art as that of a political reporter and a cultural historian for Black people. His 4(oo) *More Years* [*Illus*. 142] shows Black people trapped behind bars formed by the American flag, to him a symbol of repression and "Euro-American genocidal practices":

> *I deeply believe that for our four hundred years of suppression of mind and body we are owed any monies necessary to pursue our chosen profession, without having to worry about our bills or measuring up to white aesthetic values. We should be able to do our thing for our people or for all people if that is our need. Black artists, as you can see, generally produce functional art: art with a message. I guess it's a part of our African heritage. I believe that Black art should reflect the needs of the community and be an integral part of the day-to-day existence of our people, relating to life in the way our African heritage in art does. [Personal communication with the author.]*

Chandler admits that his art is propaganda created to reshape the attitude and values of Black America toward the development of

143 Dana Chandler,
*Household Weapons: Turpentine,
Bullets, Salt, Pepper*, 1975.
Acrylic, 72″ x 40″.
Courtesy of the artist.

Pan-Africanism. Because, in his opinion, Blacks in America are being killed mentally, physically, and economically, he attempts to create works that suggest methods of defense. In his *Revolutionary Still Life* series, departing from the conventional approach to still life, Chandler offers imaginative works that "become functional, as they depict the necessary tools for our survival in a land determined to exterminate us" [*Illus.* 143].

REALITY AND THE DREAM

Artists are communicators who, through various media, express thoughts and feelings about their inner world and their perceptions of the outer world. Works of art are thus individualized expressions of the "real" world or the "unreal" world. They not only express the real as in everydayness but also the play or fantasy side of human nature, which is so often ignored in today's technological societies.

AL HOLLINGSWORTH (b. 1928), in addition to painting, involves himself in creating mixed-media works that involve their viewers in a total sensory experience. Such assorted materials as wire hangers, fishbones, clotheslines, teeth, wood, cloth, and glass find their way into his collages. One of these, *Memorable Wall* [*Illus.* 144], also in-

153

144 Al Hollingsworth,
Memorable Wall, 1963–64.
Oil, acrylic, collage,
assemblage, 6′ x 4′.
Courtesy of the artist.

154

volves graffiti, a phenomenon long common to Hollingsworth's expression:

Imagine walking down the street and suddenly you see a wall or a fence that has writing on it—you wonder who wrote the words, who carved the names. A thousand questions rush through your mind. It is so intriguing that you must see what's on the other side—however, you can't because you may have to leap over the wall or take ten minutes to walk around it.

The painting Memorable Wall *solves the problem. It is a painting based on typical neighborhood scenes of a decade ago but could very well be today. It interprets the feel of a "rumble"—a teenage fight—a "bop." I utilized some statements as design matter, such as "walk cool"—"no bopping." The wall is small enough to walk around (four feet wide) and see the other side—it is too tall to leap over (eight feet tall). [Personal communication with the author.]*

WILLIAM PAJAUD (b. 1925) creates dynamic forms that have their source in his early life as a native of the South and his later experiences as a resident of the urban West. His *Solid as a Rock* [*Illus.* 145], an expression of Black life in the bayou, reflects the mixture of sensitivity and physical strength that is the essence of Black en-

145 William Pajaud, *Solid as a Rock*, 1970. Oil, 30" x 24". Courtesy of Contemporary Crafts, Los Angeles.

146 Charles Young,
Musicians, 1972.
Oil, 60″ x 44″.
Courtesy of the artist.

durance. Pajaud's expressionistic handling of the subject is achieved through surface texture and application of paint rather than through choice of colors or the action of the figure.

CHARLES YOUNG (b. 1930) creates paintings that express his concern for movement and explicitly denote the nature of his themes. In his *Musicians* [*Illus.* 146] he uses the repeated contrast of black and white piano keys to lead the viewer in the direction of the most important performer, the piano player. The simplicity with which Young has rendered supporting shapes allows for the full emergence of this figure. The exaggeration and agility of the brushstrokes suitably portray the vitality of musicians "into their thing."

BOB THOMPSON (1937–66), who died in Rome at age twenty-nine, was an artist concerned with expressing his inner feelings rather than depicting objective form. Because of the intensity of his involvement, he transformed ordinary experiences into pictorial works of extraordinary vitality. Painting for Thompson was a necessity. From 1961 to 1963 he traveled through Europe studying Western painters of the classical tradition, and later reshaped their themes into a record of his own fantasies and nightmares. Although

156

derived from Goya, Titian, Poussin, and others, his art was very personal. Flat color areas, distortions, and spatial relationships all became personal symbols for his allegorical statements.

Thompson was preoccupied with the dualism of good and evil. He saw beasts as ferocious and meek at the same time and demons and lechers as both monstrous and gentle; he saw in mountains and trees the same sensuality that he saw in the bodies of women. To him, birds symbolized power and freedom; and the functions of the devil and the satyr excited him. The devil in his *Maidens* [*Illus.* 147] is portrayed in the midst of three maidens who are vibrantly painted in flat tones with no concern for light and shadow. The devil, the female figures, and the trees appear to be engaged in a common dialog.

An unusual painter whose short life produced an amazing number of works, Thompson relied heavily on his one intense drive and resourceful imagination to catch glimpses of life's meaning:

> *I had a dream once where the birds sort of went like that and swept up everything, including me, you know, and took me away. The wind was so strong and powerful and yet they were so free and soaring. [Quoted in "Bob Thompson: Important Works in New York Collections." Catalog of an exhibition, 3–30 March 1968, at the Martha Jackson Gallery, New York.]*

147 Bob Thompson, *Maidens*, 1961.
Oil on canvas, 26" x 21".
Collection of
Dr. and Mrs. Leon O. Banks,
Los Angeles.

148 Emilio Cruz,
Figure Composition 6, 1964.
Oil on canvas, 32″ x 40″.
Collection of
Mr. and Mrs. Herbert S. Falk,
Greensboro, N.C. (Photograph
by John D. Schiff.)

EMILIO CRUZ (b. 1938), like Bob Thompson, orchestrates an art of imagination and fantasy, for his style is rich in challenging shapes, colors, and movement. The dazzling interplay of figure and field in Cruz's *Composition* 6 [*Illus.* 148] is typical of his artistic style. In this highly decorative, almost startling work, Cruz recalls sculptural human figures of the ancient past and places them in individualized settings. The figures are viewed from many perspectives simultaneously, and Cruz combines vibrant colors and complex spatial relationships to produce a surreal yet perceptible world.

TEIXEIRA NASH (b. 1932) and EDGAR SORRELLS (b. 1936) differ in some aspects of their painting styles, but they have in common close ties to the expressionist movement. Both use color and visual distortions to intensify subject matter and content. Nash makes people her principal subject matter, and *Figures* [*Illus.* 149] serves as an interesting example of her current style. Sorrells uses a coloristic style characterized by large, swirling, heavily textured paint passages. Several examples of his work, such as *Thoughts Concerning a Father/Son Form* [*Illus.* 150], seem to be inspired by primeval life. He creates forms that emerge only on close examination; he feels that these developing images reflect the positive spiritual-physical space of Black people.

149 Teixeira Nash, *Figures*.
Courtesy of the artist.

150 Edgar H. Sorrells, *Thoughts Concerning a Father/Son Form*, 1969–70. Graphite and modeling paste on masonite, 24″ x 24″. Collection of Laila Mannan, Amherst, Massachusetts.

151 William Henderson,
Non Violent, 1968.
Oil, 6' x 10'.
Courtesy of Contemporary
Crafts, Los Angeles.

WILLIAM HENDERSON (b. 1943) has recently changed his artistic focus. In such early works as *Non Violent* [*Illus.* 151] he was concerned with emotional subjects of a predominantly social and political nature. *Home* [*Illus.* 152] and Henderson's other recent compositions are, in contrast, highly personal expressions. The loose, amorphous, geometric forms used in *Home* and its austere dark green and white colors suggest an otherworldly existence. But although they are different in subject matter and content, there is a conceptual relationship between Henderson's early and late styles. Both represent extremes in the world of reality.

152 William Henderson,
Home, 1971.
Courtesy of the artist.

LESLIE PRICE (b. 1945). Surrealism is perhaps the most important influence on the art of Leslie Price, for it has guided his unique synthesis of abstract form and romantic content. In his dreamlike portrayals, the spiritualization of matter seems a primary goal. Price's uncomplicated illusions are expressed through design concepts that combine geometric shapes with a world of natural growth. His works are symbols of nature in which lyrical, spatial configurations are enclosed in highly technical, hard-edged mathematical shapes.

In his highly personal, mandalalike work *Purusa* [*Illus.* 153], Price uses nature as a silhouetted textural pattern. The painting's controlled forms suggest a spatial ambivalence that is emphasized by the radiating circular area in the center of the work. The bold, dramatic lines and torch shapes superimposed over the natural environment create a strange, unreal atmosphere that decisively combines the concepts of abstraction and surrealism.

153 Leslie Price,
Purusa, 1971.
Oil, 4½' x 6½'.
Courtesy of the artist.

SUZANNE JACKSON (b. 1944) creates paintings filled with symbolic metaphors of reality versus fantasy and aloneness versus loneliness. She considers her paintings as attempts to express "conflicts within the mind, conflicts of choice, of loves, of sensitivities."

Grandparents [*Illus*. 154] and *Escaped* [*Illus*. 155] are typical of Jackson's themes, which echo her past and reflect her feelings for nature; birds and plants frequently play important roles in her compositions. Her allegiance to nature is suggested by numerous atmospheric voids, which, much a part of her compositional structure, contribute to the mystery of her subjects and reward the viewer who searches for the possibilities locked within them.

154 Suzanne Jackson, *Grandparents*, 1970. Acrylic wash, 52¼″ x 45½″. Courtesy Ankrum Gallery, Los Angeles.

155 Suzanne Jackson, *Escaped*, 1970. Acrylic wash, 36″ x 32″. Courtesy Ankrum Gallery, Los Angeles.

161

156 Irene Clark,
Rolling Calf. Oil.
Courtesy of the artist.

157 Dan Concholar,
untitled collage, 1970.
Acrylic and canvas, 20″ x 20″.
Courtesy of Contemporary
Crafts, Los Angeles.

IRENE CLARK (b. 1927), in *Rolling Calf* [*Illus*. 156], also exhibits poetic charm and mystery through animal forms. The normal relationships of size among the animals are abandoned in this composition. A large sheep has three hooves and one human foot, and, as the artist emphasizes the unreal, other animals seem to emerge from its body. The artist has given the following explanation of her work:

> *Why folklore? As a child I was always fascinated by good stories. Having a vivid imagination, I made up many fantasies of my own. After reading many stories, I had to try to paint the substance of what I had read. [Personal communication with the author.]*

DAN CONCHOLAR (b. 1939) creates art in which he uses stylized symbols to express his ideas. Most of his works are highly abstract and illusive; their impact depends on shape relationships and texture rather than on the subjective expression of ideas. Thus, viewers sometimes find it difficult to grasp the full impact of his statements, which are based on his inner feelings and responses to the world around him. In order to share in Concholar's artistic world, the viewer must understand this artist's subtle use of the value scale, as well as his moderate use of color in the central area of his composition. In contrast to this diffused central section, a bold geometric frame is created through the use of line and a flatly painted outer area. *Illustration* 157 provides an example of Concholar's geometric collages.

Many of Concholar's recent high-intensity color compositions are exciting statements that speak to the basic problems of Blacks, American Indians, and other ethnic groups. *Bury My Heart* [*Illus.* 158], one such statement, takes its theme from the historic struggle of American Indians at Wounded Knee, South Dakota, and makes it a binding concept for all deprived peoples.

RICHARD MAYHEW (b. 1924) bases his painting method on unmixed color complements applied in juxtapositions that intensify the brightness of his compositions. He is principally a landscape painter, and, as in *Sentinels* [*Illus.* 159], is often concerned with the effects of light as it falls on land and vegetation; his handling of changing light is unusually sensitive and lyrical. Mayhew aims for subtle surface effects, and though his landscapes are somewhat mysterious and always imply the dominance of nature, they are also calm and peaceful. He sums up, rather than represents, nature, changing it as necessary for richness of color and linear grace.

BERNIE CASEY (b. 1939), a colorist with a strong sense of design, frequently uses geometric shapes in combination with subtle color

158 Dan Concholar,
Bury My Heart, 1973.
Felt pen, 17″ x 13″.
Courtesy of Contemporary
Crafts, Los Angeles.

159 Richard Mayhew,
Sentinels, 1965.
Oil on canvas, 34″ x 40″.

160 Bernie Casey,
Orbital Moonscape, 1970.
Acrylic on canvas, 28″ x 22″.
Collection of Samella Lewis.

changes; an example is provided by his *Orbital Moonscape* [*Illus.* 160]. His works are quiet but penetrating, and some are adorned with words of social significance. The locales they depict could be almost any place in the world, but their poetic statements generally deal with the social plight of Blacks in the United States. Since Casey is also a poet, this combination of forms and words is not unnatural.

Born in West Virginia and educated in Ohio, Casey feels that life experiences become part of the memory bank that contributes to one's creativity:

Sometimes ideas are given to you that you collect, keep, and hold dear for a very long time. During your lifetime these things come out (they come back). You reach into your storehouse of experience and you find an idea lying there waiting to be expressed. You may try to express this idea again and again only to have it defeat you. You know that you are doing it all wrong. But you know that you will try and try again. Then perhaps one long, long rainy afternoon you will try once more and the gods will smile upon you. Every brushstroke will be golden and you are "doing your own thing" and loving it. You have waited so long and you cherish that moment—that moment of creativity. [*From the sound track of the film* Bernie Casey: Black Artist, *copyright* 1971 *by Samella Lewis.*]

Though it demonstrates an awareness of contemporary social problems, Casey's work generally reflects enduring universal values as well. Thus when asked to name the colors of his palette, Casey responded:

I don't really know. What is the color of kindness? What is the color of communications? What is the color of compassion? What is the color of understanding? These, I hope, are my colors. [Personal communication with the author.]

GEOMETRIC SYMBOLISM

The 1960s gave rise to a multiplicity of art movements, among them Minimal painting, Hard-edge painting, and Color-field painting. Although some critics considered them too much in the mainstream to be Black art, they have attracted many Black artists.

DANIEL LaRUE JOHNSON (b. 1938), in his *Big Red* [*Illus.* 161], exhibits a symbolic geometric arrangement of white, yellow, and red rectilinear forms. They enframe a central black square that is a col-

161 Daniel Johnson, *Big Red*,
1963. Oil on canvas, 63″ x 62″.
Collection of
Dr. and Mrs. Leon O. Banks,
Los Angeles.

162 Xenobia Smith, untitled painting,
1970. Oil, 48″ x 48″.
Courtesy of the artist.

163 Milton Young, *Get Me There*,
1971. Acrylic, 48″ x 72″.
Courtesy of Contemporary
Crafts, Los Angeles.

164 Sam Gilliam, untitled painting,
1965. Acrylic on canvas, 74″ x 76″.
Collection of
Dr. and Mrs. Leon O. Banks,
Los Angeles.

lage of discarded items. The matte treatment given the black field puts it at variance with the other surfaces. The large, vibrant red area contains a discreet chromatic modulation that appears as a rhythmic and gently pulsating line. *Big Red* represents a transitional stage between Johnson's "black constructions" of the early 1960s and his recent brilliantly painted sculptures.

XENOBIA SMITH (b. 1933) has a deliberately controlled, intellectual approach to art. She devotes much of her time to the development of a rigorously pure art based on the use of straight lines placed at angles to one another. The result is dramatic and bold and often suggests energy and restlessness, as in *Illustration* 162. The painting's warm color relationships and its interplay between diverse weight lines and shapes create dynamic contrasting patterns.

MILTON YOUNG (b. 1935), while following the Hard-edge style, produces paintings that have strong references to landscape [*Illus.* 163]. His forms are predominantly large, angular expanses of a single earthy hue, but some are enlivened by brilliantly colored diminishing stripes. The convergence of his lines and forms implies a vanishing point, or single perspective.

FLEXIBLE FOUNDATIONS

No longer content with painting surfaces confined by rigid structural supports, an increasing number of Blacks are among those artists utilizing unstretched canvas and other free-hanging fabrics. In working with unframed materials, these artists must consider the draping and contour properties of cloth a major feature of their creations.

SAM GILLIAM (b. 1933) produces suspended paintings that bridge the gaps between painting, sculpture, and environmental design. He applies colors directly to raw, wet canvas so that they flow and mix, creating subtle surface modulations. In addition, he sometimes folds the canvas so that some of the paint may accumulate and dry in the crevices; these accumulations create a soft linearity that suggests Hard-edge painting. As in *Illustration* 164, Gilliam may then attach cords to the canvas and suspend it away from both floor and walls. The weight of the hanging fabric causes natural graceful folds that lend a sculptural quality to the piece.

JOE OVERSTREET (b. 1934) also suspends his painted canvases. After threading cords through eyelets placed along the edge of his paintings, he connects the cords to walls, ceilings, and floors within the display area, making these environments components of his compositions.

Suggesting both painting and sculpture, the angular outline of *Gemini IV* [*Illus.* 165] creates a dramatic relationship between shape and space. Bold geometric motifs are combined with fluid, soft, and thinly applied figure images, which subdue the dramatic impact created by the diverse angles of the canvas. Through the use of many-sided canvases, Overstreet avoids the conventional rectangular format. His compositions suggest brightly colored shields covered with cultural and religious symbols. The thrust of Overstreet's current large-scale compositions can be traced to his increased awareness of his cultural heritage; and his earlier success as an expressionist painter combined with a recent interest in traditional African imagery allows him to express with authority an art that is profound and dramatic.

165 Joe Overstreet, *Gemini IV*, 1971. Shaped canvas, acrylic, and rope, 82″ x 39″. Courtesy of Ankrum Gallery, Los Angeles.

BING DAVIS (b. 1937) produces designs based on swirling linear patterns, his bold calligraphic brushstrokes creating similarities between his technique and Action painting. Davis' *The Great American Hangup #3* [*Illus.* 166] is, like works by Gilliam and Over-

166 Bing Davis, *The Great American Hangup #3*. Mixed media. Courtesy of Contemporary Crafts, Los Angeles.

street, liberated from the confines of a wall surface; it reaches out to occupy much of the interior and floor space of the display area. The arrangement of the six unstretched canvases accented by two bags vigorously expresses the poetry of an untraditional reality, the artist having successfully infused the commonplace with new energy. He has offered the following analysis of his work:

> In my work I am concerned with taking a given medium and making a personal statement based on my perception, observations, and response to my environment. I feel that my art should be a natural extension of my existence, bringing to fruition personal images, symbols, and forms that most accurately express my perception of life. [Personal communication with the author.]

MIXED-MEDIA ASSEMBLAGES

Assemblage is the art of combining varied materials to form an artistically interesting construction. When viewed individually, the components of a successful assemblage are often aesthetically insignificant. Much of the meaning and impact of an assemblage depends on the artist's ability to orchestrate such materials into a creative whole. This challenge has become a popular one among Black artists, and "66 Signs of Neon," an exhibition of works fashioned from the debris of the 1965 Watts revolution, is considered one of the most important shows to date by a group of "constructivists." Made into a traveling show, this unusual exhibition had great impact on Black artists and Black communities in many parts of the United States.

NOAH PURIFOY (b. 1917), one of the participants in "66 Signs of Neon," gives the following account of the origins of the work he contributed to the exhibition:

> While the debris was still smoldering, we ventured into the rubble like other junkers of the community, digging and searching, but unlike others, obsessed without quite knowing why.
>
> By September, working during lunchtime and after teaching hours, we had collected three tons of charred wood and fire-molded debris. Despite the involvement of running an art school, we gave much thought to the oddity of our found things. Often the smell of the debris, as our work brought us into the vicinity of the storage area, turned our thoughts to what were and were not tragic times in Watts, and to what to do with the junk we had collected. [Personal communication with the author.]

169

167 Noah Purifoy, *Sir Watts*,
1966. Found objects (wood, metal,
glass, etc.), 24″ x 20″ x 6″.
Courtesy of the artist.

168 Noah Purifoy,
untitled construction, 1970.
Copper, brass, sheet steel, and tin,
88″ x 55″. Courtesy of the artist.

Sir Watts [*Illus.* 167] illustrates Purifoy's use of these found objects. The sculptural form, although intended to be seen from all sides, depends principally on a frontal view for its impact. The "knight," constructed of wood, metal, glass, an old purse, discarded drawers, and a multiplicity of safety pins, commemorates the struggles of a people in battle.

Another work Purifoy fashioned from the debris of Watts is an untitled combination of copper, brass, sheet steel, and tin affixed to a base of wood [*Illus.* 168]. The work displays subtle textural and relief qualities produced by the overlapping of rectilinear metal shapes. A large indented rectangular area at the top of the form is filled with bullet cartridges placed in a highly repetitive and emotional relief pattern.

MARIE JOHNSON (b. 1920) makes painted constructions that are striking in their form, color, and texture. Her cut-out figures are often portraits of people she has known. Two-dimensional in ap-

170

pearance, they consist of a variety of materials but rely most heavily on old wood and clothing. *Papa, The Reverend* [*Illus.* 169], for example, is composed of a weathered wood that contributes to the representation of age and endurance. The detailed features of the figure are handled in relief, which increases the lifelike quality of the characterization.

EDWARD BURAL (b. 1937) creates assemblages from an unusual assortment of materials. His *Stuka Ju 87* [*Illus.* 170], for example, is a combination of sheet metal, paint, valves, decals, and nails. The presence of both organic and mechanical references in the assemblage gives the impression of opposite forces in competition with each other. The stencils and cross at the base of the construction lead the viewer to believe that this could be a mass-produced object of destruction.

BETYE SAAR (b. 1926) grew up in Watts near the famous Watts (or Simon Rodia) Towers, whose construction she had watched from a distance. Although she first saw their majestic quality close-up after she reached adulthood, the impact of the towers upon her work is

169 Marie Johnson, *Papa, the Reverend*, 1968. Mixed media, 36″ x 24″. Courtesy of Contemporary Crafts, Los Angeles.

170 Edward Bural, *Stuka Ju 87*. Assemblage, 14″ x 11½″. Betty and Monte Factor Family Collection. (Photograph by Richard Fish, Los Angeles).

171

171 Betye Saar, *Eshu (The Trickster)* (detail),
1971. Leather, straw, shells,
cloth, wood, and feathers, 42″ x 27″.
Collection of Alvin P. Johnson,
Charlottesville, Virginia.

172 Betye Saar, *Nine Mojo Secrets*,
1971. Fiber, seeds, and beads,
49¾″ x 23½″ x 1¾″. Collection of
Olga James Adderley, Los Angeles.

evident, and she feels that her memory of their construction con-
tributed measurably to her artistic expression. The towering spirals,
created from such castoff items as broken glass and bottle tops, in
addition to steel and cement, apparently made a lasting impression
on Saar's artistic imagery. The occult, astrology, and social and po-
litical concerns have been among the other contributors to her
mature style.

Saar's artistic production exhibits gradual changes in subject
matter and execution. From prints on the occult she has moved to
works expressive of her African ancestry, and her compositions have
become more three dimensional. Boxes and constructions of social
or historical significance are now her major interest. With *Eshu*
[*Illus.* 171], for example, Saar reaches back into African tradition
for Black-American roots buried in centuries of separation. Con-
structed of leather, wood, straw, shells, cloth, and feathers, the
composition reflects the earth tones prevalent in traditional African
sculpture.

Saar's *Nine Mojo Secrets* [*Illus.* 172], which includes references
to astrology and voodoo, is said by the artist to be a result of her
concern with the mysteries of life embodied in "the secrets of
Africa, Oceania; the limbo of before birth and after death." The
work's astrological symbols—moons and stars—combined with the
mystic eye and other symbols of the cosmos form a rhythmic

173 Betye Saar,
The Liberation of Aunt Jemima,
1972. Mixed media, 11¾" x 8" x 2¾".
University Art Museum, Berkeley
(purchased with the aid of funds
from the National Endowment
for the Arts; selected by the
Committee for the Acquisition
of Afro-American Art).
(Photograph by Colin McRae.)

pattern enframed by the edges of the windowpanes. The central section of the work reveals a photographic depiction of Africans in ceremony. Below the window frame is a "skirt" made of fibers, seeds, and beads. The solid form of the window and the fibrous skirt create a combination that resembles a ceremonial mask.

In the late 1960s Saar began to collect and use as art materials certain derogatory commercial images of Blacks. Hoping to expose the racism they conveyed, she incorporated into her work the emblems of such products as Darkie toothpaste, Black Crow licorice, and Old Black Joe butter beans. In her *Liberation of Aunt Jemima* [*Illus.* 173] the well-known symbol for a line of food products is transformed into a gun-carrying warrior for Black liberation. A collage of pancake-flour labels acts as a background for the imposing figure. Although the lower portion of the doll's body carries a sign of her former role, the viewer senses that the real Aunt Jemima will soon be free.

Saar dissolves distinctions between painting and sculpture and compels us to experience her multidimensional works from an un-

173

174 Ron Griffin, *Bound Figure*,
1971. Mixed media, 76″ x 48″ x 16″.
Courtesy of Contemporary
Crafts, Los Angeles.

usual perspective. In such attacks on traditional Western attitudes
and images, she uses her mojo consciousness to aid in the liberation
of all Aunt Jemimas and Uncle Toms.

RON GRIFFIN (b. 1938) devises both two- and three-dimensional con-
structions. His *Bound Figure* [*Illus.* 174] is a combination of shaped
canvas and sculpture; the canvas, open in the center, reveals a
human form imprisoned in an irregularly constructed compart-
ment. The figure is covered with a transparent black plastic film and
a web of white string. The use of the wrappings imparts a feeling of
terror and gives anonymity to the figure.

174

John Outterbridge (b. 1933) is an enthusiastic exponent of junk art:

> A lot of times I go to junkyards because junkyards are groovy places. Junk-
> yards illustrate to me much of what the society that we live in really is all
> about—discarded materials. Materials that have related to human experi-
> ence in a very profound way. You go into a junkyard and you can pull
> these things out. You try and give them life again. This is realness, this
> is truthfulness to me from a people point of view, from a folky point of
> view. I see much of my own existence as isolation, as sort of on the out-
> side of the real perimeter of life, within the society we know. This is why
> my work involves so many materials and maybe many moods. [Personal
> communication with the author.]

Outterbridge's *Shoeshine Box* [*Illus.* 175] is a personal icon of his "past remembrances." This sculptural assemblage directly involves the viewer on an intimate level through the use of a highly polished reflective surface. Taking advantage of the stains often found on recycled surfaces, the piece exhibits interesting chromatic and tex-tural qualities; and the subtle relief of its etched and engraved end

175 John Outterbridge,
Shoeshine Box, 1968.
Chrome, steel, and fiber,
3½′ x 3′ x 1½′.
Courtesy of Contemporary
Crafts, Los Angeles.

175

panel provides a contrast to the smooth, polished metal. Contrasting with the metallic casing are an organic-fiber "shoeshine brush" and the interior wood support of the sculpture.

Other examples of Outterbridge's interest in diverse materials include his *Rag Man* series, a group of stuffed-canvas constructions. One of these, *Case in Point* [*Illus.* 176], combines leather belts and stuffed-canvas packages as a monument to the common people.

IBIBIO FUNDI (b. 1929) builds provocative constructions using wooden blocks and industrial forms. In viewing Fundi's *Wooden Sketch for a Possible Non-Functioning Machine* [*Illus.* 177], one recognizes bits of familiar objects—a chair and table legs, wooden disks, and laminated shapes. The interplay of thick and thin, curvilinear and angular, open and congested spaces gives heightened interest to the piece. Composed of many dissimilar shapes, the construction achieves its unity through basic color application.

JOHN STEVENS (b. 1935), like Ibibio Fundi, creates wood constructions; but his are somewhat different in subject matter and style. Stevens' *Silver Saddle* [*Illus.* 178] is an additive sculpture that com-

176 John Outterbridge,
Case in Point, 1970.
Courtesy of the artist.

177 Ibibio Fundi,
*Wooden Sketch for a Possible
Non-Functioning Machine*, 1968.
Wooden construction and paint,
24″ high. Courtesy of
Contemporary Crafts, Los Angeles.
(Photograph by Jonathan Eubanks,
Oakland, California.)

178 John Stevens, *Silver Saddle*,
1963. Tar, wood, metal, and enamel,
36″ x 48″. Courtesy of the artist.

bines massive wooden components with metal, tar, and enamel. The basic structural simplicity of *Silver Saddle* suggests that it has much in common with Minimal, or Primary, sculpture, despite its expressionistic handling of paint and surface texture.

SCULPTURE

ADDITIVE OR DIRECT SCULPTURE

One of the most frequently seen examples of additive or direct sculpture is the construction. Constructions (or assemblages) can be made of one or more of a variety of materials, some of the most popular being wood, metal, fiber, and glass. The United States, a highly industrialized country, provides an abundance of discarded objects for the constructivist; and Black artists, because they generally cannot afford the traditional materials of sculpture, have been particularly apt to work with these less expensive, more readily available resources. Direct metal sculpture, a branch of assemblage, has become of particular importance to Black artists. Metal has long been used as a medium by sculptors in Ghana, Nigeria, Dahomey, and other areas of West Africa; and, like their African ancestors, many modern Black-American artists have found metals to be expressive and aesthetically pleasing materials.

JUAN LOGAN (b. 1946) explores linear space in sculpture. His *Woman Reaching Out* [*Illus*. 179] suggests a three-dimensional drawing in which contours serve to define voids, transforming them into meaningful shapes. A dramatic sweeping curve, the principal suggestion of movement in this composition, is supported by a strong vertical whose triangular tip advances the concept of motion; the movements of the lines of the sculpture are swift and direct. The effective combination of a never-ending circular motion and a secondary vertical one stimulates contrasting energy forces, all of which are stabilized by the voids and series of triangular shapes located at the base of the sculpture. In *Growth Process* [*Illus*. 180] Logan uses repetitive curvilinear steel forms to explore aspects of growth. His series of homologous organic shapes transforms the hard steel into an assemblage of lyrical arrangements that interplay like a living organism operating a heavily vibrating machine. Logan's art

179 Juan Logan, *Woman Reaching Out*, 1971. Welded Steel, 47″ high. Collection of Samella Lewis.

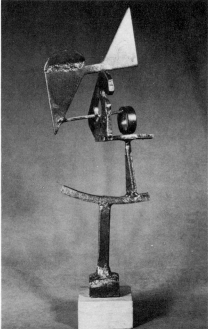

180　Juan Logan, *Growth Process*, 1973.
Painted galvanized steel, 53″ x 53″ x 84″.
Courtesy of the artist.

181　John Riddle, *Construction*,
1972. Welded steel, 21″ high.
Collection of Samella Lewis.

gives tangible qualities to abstract ideas and is based on a non-figurative style in which the major concerns are the formal organization of plane and the expression of volume by means of modern industrial material.

JOHN RIDDLE (b. 1933), a student of plant forms, produces metallic art that conveys a feeling of life and growth; in so doing, he extracts humanistic values from materials designed to serve a mechanized world. Although many of his geometrically structured sculptures are inspired by social problems and thus often carry social messages, Riddle keeps the viewer of his sculptures conscious of their organization and complementary forms. *Construction* [*Illus.* 181], a reflection of Riddle's growing interest in African art, demonstrates his capacity to create a work in which form subtly takes precedence over subject matter.

MEL EDWARDS (b. 1937), a graduate of the University of Southern California, uses straight-edged triangular and rectilinear forms in his

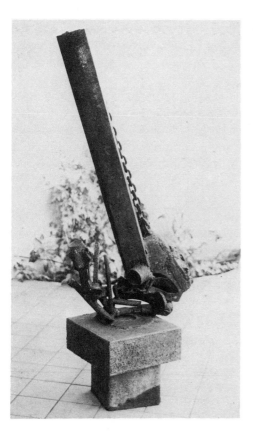

182 Mel Edwards, *A Necessary Angle*, 1965. Steel, 53″ x 19″. Collection of Dr. and Mrs. Leon O. Banks, Los Angeles. (Photograph by Adam Avila.)

fabricated sculptures. In *A Necessary Angle* [*Illus*. 182], for example, there is a contrast between the geometric structures of the lower portion of the sculpture and the organic shapes of the upper section of the composition. These contrasting areas create a feeling of tension that is further emphasized by the sharp points of the hook that hangs from the central section of the triangular void.

RICHARD HUNT (b. 1935), one of America's leading direct-metal sculptors, acknowledges the strong influence exerted on his work by Julio González (1879–1942), the Spanish artist who, working in Paris in the 1930s, was among the first to devise welded-iron sculptures. Hunt's own ability with the welding torch allows him to transform metal into clear, detailed, and highly plastic constructions which, though primarily abstract, often include human, animal, and plantlike shapes. The organic element in Hunt's sculptures is demonstrated by *Illustration* 183, in which sinuously twisted branches and tendrils combine to add a sense of continuity. In recent years Hunt has also been involved in the casting of large

183 Richard Hunt, untitled construction, 1964. Steel, 32″ x 12″ x 8″. Collection of Dr. and Mrs. Leon O. Banks, Los Angeles. (Photograph by Adam Avila.)

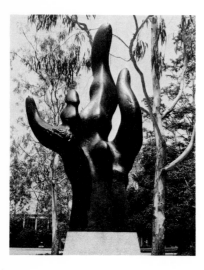

184 Richard Hunt, *Why?*,
1974. Bronze, 7½' high.

figures. Castings of *Why?* [Illus. 184], his first large-scale bronze sculpture, have been on display at the University of Chicago and at the University of California, Los Angeles.

ALLIE ANDERSON (b. 1921), a constructivist who uses car bumpers as his principal medium, organizes and welds these castoffs into compositions whose patterns of light and shadow suggest gentle movement. Indeed, an Anderson construction often has a sensuous quality, for a feeling of embrace is provided by the curving automotive parts that form it, as in *Illustration* 185.

ED LOVE (b. 1936) makes sculptures of steel that strongly recall powerful African deities. In *Osiris* [Illus. 186], from his *Monster Series #3*, Love combines steel shapes and manufactured automobiles to create a figure that towers over the viewer and projects the strength and power of the Egyptian deity who rules the dead. In speaking of his guardians and "good" monsters, Love has said:

> It is my intention to be able to confirm: to work towards an iconography that reflects the memories and prophecies of spirits, known and unknown. And in so doing, cause that energy, ancient and precognitive, to be released. This energy source, this repository of life forces, is what I wish to confirm. [Quoted in the catalog of an exhibition, August 1973, at the Corcoran Gallery, Washington, D.C.]

185 Allie Anderson,
Specter of River Rouge, 1969.
Welded steel, 76″ x 25″.
Courtesy of the artist.

186 Ed Love,
Osiris, 1972.
Steel, 12′ high.
Courtesy of the artist.

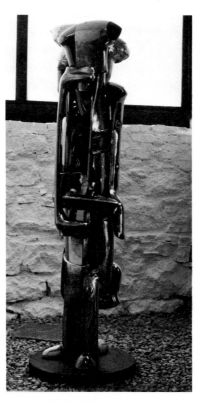

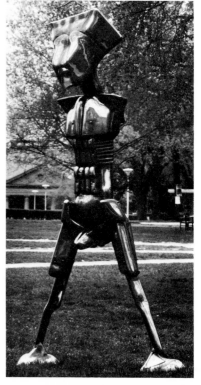

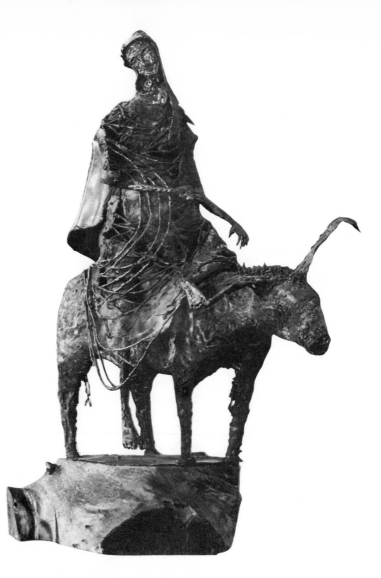

187 P'lla Mills, *Star of Bethlehem*, 1961. Welded metal, 30″ x 12″ x 20″. Collection of the Golden State Mutual Life Insurance Co.

P'LLA MILLS (1918–64) devised constructions that include welding rods and, in some cases, sheet metal and that involve a distinctive buildup of form. The metal in her compositions has been cut, forged, and combined by use of an oxyacetylene torch, and the alternate heating and cooling of the metal is responsible for its rough texture or molded effect. In *Star of Bethlehem* [*Illus.* 187] Mills exploits semiaccidental effects to achieve a fascinating representation of Mary seated upon a donkey. Rods are curved and joined to suggest the complexity of a tunic that drapes but fails to contain the human form; the rough surfaces suggesting the bulk of the animal are arranged with greater simplicity. Its juxtaposition of linear and bulky textured forms helps to make the composition a visually rich and expressive statement.

181

INDIRECT SCULPTURE

Sculptural compositions devised in a highly plastic medium, such as clay or wax, and then cast in metal, are considered *indirect sculpture*. Bronze, aluminum, copper, and lead are among those metals most often used in sculptural casting, a process that has existed for many hundreds of years and one that has been used by diverse peoples in Africa, Asia, and Europe.

Though an expensive material, bronze is probably the most popular of the metals; and those artists able to pay for it are usually satisfied with the warmth and character it gives their works. An alloy of copper and other metals, bronze develops a patina as it ages, and its surface texture can be changed through burnishing or through the use of chemicals.

DOYLE FOREMAN (b. 1933) is one of the few Black artists who create almost exculsively in bronze. His *Corner* [*Illus*. 188], a work with African references, was translated from wax into the more permanent material. And even in bronze the opposition of the high and low relief designs decorating the surface form a complex and uncommon relationship.

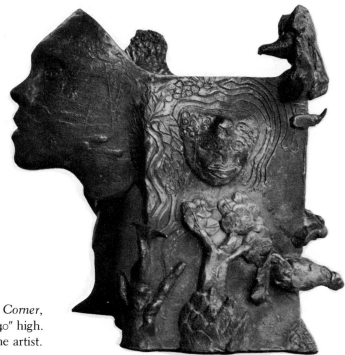

188 Doyle Foreman, *Corner*,
1968. Bronze, 40″ high.
Courtesy of the artist.

BARBARA CHASE-RIBOUD (b. 1936), like many Black American artists throughout history, is perhaps better known in Europe than in the United States. Supported by an extensive academic background, she makes skillful use of a combination of materials and techniques. Chase-Riboud's sculptures demonstrate the traditional lost-wax technique and include braided-, knotted-, and wrapped-fiber areas that recall weaving and the fabric arts. Her reasons for combining "hard" and "soft" materials are both technical and aesthetic. The braided and knotted "skirts" on some of her works serve as a mask, or costume, that covers the supporting member. The flaccid, visceral forms of the cords provide a contrast to the obviously heavy and unyielding bronze. These supporting cords also act as a transition between the sculpture and the floor, allowing the viewer's eye to travel along "lines" into the complexities of the form.

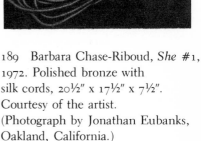

Such long, wrapped cords emanate, for example, from the triangular form in *She* #1 [*Illus.* 189]. The fabric elements tie the tangled mass of twisted fiber on the floor to the metal form on the sculpture stand. The sculpture is a beautiful example of contrasts—in materials and in the projection of ideas.

189 Barbara Chase-Riboud, *She* #1, 1972. Polished bronze with silk cords, 20½″ x 17½″ x 7½″. Courtesy of the artist. (Photograph by Jonathan Eubanks, Oakland, California.)

SUBTRACTIVE SCULPTURE

The carver, or *subtractive sculptor*, begins with a block of material and cuts or grinds away areas until the desired form is realized. The properties of the material—its grain and density, for example—are significant in determining the nature of the forms that emerge. Along with careful planning, the subtractive method of sculpture requires a thorough knowledge of the physical properties of sculptural materials. Stone and wood are the two media used most frequently in this process.

MARGARET BURROUGHS (b. 1917) is a subtractive sculptor who often makes use of marble, as in *Head* [*Illus.* 190], a portrait of a deindividualized and timeless character. Through her planal approach to the work, the artist shows her deep understanding of the medium.

190 Margaret Burroughs, *Head*, 1965. Marble, 12″ x 8″. Courtesy of the Artist.

191 John Payne, *Horney Box*, 1969. Wood, 24″ x 30″.
Courtesy of the artist.

Active both in sculpture and in printmaking, Burroughs is the
director of Chicago's DuSable Museum of Afro-American Art.

JOHN PAYNE (b. 1929) builds his sculptural expressions through a
combination of additive and subtractive methods. His *Horney Box*
[*Illus.* 191] is composed of blocks of thin wooden boards whose
varied grain has been made more interesting through lamination.

PLASTIC SCULPTURE

Plastic, a product of modern technology, is a medium Black art-
ists are just beginning to utilize on a wide scale. Since its use in art
has no historical precedent to serve as a guide, plastic offers the
artist an opportunity to express ideas and feelings in innovative
ways. The many types of plastics now available make them suitable
for almost any artist, whether he or she works in the direct, indirect,
or subtractive method.

FRED EVERSLEY (b. 1941) creates his sculptures largely from cast
resin, a medium that makes possible many different effects, ranging

192 Fred Eversley, *Oblique Prism II*, 1969.
Polyester, 6″ x 4½″ x 5½″. Collection of
Dr. and Mrs. Leon O. Banks, Los Angeles.

from opacity to complete transparency. Eversley casts resin, a
technically demanding material, into large cylinders, then, through
cutting and polishing, alters their form [*Illus.* 192]. Care must be
taken in handling the sculpture, since the stresses created by varia-
tions in its thickness can result in the shattering of a work before
it is annealed. The subtle, transparent colors Eversley uses in a
work intensify as the body of the piece thickens.

LARRY URBINA (b. 1943) employs the additive method in working
with plexiglass, as in *Pink Fluorescent* [*Illus.* 193]. The cubic form
of this work is a simple one, but its diagonal interior planes capture
the viewer's interest. The color and spatial relationships between
planes vary with the viewing angle.

BEN HAZARD (b. 1940), like Urbina, works with sheet acrylic, but he
handles his forms in quite a different manner, assembling his
vacuum-formed plastic components in low relief. Hazard's *Modular
Series II* [*Illus.* 194], simple in form, is composed of several inter-
locking shapes. The highly reflective surface is made rich and

interesting through the refraction of light and the reflection of surrounding forms.

EARL HOOKS (b. 1927) illustrates still another way of working with plastic, the subtractive method. His *Female Torso No. 2* [*Illus.* 195] is carved from polyurethane foam and covered with pigmented resin. Reflecting light in much the same way as a pearl, this curving form is the essence of sensuality.

MAHLER RYDER (b. 1937) is a sculptor who makes extensive use of modern technology to produce forms and ideas expressive of past and present generations. Working principally in fiberglass, he shapes it into geometric and, at times, curving pneumatic forms and often combines it with wood and string to create ritualistic icons. *Taft* [*Illus.* 196], a recent Ryder creation, is a striking arrangement of geometric forms accentuated by colored strings, which add to the feeling of naturalism the sculpture provides, despite its manufactured materials.

CRAFTS

The artificial division between crafts and the so-called fine arts is a relatively recent Western device. Today this division has become more difficult to justify or explain because much of contemporary art is not only aesthetic but utilitarian.

The craft items of the colonial period in America were generally useful, handmade articles; some were also unique and beautiful. Most artisans, however, exhibited a relative sameness in their work and, with few exceptions, produced forms that carefully repeated traditional European design principles. This repetition fostered a high degree of technical skill but little innovative design.

The history of Black involvement in crafts is long and varied. In seventeenth-century Africa the crafts of weaving and woodcarving were usually practiced by males, whereas the making of pottery was undertaken principally by females; this was the reverse of the European pattern. Because they were forced to adhere to colonial labor patterns, Africans brought to America had to abandon their customary division of these labors: the men became potters, bringing to the work their design experience in weaving and woodcarving, and the women switched to weaving, bringing to it their knowledge of ceramic design. Examples of the resultant influence of wood-

195 Earl Hooks, *Female Torso No. 2*,
1968. Polyurethane and epoxy, 48″ x 20″.
Courtesy of the artist. (Photograph by
Gunter's Studio, Nashville, Tennessee.)

196 Mahler Ryder,
Taft, 1971–72.
Fiberglass on wood and plastic,
6′ x 4′. Courtesy of the artist.

carving on pottery can be seen in the "monkey pots," or grotesque
jugs, produced by slave artisans for use by field hands (see *Illus.* 2).

In the nineteenth century the effects of the Industrial Revolution
forced many American craftsmen to approach their craft as a pas-
time rather than as a major source of income. The weaving of
cloth, for example, once a "cottage industry" in the United States,
became primarily a factory-based operation after 1840 due to the
introduction of the power loom. Individual craftsmen who had pre-
viously competed with each other for trade now had an additional
competitor in the machine, one that could reproduce a design a
thousand times without perceptible variations. Unable to compete
successfully with the more profitable and more productive machine,
many craftsmen were forced to take a greater interest in the creative
application of their skills than in a "utilitarian" one. They began to
produce creative, one-of-a-kind items, for individual clients or for
sale in shops whose patrons demanded something unique and dis-

187

197 Sargent Claude Johnson, *Tea Pot*, 1941. Glazed earthenware, 4¾" x 8" x 3½". Collection of The Oakland Museum (gift of Mrs. Dorothy Collins Gomez).

played their possessions as symbols of affluence. But with increased machine production, many craft items became common, their possession indicating little about class status. Technology had reduced their social and economic significance by lowering production costs and making more of them available at lower prices.

The machine was also partially responsible for the loss of the few "African memories" that existed in early American crafts. Though these Africanisms survived until the late nineteenth century in remote areas of the New England states or among those Americans too poor to afford the products of the industrial age, they gradually disappeared as improved transportation routes created a large migrant population and as a culture based on standardized material goods developed.

SARGENT JOHNSON, well-known as a sculptor (see page 78), was also accomplished in ceramics and enamels, areas in which he was strongly influenced by the works of Mexican, pre-Columbian, and African artists. Johnson made numerous trips to Mexico between 1945 and 1965 and was particularly inspired by the archaeological finds at Monte Albán and Mitla. A ceramic teapot by Johnson now in the Oakland Museum collection [*Illus.* 197] shows the influence of folk art on his work; the lithe, feline handle, for example, has affinities with both African and Mexican motifs. Oval-shaped, the teapot is made of a low-fire earthenware and is glazed brown. Its

slow, gentle curve, echoed by the jaguarlike handle, shows the artist's concern with elongated form as a means of suggesting movement.

The enameled metalworks created by Sargent Johnson demonstrate a primarily industrial technique. Indeed, because his friendship with one of the firm's owners allowed Johnson to experiment in its workshop, most of these pieces were made on the premises of the Paine-Mahoney Company, a manufacturer of industrial ceramic products in San Francisco. Thus provided with the space and equipment necessary for such work, Johnson produced, between the years 1947 and 1967, over one hundred enameled compositions.

ALLEN FANNIN (b. 1939) hand-spins the yarns he uses to make his expressive weavings. Unlike much of the work made with handspun yarns, his pieces are usually quite fine, their texture showing excellent control of the processes of yarn preparation. Fannin suggests that every handweaver "must ultimately spin in order to have complete design control over his product."

Many of Fanin's weavings are interesting conjunctions of handspun wool, flax, rayon, and monofilament line. Often three-dimensional, or exhibiting depth by means of overlapping planes, his works contrast areas of uncovered warp with areas of solid weaving. Some of them also juxtapose the controlled irregularity of handmade yarn and the glossy, shimmering regularity of monofilament. The woven images created by Fannin have much in common with Minimal painting and sculpture in that they rely on simplicity of shape and surface texture rather than on chromatic complexity [*Illus.* 198].

Although he was among the first to create sculptural woven forms, his work never gained acceptance within the contemporary craft community, nor, more important, among the general public. Because of this, and because of his dedication to handloom weaving as an economically viable twentieth-century trade, Fannin ceased to pursue weaving strictly as an art form. Instead, beginning in 1971, he expanded into what had once accounted for only a small portion of his total output: the production of handspun, handwoven specialities for direct retail sale. Since that time, Fannin has become one of the foremost authorities on small-scale handloom production, from both a technical viewpoint and an economical one.

MAREN HASSINGER (b. 1947) does not consider her works either as fibrous structures or as weavings, although they exhibit techniques

198 Allen Fannin,
untitled construction, 1969.
Nylon, linen, and plexiglass,
7' x 3'. Collection of
Mr. and Mrs. Michael Glaser,
Los Angeles.

199 Maren Hassinger, *Arch*, 1972. Steel cable, 5′ x 8′.
Courtesy of the artist.

common to both. Her "woven sculptures," as she calls them, are creations of line rather than mass, and, as such, have close affinities with drawings: "The cable pieces are seen as primarily linear against white. The clarity, or purity, of these lines and implied volumes is apparent. Relaxed loops and easy curves are the tendency, nearly the rule, with these pieces" (personal communication with the author).

Illustrative of Hassinger's work is *Arch* [*Illus*. 199], a piece that exhibits the sort of gentle, rhythmic curves that result when wire cables are arranged so as to be self-supporting. Woven together, the frayed ends of the "strong" and gently curving cables create a visual tension and complexity.

NAPOLEON JONES-HENDERSON (b. 1943) is a member of AfriCOBRA (African Commune of Bad Relevant Artists), a Chicago-born organization founded in 1968 and dedicated to enhancing the Black aesthetic in the visual arts. While other members of the organization concentrate principally on paintings and prints, Jones-Henderson uses rope, jute, fiber, and other organic materials to create wall hangings and floor pieces that both suggest the African past and contribute in a positive way to the present.

200 Napoleon Jones-Henderson, *Wholy People*, 1972. Wood and metallic gold yarns, 8' x 5'. Courtesy of the artist.

In Jones–Henderson's *Wholy People* [*Illus.* 200] woven wool and metallic gold yarns form a colorful geometric textile. The use of graffiti is typical of AfriCOBRA, and the work's vertical shield in the colors of the Black liberation movement adds to the strength of the message.

LEO TWIGGS (b. 1934) views his batik not as textile art but as paintings: "I paint with dyes and use wax on fabric instead of . . . pigment on canvas" (quoted in Samella S. Lewis and Ruth G. Waddy, *Black Artists on Art*, vol. II [Los Angeles: Contemporary Crafts Publishers, 1971], p. 88). His works make effective use of the colorful, crackled textures achieved when dye is applied to a layer of cold wax bent so as to expose areas of the fabric beneath it. The irregular lines produced by Twiggs' brush or other painting tool clearly show the fluidity and sponteneity of his technique. Occasional accidental drips of wax are allowed to remain on the surface of the fabric in order to add to its texture.

Commemoration Series #9 [*Illus.* 201], through its strong yet sensitive treatment of forms, exhibits Twiggs' fine control of his medium. The overlays used to produce this work give it much the same

feeling as a watercolor, but with a more subtle color range. The X formed by the design of the Confederate flag, plus the human "trinity" enclosed in a simple oval frame, are grouped with graphic simplicity and effectiveness. The juxtaposition of images within the oval framework suggests a commemoration of the past.

Stained-glass murals represent an art form that is frequently but seldom effectively revived. The "light murals" of DOUGLAS PHILLIPS (b. 1922) provide exception to this rule largely because they are unencumbered by the medieval methods and forms common to

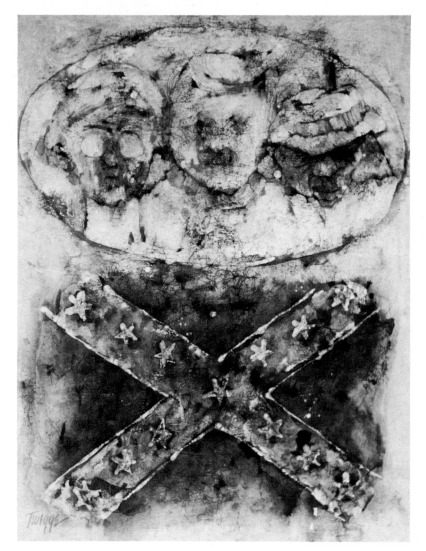

201 Leo Twiggs,
Commemoration Series #9, 1971.
Batik, 38″ x 32″.
Courtesy of the artist.

202 Douglas Phillips, window for the First Congregational Church, Painesville, Ohio, 1960. Stained glass. Courtesy of the artist.

most revivals of this pre-Renaissance art. Phillips creates stained-glass windows that are compatible with the simplicity of contemporary architecture. His windows for the First Congregational Church in Painesville, Ohio [*Illus.* 202], are excellent examples of his style. The windows are devoid of the traditional spiritual representations and, through the sweeping upward movement of their leaded dividers, suggest humanity's striving for greater worlds. Adding to the overtone of transcendence, the rich blues and greens, vibrant purples, yellows, and reds of the lower portions of the windows give way to lighter, more aerial shades in their upper sections.

DOYLE LANE (b. 1925) is an outstanding ceramist whose work ranges from utilitarian earthenware and stoneware to "clay paintings" (clay pieces in which the glazes have been applied like oils) and murals. Usually classical and simple, his pottery achieves a sense of intricacy through its special glaze effects; the surface of Lane's pottery often exhibits a visual quality that all but forces one to handle the work. His glazes are sometimes matte and low-key, and other times brilliant, intense, and glowing with color.

193

203 Doyle Lane, untitled construction, 1975. Clay, 21″ x 21″. Courtesy of the artist.

204 Bill Maxwell, *African Past*, 1968. Stoneware, 24″ high. Courtesy of Contemporary Crafts, Los Angeles.

The clay paintings by Lane represent a variety of shapes and styles and frequently are given rich textural treatments through unusual glaze applications [*Illus.* 203].

BILL MAXWELL (b. 1934) has experimented with most of the textures possible for clay pottery. Inventive and executed with a raw directness, his forms include many organic icons that recall the Black American's African past [*Illus.* 204]. Most of Maxwell's pieces are hand-built, but some are combinations of hand-built and wheel-thrown sections.

His ceramic sculpture *Jomo #1* [*Illus.* 205] is a product of Maxwell's slab construction method: clay is rolled on textured surfaces, draped, and formed into slabs that, after being paddled into shape, are often decorated with stamping and iron oxide to give them more exciting surfaces. Composed of several clay pieces, *Jomo #1*, a "cruciform sculpture," gets much of its impact from the placement of heavily textured areas alongside smooth projecting planes. The work conveys the presence of a Black ancestral figure without resorting to a duplication of African forms.

Maxwell's *Double-Spouted Weed Pot* [*Illus.* 206], also a slab construction, reminds one of a monumental edifice covered with sandy debris. This unglazed clay form takes full advantage of the subtle light-reflecting properties of its sand-flecked surface. The projecting double necks are integrated by a horizontal clay slab, which also creates visual interest and breaks the plane of the body of the vessel.

CAMILLE BILLOPS (b. 1934) produces imposing combinations of wheel-thrown and hand-built forms. Her terra cotta *Three-Headed Fountain* [*Illus.* 207], for example, consists of several wheel-thrown forms that have been joined to several hand-built ones by means of fine, incised lines and painted decorations. The three heads seem both human and animal, and the hornlike projections of their faces create visual interest and complexity that contrast with the long, unbroken curve of the central form.

205 Bill Maxwell, *Jomo #1*, 1968. Earthenware, 14″ high. Courtesy of Contemporary Crafts, Los Angeles.

206 Bill Maxwell, *Double-Spouted Weed Pot*, 1970. Stoneware, 7″ high. Courtesy of Contemporary Crafts, Los Angeles.

207 Camille Billops, *Three-Headed Fountain*, 1969. Ceramic, 28″ high. Courtesy of the artist.

195

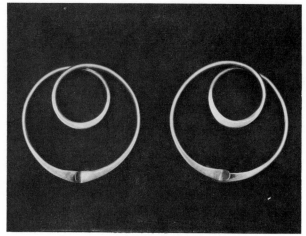

208 Art Smith, earrings,
1968. Silver, 3″ wide.
From the collection of Val Spaulding.

209 Art Smith, earrings,
1968. Silver, 3″ wide.
From the collection of Val Spaulding.

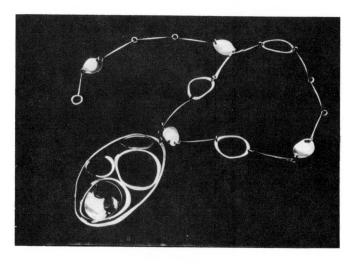

210 Bob Jefferson, pendant, 1968.
Gold. Courtesy of Contemporary
Crafts, Los Angeles.

ART SMITH (b. 1923) was one of Greenwich Village's first creative jewelry makers. His work often combines sterling silver and semiprecious stones and, over the last four decades, has become progressively more delicate. Many of Smith's recent necklaces, for example, include fine wires that coil around the neck or hang like miniature mobiles from a circular support. This simplicity also extends to

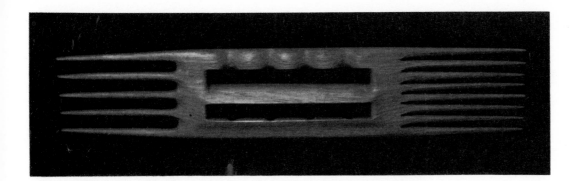

211 Manuel Gomez, *Wooden Natural Comb*, 1971. Rosewood, 11″ x
3½″. Courtesy of the artist.

Smith's other jewelry forms. His rings have simple cabochon-cut
stones and pearls as their dominant design element, and the ear-
rings that he creates are simple and unobtrusive [*Ills.* 208, 209].

BOB JEFFERSON (b. 1943) uses a rather personalized technique in
creating jewelry. Delicate explorations of space, many of his jewelry
forms show the influence of his training in furniture design and
welded-steel sculpture. One such piece, the pendant in *Illustration*
210, consists of a single-gauge wire that has been cut and soldered
to create appealing linear relationships.

In Western cultures, jewelry is usually thought to involve "pre-
cious" or "semiprecious" materials; elsewhere in the world rarity
does not play as great a role in determining highly valued objects of
personal adornment. The work of MANUEL GOMEZ (b. 1948) echoes
this regard for more commonplace materials. His pendants and
combs are made from pieces of wood that have interesting grain
patterns and coloration; their impact is provided by their subtle
coloring, finish, and design rather than by their qualities of light
reflection [*Illus.* 211].

JOANNA LEE (b. 1937) takes macramé beyond its traditional role as a
fabric-making technique into the realm of jewelry design. The neck-
piece by Lee in *Illustration* 212 makes effective use of a single type
of knot, varying it only in terms of direction. The shiny metallic
surface of the copper tubing acts as a contrast to the subtle sheen of
the fibers.

212 Joanna Lee,
macramé neck piece, 1972.
Courtesy of Contemporary
Crafts, Los Angeles.

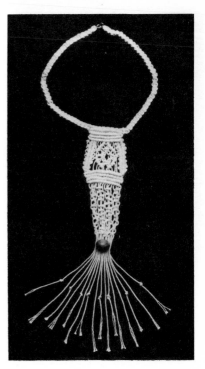

213 Evangeline Montgomery, *Ancestor Box I, Justice for Angela*, 1971. Bronze, 3″ x 4″ x 3″. Courtesy of the artist. (Photograph by Jonathan Eubanks, Oakland California.)

214 Evangeline Montgomery, pendant, 1970. Copper, silver, brass, enamel, 4″ x 3″. Courtesy of Contemporary Crafts, Los Angeles.

EVANGELINE MONTGOMERY (b. 1933) works primarily in metal and produces such items as lost-wax cast boxes and incense burners. A good example of her work is provided by *Ancestor Box I, Justice for Angela* [*Illus.* 213]. The piece is dominated by the Ashanti symbol for justice, which, in this reference to Angela Davis, represents the tie between contemporary Black Americans and their African past.

Montgomery is also an accomplished jeweler, and her jewelry forms exhibit the spontaneity and expressionistic textural properties of her boxes. Usually fusions of such metals as bronze, copper, gold, and silver that have been combined with uncut stones or rock crystals, Montgomery's "crusty" jewelry forms convey a sense of undulating movement and are often both sophisticated and evocative [*Illus.* 214].

MARGARET COLLINS (b. 1922) creates articles of personal adornment by combining ancient trade beads of African and European origin with decorative elements produced in contemporary Africa [*Ills.* 215, 216]. Such beads served originally as symbols in an extremely informative language, conveying place of origin, age group, marital status, and so on. Today purely decorative uses of them are becom-

215 Margaret Collins, necklace, 1973.
Antique glass beads ("trade" beads)
with contemporary accessories,
29″ strand. Courtesy of the artist.

216 Margaret Collins, necklace, 1973.
Antique glass beads ("trade" beads)
with contemporary accessories,
29″ strand. Courtesy of the artist.

ing increasingly common in urban communities in Africa as well as in those of the rest of the world. While one regrets the probable loss of the traditional language of the beads, it is a comfort to know that their aesthetic appeal endures.

DRAWING

One of the earliest forms of communication, drawing is held by many artists to be the most basic artistic expression and the one most useful for experimentation. Line, shape, texture, and value are among its major variables; color, since its use is infrequent, must be considered only a supportive element.

An absolute, clear distinction between painting and drawing is difficult to make; however, drawing is, in general, a more conventional graphic art, with a linear emphasis rather than a strong reliance on color modulation. For most purposes, the medium is the basis on which the two types of art are usually distinguished—charcoal, pastel, conté crayon, ink, and graphite being the characteristic media of drawing.

199

MARION SAMPLER (b. 1920) is an artist whose drawings make skillful use of line. *Chair* [*Illus*. 217], an ink drawing by Sampler, provides an example of his sensitive rendering of everyday objects. It also illustrates that, though ink is his principal medium, Sampler's works incorporate a great deal of control and value gradation.

ARTHUR MONROE (b. 1935) creates drawings that are expressionistic and full of spirit and vigor. Incorporating energetic, semiautomatic strokes, his style is indicative of gesture drawing and may be regarded as a blending of drawing and painting. In his *Self-Portrait* [*Illus*. 218], for example, the means used to apply the ink range from wash to dry brush, and the brushstrokes vary from long to short and from thick to thin. The figure Monroe presents is filled with restless energy, his clothing and hair depicted through a combination of splashes and turbulent strokes. An exciting graphic portrayal, this self-portrait gives the viewer significant insight into the personality of the artist.

217 Marion Sampler, *Chair*, 1969. Ink, 26″ x 20″. Collection of Dr. and Mrs. Leon O. Banks, Los Angeles.

218 Arthur Monroe, *Self-Portrait*, 1965. Ink wash. Courtesy of the artist.

JAMES LAWRENCE (b. 1947) produces drawings distinguished by their imaginative quality. In *Growth of a Child* [*Illus*. 219], for example, he combines visual realism with distortions of pictorial space. Increased interest in the figure of the child is achieved through the division of the composition into two rectangles. The upper rectangle is limited on two sides by broad coarse-textured bands; these form a "frame" that blends with the stark silhouette of the trees.

MARVIN HARDEN (b. 1935) creates intricate compositions that express a unique and personal iconography. An outstanding draftsman, he relates images of animal and plant life by combining visual symbols of contrasting dimensions. Harden's placement of precisely drawn cows or trees against a broad simplified expansive shape introduces concepts of photographic realism and clean simplicity [*Illus*. 220].

219 James Lawrence, *Growth of a Child*, 1970. Ballpoint pen, 24″ x 18″. Courtesy of the artist. (Photograph by Jonathan Eubanks, Oakland, California.)

220 Marvin Harden, *ritual of consumption, illusion, share and salient flaw*, 1971. Pencil on paper, 30″ x 22¼″. Collection of Clark Polak.

RAYMOND LARK (b. 1939), a contemporary Realist, gives his subjects pictorial conventional form but personalizes his images through an abundance of detail and surface texture. Displaying a stylistic kinship with art of the past, Lark's drawings are intense renderings of subjects with strong emotional impact:

I try to throw myself into the complete feeling of the subject that I am recording. I will only work from the surroundings and people that stimulate me. People often ask me why I always paint and draw old people, poverty, and depressing subjects; they would buy some of my work if I would draw or paint them, this, or the other. I am not concerned with pleasing the public with my subject matter. If I do not get that certain emotional feeling and dynamic charge [from something], I will not attempt to record it. I may get turned on by an old pair of shoes, a scrub bucket and a mop, a poor old lady, fire, a child of poverty, color in a dress, or the structure of a body. I can see beauty in earthy subject matter that most people feel is very insignificant. I usually elevate to full status subject matter that nobody seems to care about. [Personal communication with the author.]

Lark's figurative compositions are enriched with line patterns that act as nets covering the surfaces of his works. In *Bernard's Daddy* [*Illus.* 221] the surface planes are animated by the inclusion of a web

221 Raymond Lark, *Bernard's Daddy*, 1971. Pencil drawing, 23¾" x 32½". Courtesy of the artist.

222 Murry DePillars,
The People of the Sun, 1972.
Pen, ink, and pencil, 40″ x 32″.
Courtesy of the artist.

of lines that at times follows the form of the figure and at other times opposes it. The shimmering surfaces that result suggest the reflections of light on a body of water.

MURRY DEPILLARS (b. 1938). Uncle Remus, Aunt Jemima, and other sterotypical characterizations of Blacks are used by graphic artist Murry DePillars as subject for his compositions. He attempts to reverse the past influences of these submissive characters by placing them in scenes in which they aggressively participate in the struggle of Blacks and other third-world peoples against exploitation and discrimination. In DePillars' *In Tribute to the Family… The People of the Sun* [*Illus.* 222] the major figure, a defiant Uncle Remus, is shown emerging from a book of folk tales, beneath which lie the littered remains of a decadent society. Overweight white nudes disport themselves beneath a monumental cross bearing the "crucified" seal of the United States, and a reference to the fate of

203

223 Donald Coles, untitled drawing. Graphite. Courtesy of Contemporary Crafts, Los Angeles.

minority cultures is made through the "Indian" skulls at the foot of the cross and at the base of the United States history book.

DONALD COLES (b. 1947) has developed a drawing style that is highly disciplined and imaginative. Filled with awesome constructions, his dreamlike compositions are intended to awaken in the viewer imaginings generally suppressed. As in the surrealistic pencil drawing in *Illustration* 223, Coles often uses massive constructions to represent the systematization of human life and the denial of individual rights. The loneliness of people in the modern mechanized world is a recurrent Coles theme.

RON ADAMS (b. 1934), by using freely brushed patterns, gives his drawings a spontaneous, relaxed effect. *Skull [Illus.* 224], a black-ink rendering by Adams, is representative of his bold drawings. Going beyond mere factual representation, the artist depicts his

subject with ambiguous features that suggest a variety of forms. Like most of his compositions this one has a brooding, ominous quality and seems to hold a mystery within.

JOSEPH GERAN (b. 1945), a close observer of nature, uses nature's amazing structural designs as the basis for much of his art. The delicate lines in the drawing *Ananse* [*Illus.* 225] resemble the web of a spider, and Geran has combined them with masks and small human figures that suggest Africa and its cultural experiences. (The heroic spider Ananse is an important character in African folklore: his web symbolizes the sun and its rays and, therefore, God.)

224 Ron Adams, *Skull*, 1968.
Ink wash, 20″ x 14″. Collection of
the Golden State Mutual
Life Insurance Co.

225 Joseph Geran, *Ananse*, 1971.
Pen and ink, 10″ x 12″.
Courtesy of the artist.

226 Ron Moore, untitled drawing, 1969. Pencil, 13″ x 17″. Collection of Naomi Caryl, Los Angeles. (Photograph by Chris McNair Studio, Birmingham, Alabama.)

RON MOORE (b. 1944) is an artist for whom the rhythmic patterns of animal and plant forms hold special appeal; his drawings are thus filled with restless energy and vigor. In viewing such works as the drawing shown in *Illustration* 226, one is immediately conscious of Moore's technique. It is characterized by a crisp and highly intellectualized delineation of three-dimensional organic form.

GRAPHIC PROCESSES: ECONOMICAL AND AESTHETIC APPROACHES TO COMMUNICATION

Among the major problems that confront artists today are earning a living and communicating with as many people as possible. Printmaking and other methods of creating quality reproductions offer answers to both these imperatives. Improved printing methods have made it possible for more people to own original works of art and fine reproductions by outstanding artists. So great has been the recent technological progress in printing that it is now possible to achieve a machine reproduction equal in quality to a handdrawn original.

Thus we are witnessing a renaissance in the production of original prints—that is, prints made from artwork created especially for

reproduction and, generally, offered in limited editions supervised by the artist. For the most part, the methods used to create such prints fall into four categories: relief, intaglio, planographic, and stencil. *Relief prints* are made by transferring ink from a raised surface onto paper or some other two-dimensional material. *Intaglio,* the reverse of relief printing, is the making of impressions from recessed surfaces that hold ink. *Planographic prints* are pulled from smooth, inked surfaces on which drawings have been made and, in most cases, sensitized for printing by means of chemicals; lithography, in which the drawing is generally executed on limestone or on a metal plate, is a planographic process. The *stencil method* of printmaking involves the masking of certain areas of the surface being printed on so that the only areas left open and receptive to ink represent the desired design; when the masking material used is silk, treated so that some of its areas are no longer porous, the process is called *silkscreening.*

Although most collectors still prefer the small-edition original print, a good case can be made for the production of less-limited originals and other quality reproductions. The issue should be quality, not quantity. For rather than decreasing interest in original works, inexpensive prints and reproductions tend to encourage collecting by those who might not otherwise be able to afford commercial works of art. The fact that several thousand records of a musical composition are produced in no way lessens the quality of the composition as created by the composer.

Stone, metal, wood, linoleum, and screens of various materials (primarily silk, nylon, and metal) are the surfaces most commonly used in graphic design. The relative inexpensiveness and ease with which prints can be produced from linoleum and wood make these materials particularly popular among Black artists involved in printmaking. The linoleum print and the woodblock print are both examples of relief printing, an ancient graphic process that lends itself to a wide variety of subjects and stylistic variations.

RELIEF

RUTH WADDY (b. 1909) often uses linoleum as a principal medium; *The Key* [*Illus.* 227], one of her early works, is a linoleum composition in which both geometric and figural elements are used. Waddy's ability to handle the medium effectively is demonstrated by her retention of a major portion of the linoleum in creating her image. Another Waddy linoleum print is a boldly colored but simple state-

227 Ruth Waddy, *The Key*, 1969. Linoleum print, 24″ x 18″. Collection of Samella Lewis.

ment that echoes forms common to African sculpture [*Illus*. 228]. Because inks are applied to the linoleum by means of a brush, it is possible to print several colors simultaneously using the same master.

Largely self-taught, Waddy is a Los Angeles–based artist and the founder of Art West Associated, an organization of Black artists established in the early 1960s. Through Art West and independently, she has been instrumental in encouraging many Blacks to pursue their interest in art.

VAN SLATER (b. 1937) is another printmaker who creates compositions in relief. One of these, his *Eula Seated* [*Illus*. 229], contrasts a forceful geometric background and a dejected female figure. The effective use of the wood surface gives a spontaneous appearance to the print and convincingly suggests the material used.

INTAGLIO

The intaglio printmaking method, the reverse of relief printing, produces impressions from recessed surfaces housing ink, rather than from inked surfaces that are raised.

228 Ruth Waddy,
untitled linoleum print,
1969. 24″ x 18″.
Courtesy of the artist.

229 Van Slater, *Eula Seated*, 1964.
Woodcut, 26½ x 18″. Courtesy of
the artist. (Photograph
by Ivor Protheroe, Los Angeles.)

209

Leon Hicks (b. 1933) makes use of the intaglio process in a series of etchings called *New Faces*. As shown in *Illustration* 230, one face from the series is an effective work that has the soft quality produced by close value changes and luminous yet earthy color tones. With gentle and subdued shapes, Hicks fuses the haunted face with an environment to form a composite view of figure and field. The resulting quality is one of subtle splendor.

Known for his fine technical ability, Hicks demonstrates a facile use of line that ranges from intricate vertical patterns to delicate horizontals. At times his lines are incised so deeply that they appear to be excised on his prints. Generally the artist covers the entire area of his printing surface and does not allow any of the ground to appear. Because of this approach and his use of closely related colors, Hicks creates works that reflect soft monochromatic patterns achieved through overlays of separate plates. His special sensitivity in the use and variation of line gives his work the visual richness achieved only by a mature and dedicated artist.

230 Leon Hicks,
from the series *New Faces*,
1969. Intaglio, 20″ x 16″.
Collection of Samella Lewis.

231 Marion Epting, *Alternative*,
1968. Intaglio, 38″ x 28″.
Courtesy of Contemporary Crafts,
Los Angeles.

MARION EPTING (b. 1940) uses a variety of printing techniques to
produce strong social and political statements, and he frequently
makes visual phrases an integral part of his design. For example, in
Alternative [*Illus.* 231], an etching that attempts to call attention to
racial struggles in America, he places a flag in the upper area of the
composition to express idealized, organized, and stately aspects of
the nation; the lower portion suggests the realities of life and its
growing conflict and opposition. *Alternative* is about conflicts and
dualisms, subjects of marked interest to the artist:

> *To find yourself attempting to defend one side or the other of a dualism
> is to find yourself in a position that is uncomfortable, confining, limit-
> ing, prejudicial, impossible to maintain, and dishonest.*

> *Dualisms, or what may be referred to as examples of the operation of the
> "rule of two" are, by their nature and definition, situations which are
> potentially conflicting.* [Quoted in Samella S. Lewis and Ruth Waddy,
> Black Artists on Art, *vol. I (Los Angeles: Contemporary Crafts Pub-
> lishers, 1969), p.* 109.]

232 Marion Epting, *Share*, 1969.
Intaglio, 16″ x 10″. Courtesy of
Contemporary Crafts, Los Angeles.

Epting also expresses his concern for the struggles of Black Americans in an intaglio print titled *Share* [*Illus.* 232]. In this composition he uses a field of red, white, and blue to suggest the flag. A black arrow confronts a white barrier that it must penetrate in order to share in the benefits of the nation.

Russell Gordon (b. 1932) is the creator of *Kaleidoscopic Portrait Series #5* [*Illus.* 233], an intaglio print whose upper portion is filled by bristling hairs that resemble the tentacles of a squid. The individual hair shafts are enlarged and their rhythmic movements and abrupt changes in direction create strong visual and textural interest. A wide variety of grays is achieved through the use of the aquatint

technique, and the etched and aquatint areas combine to make the work an epitome of "psychedelic" portraiture. Monumental in scope, Gordon's prints are like photographic close-ups.

LITHOGRAPHY

Lithography, unlike relief and intaglio, is a planographic method of printing. Smooth limestone that has been chemically sensitized and inked is the surface from which a lithographic print is pulled. Closely related to drawing—crayon or touché drawings are sometimes made directly on stones—lithography provides for a wide range of value changes, from extreme lights to darks.

MARGO HUMPHREY (b. 1942) has turned, in her recent works, to subjects based on the activities of inner-city dwellers, subjects that make us realize how tenuous is our hold on life. Her *Crying Ain't Gonna Help None Baby or Don't Shed Your Tears on My Rug [Illus.*

233 Gordon Russell,
Kaleidescopic Portrait Series #5
1970. Color etching, 27" x 23¾".
Collection of The Oakland Museum
(gift of the Donors'
Acquisition Fund).

234 Margo Humphrey, *Crying Ain't Gonna Help None Baby or Don't Shed Your Tears on My Rug*, 1971. Lithograph, 14½" x 14". Courtesy of the artist.

234], a strong composition of pure, brilliant colors, demonstrates Humphrey's command of the difficulties of close color registration.

In an early stage of her artistic development, Humphrey directed her attention toward the African past, gaining from it inspiration and material for her creative production. Among the important lithographic works she produced during this period is the outstanding *Zebra* series [*Illus.* 235], whose animal and human forms are sharply delineated from their environments by means of light lines.

DEVOICE BERRY (b. 1937) creates lithographs that reflect a mixture of symbolism and realism. An artist who captures the inner mood of his subjects and exhibits a great capacity for compassion, Berry is able to combine his sensitive style with a high degree of drama and a great facility for design.

Berry is concerned with social issues, and his highly expressive themes extend beyond the realm of personal matters. *Figures* [*Illus.* 236] is a composition in which he expresses the essence of struggle by means of repeated angles and dynamic figures filled with anxiety and compassion. The orchestration of the bodies, their intense religious gestures, convey passion and suffering.

235 Margo Humphrey,
A Second Time in Blackness
(from the *Zebra* series) 1968.
Lithograph, 22″ x 10¾″.
Courtesy of Contemporary
Crafts, Los Angeles.

236 Devoice Berry, *Figures*,
1970. Lithograph, 43″ x 33″.
From the collection of
Dr. Herman W. Dorsett,
Miami, Florida.

Silkscreen, or serigraphy, is a branch of stencil printing whose history can be traced back to ancient China; its development in the West is as recent as the 1930s, however. An opportunity for the artist to create complex and exciting visual relationships through line, shape, and color, the process involves blocking out areas of a mounted screen—with glue, shellac, wax, paper, or plastic film—to create a stencil of the desired image and then applying ink so that it passes through the remaining porous areas onto a surface beneath.

Some of the most exciting artwork produced by silkscreening is that done by HOWARD SMITH (b. 1928), a Philadelphian who was a resident of Finland for fourteen years (1962–76) and currently lives in Santa Monica, California. Smith's *Design Multiple* [*Illus.* 237] is a highly successful print derived from a stencil of plastic film. Its repeated triangular shapes form a complicated optical pattern,

237 Howard Smith, *Design Multiple*, 1969. Silkscreen, 54″ x 42″. Courtesy of Contemporary Crafts, Los Angeles.

238 Howard Smith, *Multiple Design*, 1969. Silkscreen, 42″ x 50″. Collection of David Wong, Los Angeles. (Photograph by Armando Solis, Los Angeles.)

and its color scheme—red, black, and white—emphasizes the interplay of shapes through contrast. Smith's bold use of color and honest regard for clean shape help him create imaginative, lively designs that coordinate old- and new-world qualities. African and Asian cultures have been of special interest to Smith, and his designs, whether for paper prints or for textiles, show the influences of both continents [*Illus.* 238].

JEFF DONALDSON (b. 1932). The credo of numerous Black artists who gained attention in the late 1960s and early '70s demands that they view themselves first as responsible members of cultural groups and only secondarily as individual contributors. Because these artists believe that maximum fulfillment is obtained by pooling their efforts, they have joined organizations that foster coordinated explorations of Black aesthetics. The work of Jeff Donaldson, an AfriCOBRA founder, must be considered within the context of that organization.

Sharing the belief that there are qualities intrinsic to Black people, AfriCOBRA members have decided to use specific visual

239 Jeff Donaldson,
Victory in the Valley of Eshu,
1971. Gouache, 36″ x 26″.
Courtesy of the artist.

elements to express their common denominator as a group. These elements are "bright colors, the human figure, lost and found line, lettering, and images which identify the social."

Like other members of AfriCOBRA, Donaldson produces art to communicate and to express positive modes of thought. In the silk-screen print *Victory in the Valley of Eshu* [*Illus.* 239] Donaldson makes a positive, direct statement. He uses the organization's "bright, vivid, singing Kool-Aid colors of orange, strawberry, cherry,

lemon, lime and grape" to express the "pure vivid colors of the sun and nature. Colors that shine on Black people, colors that stand out against the greenery of rural areas."

THE PHOTO SILKSCREEN

Photography has contributed a new dimension to printmaking, the *photoscreen*. Originally developed primarily for commercial use but rapidly becoming important in the fine arts, photoscreening is the process of transferring a photographic image to a screen. It can be accomplished through two basic means: direct application of a photographic emulsion or the use of photo-sensitive film. A photographic emulsion is usually a light-sensitive mixture of gelatin and chemicals (halides) and can be prepared commercially or by the individual artist. Its direct application to a screen most often involves spraying or the use of a brush or squeegee. Photo-sensitive film is film coated with a similar gelatin-based mixture. It is sold affixed to a plastic backing and serves the same purpose as a directly applied emulsion but with greater ease and efficiency.

Both photographic emulsions and photo-sensitive films vary widely in light sensitivity. Some require a sophisticated darkroom to transfer the image from the negative successfully, while other emulsions and films are "slow" and can be exposed under natural sunlight.

Multiple-color prints are also possible through photoscreening. Color separation, variation in the exposure times of a negative, and combinations of photo imagery and hand-cut screens are all effective ways of introducing color into prints. Color separation is achieved by photographing an image through variously colored lenses. When the resulting negatives are transferred to screens and each is printed in one of the four basic inks (magenta, blue, yellow, and black), they can be combined to reproduce the color of the original image.

CAROL WARD (b. 1943) uses photo collage and multiple-color screens to create such prints as *Foloyan* [*Illus.* 240], a study of tenement living. The dramatic geometric pattern evident in the print is achieved by the inclusion of such shapes as the window and the American flag. Significant among the colors used are black, red, and green, the triad symbolic of Black liberation. Like numerous other Black artists, Ward finds her subjects in everyday scenes involving ordinary people. Because of her fine ability as a photographer, she

240 Carol Ward, *Foloyan*, 1973.
Photo-silkscreen, 40″ x 30″.
Courtesy of the artist.

finds photoscreen a natural medium for her provocative visual statements.

LEV MILLS (b. 1940), on graduation from the University of Wisconsin, was awarded a Ford Foundation fellowship that allowed him to study at the University of London's Slade School of Fine Arts and at Atelier 17 in Paris. He is now a member of the art faculty at Clark College in Atlanta. Mills is typical of this generation's highly talented, university-trained graphic artists in that he developed his creative talents in conjunction with a great respect for contemporary materials and techniques.

In his prints Mills combines an immaculate technical facility with a personal vision of the meaning of Black identity. The serigraph *I'm Funky, But Clean* [*Illus.* 241], a highly decorative work, shows the architectural boldness of his design. It also shows the sincerity

of Mills' psychological insights into the spirit of the contemporary young Black male.

In the following statement Mills expresses his continuing concern for technique and technology:

> More and more the artist is becoming a technician, constructor, or a "structurist." This is due to the ever-changing society in which we live. All of us are living closer to machines, tools, computers, and materials that are used in our everyday endeavors. I am greatly influenced by the discovery of new materials that might be used to produce a work of art. It is necessary to define these components that make art meaningful as new media are produced.
>
> The ongoing effort of a "structurist" is to struggle with forms—to build up, modify, tear down, and build up again before the resolution of a given piece of work finally does take place. This has opened new avenues to visual expression. Certainly this new art is not quite like any art of the past. However, the times in which we live and the materials now available to use are not like anything we have ever known before. [Personal communication with the author.]

241 Lev Mills, *I'm Funky But Clean*, 1972. Serigraph, 30″ x 22″. Collection of Samella Lewis.

242 Cleveland Bellow, #7 from the series
There Is No Need for a Title,
1970. Acrylic and silkscreen, 24″ x 18″.
Courtesy of Contemporary Crafts,
Los Angeles.

243 Cleveland Bellow, #5 from the series
There Is No Need for a Title, 1969–70.
Acrylic and silkscreen, 24″ x 30″.
Courtesy of the artist.

CLEVELAND BELLOW (b. 1946) combines drawing and photoscreen-
ing to create works on contemporary Black heroes and inner-city
life. Using intense colors for his backgrounds, he has produced such
compositions as *Duke Ellington* and those in the series *There Is No
Need for a Title* [Ills. 242, 243].

244 Cleveland Bellow, Oakland billboard, 1969. Silkscreen, 9′ 7″ x 21′ 7″. Courtesy of the artist.

During the late 1960s, Bellow became interested in billboards and set out to create positive images to be exhibited on noncommercial billboards; in his initial effort in this regard, he created a thirty-six sheet silkscreen print. In 1970, with the cooperation of the Oakland Museum and Foster-Kleiser Billboards, this print was applied to ten billboards along the streets of Oakland and Berkeley. The print shows a Black youth with arms upraised in a gesture that is open to individual interpretation [*Illus.* 244].

Because of his deep concern for the human condition, Bellow believes it is necessary to "get art out of the museums." He hopes that his art will get to people and that from it they will sense the total realities of inner-city life—the fear and hate, the joy and love.

Body Printing: A Monoprint Process

Monoprinting offers a way for artists to experiment with many devices and materials to produce a single print. David Hammons (b. 1943) utilized this technique in creating *Couple* [*Illus.* 245], a dramatic black-and-white portrait of two figures in ornamental robes. The type of monoprint in which Hammons specializes is the *body print*. The form, or material, to be printed is first covered with a substance that has a greasy transparent base. The act of transferring the desired images to the transitional paper ground and separating the objects from the ground without smudging them is a major challenge for the artist and a principal part of the process. When the images have been transferred to the ground, powdered pigment is then dusted over the surface, where it adheres to the

223

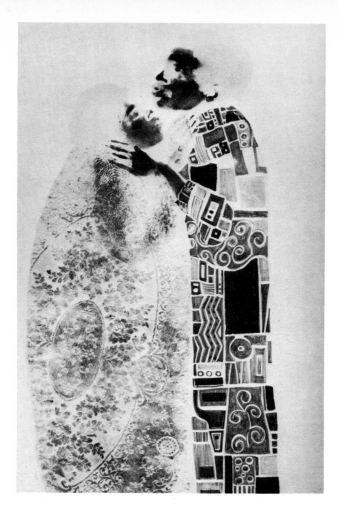

245 David Hammons, *Couple*,
1970. Bodyprint and paint.
Collection of
Dr. and Mrs. J. Eugene
Grigsby III, Los Angeles.

grease. A strong fixing agent is then applied, and the resulting image resembles a reversed photographic negative. In *Couple*, Hammons has combined body printing with direct painting and thus produced a mixed-media composition.

STREET ART

The social ferment in the United States during the last two decades has led to a great interest in the identification of its ethnic groups. The rediscovery of values and traditions has proved vital to the stimulation of ethnic awareness and pride. The association with past cultural achievements has been most successful when approached with reference to the present; the wealth of tradition can be utilized effectively only if the day-to-day difficulties of life are recognized and confronted. An ethnic group seeking to cope with

today's complicated problems must first have organized ideas and systems that are clearly understood and can evoke responses.

Outdoor murals, *billboard art*, and *street art* are all terms used to describe the community-oriented art projects springing up in urban centers across the United States. Rapidly becoming aware of the impact of visual symbols as a means of disseminating social ideas, Black artists are using street art to interpret the experiences shared by Black Americans. *Peace and Salvation Wall of Understanding* [*Illus.* 246], a composition painted by WILLIAM WALKER on the side of a building in Chicago, serves as a striking example of contemporary work in this mode.

Street art is first a message-oriented art, for it seeks to influence opinions regarding cultural and social goals. Its subject matter generally reflects social conditions, and the street artist is usually attempting to provide visual experiences that promote dignity, pride, and self-understanding. Because of the social nature of street art it is necessary for those interested in pursuing it seriously to experience the environments of their subjects and first critics. Artists using this means of expression have rediscovered the city as a fertile environment for creativity.

246 William Walker, *Peace and Salvation Wall of Understanding*, Chicago. Courtesy of the artist.

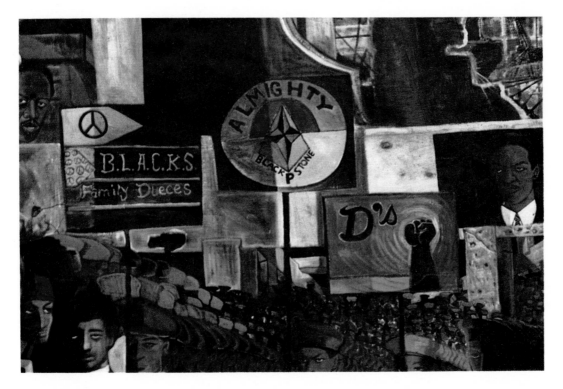

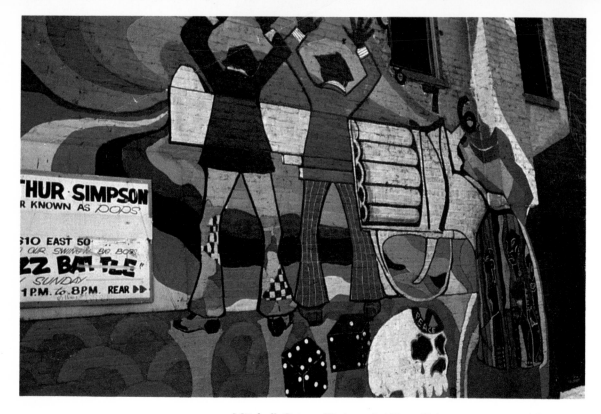

247 Mitchell Caton, *Universal Alley*; Chicago, 1971–74. Oil, 11,500′
long. Courtesy of the artist.

In such urban centers as Boston, Chicago, Detroit, Los Angeles,
and Washington, artists have organized to encourage the production
of large "collective" murals. These collaborative enterprises have
offered many Black artists their first opportunity to work on large-
scale compositions designed specifically for a mobile audience.
Chicago is the city regarded as the headquarters of this type of Black
street art, and it can boast of originating the famous *Wall of Respect*,
a mural created collectively during the 1960s. Three outstanding
Chicago street artists, WILLIAM WALKER, MITCHELL CATON, and
EUGENE EDA, have been energetic participants in the production of
"walls" in Chicago, Detroit, and St. Louis. Walker sees street art
as a form of artist-to-people communication:

*Artist-to-people communication is the kind of relationship that places
the artist and his work in a position of respect, pride, and dignity–all of
which he should have. This view is not based on the feelings of an idealist
hoping for something that cannot be or believing in something that he has
never experienced. It is founded on experience–the experience of talking
with people in a community during the time that the art project is in*

progress; of discussing their problems and the conditions of the world and trying to realize how art can become more relevant to the people of the world. [Personal communication with the author.]

MITCHELL CATON (b. 1930) is the creator of *Universal Alley* [*Illus.* 247] another highly symbolic and decorative Chicago mural. Caton's brilliant hues emphasize his strong feeling for design and brighten the surface of the otherwise darkened alley. With figures and forms expressed through simplified geometric shapes, this everyday scene is painted in a literal and easily understood style.

The Wall of Meditation [*Illus.* 248] by EUGENE EDA (b. 1939) is another work of street art—also in Chicago—that exhibits strong, expressive symbols. Its theme, Black civilization from ancient times to the present, is explored through linear organized symbols. The mural's strong impact is the result of directional line movements

248 Eugene Eda, *The Wall of Meditation*, Chicago, 1970. Oil, 20′ x 46′. Courtesy of the artist.

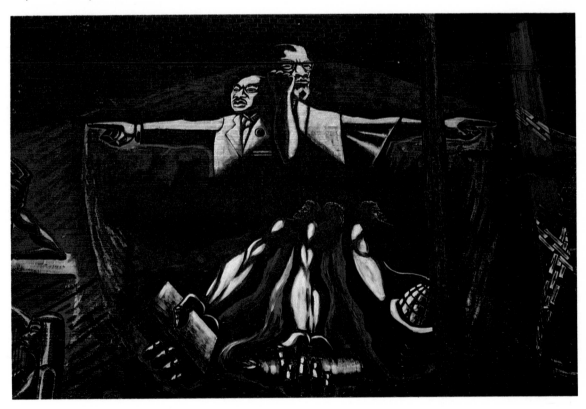

249 Eugene Eda, Howard University mural (detail) 1970. Acrylic, 16′ x 64′.

rather than mass or intensity of color. A similar technique is demonstrated in Eda's mural for Howard University [*Illus*. 249].

DANA CHANDLER (see page 152), a most eloquent spokesman for Black art who works in the Boston area, has been a participant in the street-art movement since the 1960s. Chandler feels that his outdoor artistic messages have been effective because they have prompted responses both from admirers and from dissenters. He contends that he paints murals to:

1. Let us know that we *can* paint.
2. Show direction, set precedents toward our goal of liberation.
3. Bring art to the people.
4. Talk about our history and accomplishments.
5. Instill *pride* and *respect* for self and other Black people.
6. Return to my people the skills they enabled me to gain.
7. Depict the beauty of being Black and *skilled*/educated. [Personal communication with the author.]

Chandler's Roxbury mural, called *Knowledge Is Power, Stay in School* [*Illus*. 250], effectively conveys the importance of education. He describes the mural as portraying "a brother, with the help of African Gods and natural influences, shooting out a flame in the form of a spiritual Black fist." The fist, in the colors of the Black liberation flag, destroys the great white egg, a symbol of European paternalism. According to Chandler, the destruction of the egg, which "we have been incubating in, frees us to rise up and become all that we can be and have been." The Christlike figure is meant to

250 Dana Chandler, *Knowledge is Power: Stay in School*, 1973. (Detail below.) Acrylic, 14' x 60'. Courtesy of the artist.

251 John Outterbridge,
Something from Nothing,
Compton, California.
(Detail at right.)
Courtesy of the artist.

230

be a positive symbol leading the way to unity and education. On the left-hand side of the mural, martyrs Martin Luther King, Jr., Malcolm X, and Medgar Evers are presented as sources of great spiritual power for "the ghettoized Pan-African communities."

On the west coast of the United States, street art is a more recent phenomenon. Los Angeles, San Francisco, and Compton, California, are the three major western centers in which the street art of Black Americans is currently popular. At the Communicative Arts Academy in Compton, a unique kind of street art has been developed; a combination of relief sculpture, construction, and painting has been used to decorate the exterior of the academy's main building. JOHN OUTTERBRIDGE (see p. 175) is a major figure in the community-art movement of this predominantly Black city. He and other community artists created the sculptured doors that adorn the academy and describe its goals for the community. Created from discarded materials and called *Something from Nothing* [*Illus.* 251], the designs on these doors have a mural effect reminiscent of both collage and sculpture.

The message of *Something from Nothing* and the aims of community organizations like the Communicative Arts Academy are summarized in the following statement by Outterbridge:

> *How many changes can you make in the community because you are creative and energetic? I'm trying to forget that I'm an artist, 'cause everybody's an artist. Everybody's got a song to sing. We are concerned with giving everyone an opportunity to be a part of the chorus— a choral. The results or product will be naturally harmonious.*

Bibliography

Books

Allen, Richard. *Autobiography*. Philadelphia: F. Ford and M. A. Ripley, 1890.

Aptheker, Herbert, ed. *A Documentary History of the Negro People in the United States*. 3 vols. New York: Citadel Press, 1974.

Arnold, J. W. *Art and Artists in Rhode Island*. Providence: Rhode Island Citizens' Association, 1905.

Atkinson, J. Edward, ed. *Black Dimensions in Contemporary American Art*. New York: New American Library, 1971.

Barr, Alfred. *Cubism and Abstract Art*. New York: Museum of Modern Art, 1936.

Barr, Alfred, ed. *Painting and Sculpture in the Museum of Modern Art*. New York: Museum of Modern Art, 1942.

Bearden, Romare, and Henderson, Harry. *Six Black Masters of American Art*. New York: Doubleday, 1972.

Bier, Ulli. *Art in Nigeria*. Cambridge: Cambridge University Press, 1960.

Black American Artists of Yesterday and Today. Black Heritage Series. Dayton, Ohio: George A. Pflaum, Publisher, 1909.

Boning, Richard A. *Profiles of Black Americans*. Rockville Centre, N.Y.: Dexter and Westbrook, 1969.

Boswell, Peyton, Jr. *Modern American Painting*. New York: Dodd, Mead, 1939.

Brawley, Benjamin. *The Negro Genius*. New York: Biblo and Tanner, 1966.

————. *The Negro in Literature and Art in the United States*. New York: Dodd, Mead, 1934.

————. *A Short History of the American Negro*. New York: Macmillan, 1939.

Brown, Sterling. *The Negro Caravan*. New York: Dryden Press, 1942.

Bunche, Ralph J. *The Political Status of the Negro in the Age of F.D.R.* Dewey Grantham, ed. Chicago: University of Chicago Press, 1975.

Burton, E. Milby. *South Carolina Silversmiths, 1690–1800*. Charleston: Charleston Museum, 1942.

Butcher, Margaret J. *The Negro in American Culture*. New York: Alfred A. Knopf, 1971.

Chase, Judith W. *Afro-American Art and Craft*. New York: Van Nostrand Reinhold, 1971.

Chinweizu. *The West and the Rest of Us*. New York: Vintage Books, 1975.

Clark, Victor S. *History of Manufacturers in the United States*. New York: McGraw-Hill, 1929.

Clarke, John H. *Harlem U.S.A.* New York: Collier Books, 1971.

Coen, Rena N. *The Black Man in Art*. Minneapolis: Lerner Publications Co., 1970.

Colloquium on Negro Art. 2 vols. Society of African Culture, Présence Africaine, 1968, 1971.

Cruse, Harold. *Crisis of the Negro Intellectual*. New York: William Morrow, 1967.

Cummings, Paul. *A Dictionary of Contemporary American Artists*. New York: St. Martin's Press, 1966.

Dabney, Wendell P. *Cincinnati's Colored Citizens*. Cincinnati: Dabney Publishing Company, 1926.

Dannett, Sylvia G. L. *Profiles of Negro Womanhood*. 2 vols. Negro Heritage Library. Yonkers, N.Y.: Educational Heritage, Inc., 1964, 1966.

Davidson, Basil. *The African Past*. New York: Grosset & Dunlap, 1967.

Davis, John P., ed. *The American Negro Reference Book*. Negro Heritage Library. Yonkers, N.Y.: Educational Heritage, Inc., 1966.

Diop, Cheikh Anta. *The African Origin of Civilization: Myth or Reality?* New York: Lawrence Hill and Company, 1974.

Dover, Cedric. *American Negro Art*. Greenwich, Connecticut: New York Graphic Society, 1969.

Du Bois, W. E. B. *The Education of Black People, 1906–1960: Ten Critiques*.

Herbert Aptheker, ed. Amherst: University of Massachusetts Press, 1973.
———. *The Negro Artisan*. Atlanta: Atlanta University Press, 1927.
———. *The Souls of Black Folk: Essays and Sketches*. New York: Fawcett Publications, 1961.
———. *The Suppression of the African Slave Trade*. New York: Schocken Books, 1967.

Earle, Alice M. *Home Life in Colonial Days*. New York: Macmillan, 1899.

Fagg, William, and Plass, Margaret. *African Sculpture*. New York: E. P. Dutton, 1968.
Fax, Elton. 17 *Black Artists*. New York: Dodd, Mead, 1971.
Fine, Elsa H. *The Afro-American Artist*. New York: Holt, Rinehart and Winston, 1973.
Franklin, John Hope. *From Slavery to Freedom: A History of Negro Americans*. New York: Vintage Books, 1969.
Frazier, E. Franklin. *Black Bourgeoisie: The Rise of a Black Middle-Class*. New York: Macmillan, 1962.
———. *The Negro Family in the United States*. Chicago: University of Chicago Press, 1939.
French, H. W. *Art and Artists of Connecticut*. Boston: Lee and Shephard, 1879.
Fry, Roger. *Vision and Design*. London: Chatto and Windus, 1920.

Gardi, René. *Indigenous African Architecture*. New York: Van Nostrand Reinhold, 1973.
Gayle, Addison. *The Black Aesthetic*. Garden City, N.Y.: Doubleday, 1971.
Geerlings, Gerald K. *Wrought Iron in Architecture*. New York: Schribner's, 1929.
Greene, Lorenzo Johnson. *The Negro in Colonial New England, 1620–1776*. New York: Columbia University Press, 1942.
Grigsby, J. Eugene, Jr. *Art and Ethnics*. Dubuque, Iowa: Wm. C. Brown Company, 1977.

Hale, R. B., ed. *One Hundred American Painters of the Twentieth Century*. New York: The Metropolitan Museum of Art, 1950.
Holmes, Samuel J. *Negro's Struggle for Survival*. New York: Kennikat Press, 1937. Reprinted 1966.

Horowitz, Benjamin. *Images of Dignity*. (The drawings of Charles White.) Glendale, California: Ward Ritchie Press, 1967.
Huggins, Nathan. *The Harlem Renaissance*. New York: Oxford University Press, 1971.
Hughes, Langston. *A Pictorial History of the Negro in America*. New York: Crown, 1956.

Janis, Sidney. *They Taught Themselves: American Primitive Painters of the Twentieth Century*. Port Washington, New York: Kennikat Press, 1942.
Jernegan, Marcus W. *Laboring and Dependent Classes in Colonial America, 1607–1783*. Chicago: University of Chicago Press, 1938.
Johnson, Charles S. *The Economic Status of the Negro*. Nashville: Fisk University Press, 1933.

King, Grace. *History of Louisiana*. New Orleans: F. F. Hansell & Brothers, 1903.

Larkin, Oliver. *Art and Life in America*. New York: Holt, Rinehart and Winston, 1960.
Laughlin, Charles John. *New Orleans and Its Living Past*. Boston: Houghton Mifflin, 1942.
Lewis, Samella S., and Waddy, Ruth G. *Black Artists on Art*. 2 vols. Los Angeles: Contemporary Crafts, 1971, 1976.
Locke, Alain. *Negro Art: Past and Present*. Albany, New York: Albany Historical Society, 1933.
Locke, Alain, ed. *The Negro in Art*. Washington, D.C.: Associates in Negro Folk Education, 1940. Reprint. New York: Hacker Art Books, 1968.
———. *The New Negro*. New York: Albert and Charles Boni, Inc., 1925. Reprint. Boston: Antheneum Press, 1968.
Logan, Rayford W., ed. *What the Negro Wants*. Chapel Hill: University of North Carolina Press, 1944.

Majors, M. A. *Noted Negro Women, Their Triumphs and Activities*. Chicago: Donohue & Hennebarry, 1893.
Mannix, Daniel P., and Cowley, Malcolm. *A History of the Atlantic Slave Trade, 1518–1865*. New York: Viking Press, 1962.
Morsbach, Mabel. *The Negro in American Life*. New York: Harcourt Brace Jovanovich, 1967.

Ottley, Roi. *New World A-Coming*. Boston: Houghton Mifflin, 1943.

Peterson, Edward. *History of Rhode Island*. New York: J. S. Taylor, 1853.
Porter, Dorothy B. *A Working Bibliography on the Negro in the United States*. Reproduced by University Microfilms, Ann Arbor, Michigan, for the National Endowment for the Humanities Summer Workshops in the Materials of Negro Culture, 1968.
Porter, James A. *Modern Negro Art*. New York: Dryden Press, 1943. Reprint. New York: Arno Press, 1969.

Rodman, Seldon. *Horace Pippin: A Negro Painter in America*. New York: Quadrangle Press, 1947.
Roelof-Lanner, T. V., ed. *Prints by American Negro Artists*. Los Angeles: Los Angeles Cultural Exchange Center, 1965.
Rose, Barbara. *American Art Since 1900: A Critical History*. New York: Praeger, 1967.

Saxon, Lyle; Dryer, Edward; and Tallant, Robert. *Gumbo Ya-Ya*. Boston: Houghton Mifflin, 1945.
Segy, Ladislas. *African Sculpture Speaks*. New York: Plenum Publishing Corp., 1975.
Simmons, W. J. *Men of Mark: Eminent, Progressive and Rising*. Cleveland: Revel, 1887.

Tillinghast, J. A. *The Negro in Africa and America*. New York: Macmillan, 1902.

Werlein, Mrs. Phillip. *The Wrought Iron Railings of LeVieux Carré*. New Orleans: Mrs. Phillip Werlein, 1925.
Wheatley, Phyllis. *Poems on Various Subjects, Religious and Moral*. London, 1773.
Willett, Frank. *African Art*. New York: Praeger, 1971.
Woodruff, Hale A. *The American Negro Artist*. Ann Arbor: University of Michigan Press, 1956.
Wright, Richard. *Twelve Million Black Voices: A Folk History of the Negro in the United States*. New York: Viking Press, 1941.

Exhibition Catalogues

"Aaron Douglas Retrospective Exhibition." Carl Van Vechten. Gallery of

Fine Arts, Fisk University, Nashville, Tennessee. March 21–April 15, 1971.

"African American Extensions." Studio Museum in Harlem, New York. February 15–April 19, 1970.

"African Art Today: Four Major Artists." African-American Institute, New Yrok. May 14–August 31, 1974.

"African Women, African Art." The African-American Institute, New York. September 13–December 31, 1976.

"Afri-Cobra III." University Art Gallery, University of Massachusetts at Amherst. September 7–September 30, 1973.

"Afro-American Artists, New York and Boston." National Center of Afro-American Artists and Museum of Fine Arts, Boston, Massachusetts. May 19–June 23, 1970.

"Afro-American Artists since 1950: An Exhibition of Paintings, Sculpture and Drawings." Brooklyn College, New York. April 15–May 18, 1969.

"Afro-American Images 1971." (Memorial Exhibition for James A. Porter.) Aesthetic Dynamics. State Armory, Wilmington, Delaware. February 5–February 26, 1971.

"American Negro Art: Nineteenth and Twentieth Centuries." Downtown Gallery, New York. December 9, 1941–January 3, 1942.

"American Paintings 1943–1948." Howard University, Washington, D.C. October 22–November 15, 1948.

"America's Black Heritage." Los Angeles County Museum of Natural History, Los Angeles, California. December 3, 1969–February 15, 1970.

"Art Exhibit: The Public Schools of the District of Columbia." Washington, D.C. May 3–11, 1931.

"The Art of African Peoples." Ankrum Gallery, Los Angeles, California. February 9–March 2, 1973.

"The Art of Henry O. Tanner." Frederick Douglass Institute with the National Collection of Fine Arts, Smithsonian Institution, Washington, D.C. July 23–September 7, 1969.

"The Art of the American Negro, 1851–1940." American Negro Exhibition, Chicago, Illinois. 1940.

"The Art of the American Negro: Exhibition of Paintings." Harlem Cultural Council, New York. June 27–July 25, 1966.

"The Art of the Negro." Harmon Foundation Traveling Exhibition organized in cooperation with the College Art Association, New York. 1934.

"The Barnett-Aden Collection." Anacostia Neighborhood Museum, Smithsonian Institution Press, Washington, D.C. 1974.

"Benny Andrews." ACA Galleries, New York. April 25–May 13, 1972.

"Benny, Bernie, Betye, Noah and John." Lang Art Gallery, Scripps College, Claremont, California. Contemporary Crafts, Los Angeles, California. 1971.

"Betye Saar." (Selected works, 1964–1973.) Fine Arts Gallery, California State University, Los Angeles, California. October 1–25, 1973.

"Bing Davis: Painting and Ceramics." Warbash College Humanities Center. January 14–February 4, 1973.

"Black American Artists / 71." Lobby Gallery, Illinois Bell Telephone, Chicago, Illinois. January 12–February 5, 1971.

"The Black Artist in America: A Negro History Month Exhibition." Boston Negro Artists Association, Boston, Massachusetts. 1973.

"Black Artists of the 1930's." Studio Museum in Harlem, New York. 1968.

"Black Artists: Two Generations." Newark Museum, Newark, New Jersey. May 13–September 6, 1971.

"Black Existence." Southern Illinois University, Edwardsville, Illinois. June 10–July 21, 1972.

"The Black Experience." Lincoln University, Jefferson City, Missouri. 1970.

"Black Reflections: Seven Black Artists." Flint Community Schools, Flint, Michigan, 1969.

"Blacks: U.S.A. 1973." The New York Cultural Center, New York. September 26–November 15, 1973.

"Black Untitled." The Oakland Museum, Oakland, California. October, 1970.

"Black Untitled III / Graphics." The Oakland Museum / Art Division, Oakland, California. November 28, 1972–January 7, 1973.

"Black Women Artists 1971." Acts of Art Gallery, New York. June 22–July 30, 1971.

"Bob Thompson." J. B. Speed Art Museum, Louisville, Kentucky. February 2–21, 1967.

"Bob Thompson." New School Art Center, New York. February 11–March 6, 1969.

"Bob Thompson." University Art Gallery, University of Massachusetts at Amherst. September 11–October 4, 1971.

"California Black Artists." College of Marin Art Gallery, Kentfield, California. March 13–April 10, 1970.

"California Black Craftsmen." Mills College Art Gallery, Oakland, California. February 15–March 8, 1970.

"Charles Alston." Gallery of Modern Art, New York. December 3, 1968–January 5, 1969.

"Charles White." The Gallery of Art, Howard University, Washington, D.C. September 22–October 25, 1967.

"Chase-Riboud." University Art Museum, Berkeley, California. January 17–February 25, 1973.

"Congolese Sculpture." The Museum of Primitive Art, New York. November 24, 1965–February 6, 1966.

"Contemporary African Art." Otis Art Institute of Los Angeles County, Los Angeles, California. March 13–May 4, 1969.

"Contemporary African Arts." Field Museum of Natural History, Chicago, Illinois. April 20–November 3, 1974.

"Contemporary Black Artists (A Traveling Exhibit)." Ruder & Finn Fine Arts, New York. 1969.

"Contemporary Black Artists in America." Whitney Museum of American Art, New York. April 6–May 16, 1971.

"Contemporary Black Imagery: Seven Artists." Los Angeles, California. October 10–30, 1971.

"Contemporary Negro Art." Baltimore Museum of Art, Baltimore, Maryland. February 3–189, 1939.

"Creations from Africa." Union Galleries, University of Wisconsin, Madison, Wisconsin. September 29–October 10, 1971.

"Daniel LaRue Johnson." French and Company, New York. February 1970.

"Dimensions of Black." La Jolla Museum of Art, La Jolla, California. February 15–March 29, 1970.

"Directions in Afro-American Art." Herbert F. Johnson Museum of Art, Cornell University, Ithaca, New York. September 18–October 27, 1974.

"Edward Mitchell Bannister, 1828–1901: Providence Artist." Rhode Island School of Design, Providence, Rhode Island. March 23–April 3, 1966.

"Eighteen Washington Artists." Barnett-Aden Gallery, Washington, D.C. 1953.

"Eight New York Painters." University of Michigan, Ann Arbor, Michigan. July 1–21, 1956.

"Elizabeth Catlett." Studio Museum in

Harlem. New York. September 26, 1971–January 9, 1972.

"Elizabeth Catlett, An Exhibition of Sculpture and Prints." Fisk University, Nashville, Tennessee. 1973.

"The Evolution of Afro-American Artists: 1800–1950." City College, New York. 1967.

"Exhibition." Organized by Hale Woodruff and the Harmon Foundation. Atlanta University, Atlanta, Georgia. February 1934.

"An Exhibition of Paintings by Three Artists of Philadelphia: Laura Wheeler Waring, Allan Freelon and Samuel Brown." Howard University Gallery of Art, Washington, D.C. February 1–29, 1940.

"Exhibitions by Artists of Chicago and Vicinity." Art Institute of Chicago, Chicago, Illinois. 1923.

"Exhibitions by Artists of Chicago and Vicinity." Art Institute of Chicago, Chicago, Illinois. 1931.

"An Exhibition of Black Women Artists." UCEN Art Gallery, University of California, Santa Barbara. May 5–17, 1975.

"Exhibition of Fine Arts by American Negro Artists." Harmon Foundation, New York. January 7–19, 1930.

"Exhibition of Graphic Arts and Drawings by Negro Artists." Howard University Gallery of Art, Washington, D.C. 1935.

"Exhibition of Paintings and Drawings by James A. Porter and James Lesesne Wells." Howard University Gallery of Art, Washington, D.C. April 16–30, 1930.

"Exhibition of Paintings and Sculpture by American Negro Artists at the National Gallery of Art." Smithsonian Institution, Washington, D.C. May 16–29, 1929; May 30–June 8, 1930.

"Exhibition of Productions by Negro Artists." Harmon Foundation, New York. February 20–March 4, 1933.

"An Exhibition of Sculpture and Prints by Elizabeth Catlett." Jacksonian Lounge, Jackson State College, Jackson, Mississippi. July 1–6, 1973.

"Exhibition of Works by Negro Artists at the National Gallery of Art." Washington, D.C. October 31–November 6, 1933.

"Exhibition of Works of Negro Artists." Harmon Foundation, New York. February 16–28, 1931.

"Exhibition of Works of Negro Artists." Harmon Foundation, New York. April 22–May 4, 1935.

"Fiberworks: An Exhibition of Works by Twenty Contemporary Fiber Artists." Lang Art Gallery, Scripps College, Claremont, California. 1973.

"Fifteen Afro-American Women." North Carolina A.&T., Greensboro, North Carolina. March 1–31, 1970.

"First Annual Exhibition Salon of Contemporary Negro Art." Augusta Savage Studios, Inc., New York. June 8–22, 1939.

"Five Famous Black Artists Presented by the Museum of the National Center of Afro-American Artists: Romare Bearden, Jacob Lawrence, Horace Pippin, Charles White, Hale Woodruff." National Center of Afro-American Artists, Boston, Massachusetts. February 9–March 10, 1970.

"Four Monuments to Malcolm X." (Barbara Chase-Riboud.) Bertha Schaeffer Gallery, New York. February 7–26, 1970.

"Fred Eversley: Recent Sculpture." Whitney Museum of American Art, New York. May–June, 1970.

"George Smith." Everson Museum of Art, Syracuse, New York. December 15, 1973–January 14, 1974.

"Grafton Tyler Brown: Black Artist in the West." Oakland Museum, Oakland, California. February 11–April 22, 1972.

"Harlem Artists '69." Studio Museum in Harlem, New York. July 22–September 7, 1969.

"Harlem Art Teachers' Exhibit." Harlem Community Art Center, New York. October 17, 1938.

"Harlem Art Workshop Exhibition." New York Public Library, 135th Street Branch, New York. 1933.

"Henry O. Tanner: An Afro-American Romantic Realist." Spelman College, Atlanta, Georgia. March 30–April 30, 1969.

"Highlights from the Atlanta University Collection of Afro-American Art." The High Museum of Art, Atlanta, Georgia. October, 1973.

"H. Pippin." The Phillips Collection, Washington, D.C. February 25–March 27, 1977.

"If the Shoe Fits, Hear It!" (Dana Chandler.) Northeastern University Art Gallery, Boston, Massachusetts. March 8–April 2, 1976.

"In Honor of Dr. Martin Luther King, Jr." Museum of Modern Art, New York. October 31–November 3, 1968.

"Jacob Lawrence." American Federation of Artists, New York. 1960.

"Jacob Lawrence." Whitney Museum of American Art, New York. May 16–July 7, 1974.

"The John Henry Series and Paintings Reflecting the Theme of Afro-American Folklore." Fisk University, Nashville, Tennessee. February 22–March 30, 1970.

"Joseph Delaney, 1970." The University of Tennessee, Knoxville, Tennessee. September 27–October 15, 1970.

"The Language of African Art." Fine Arts and Portrait Gallery Building, Washington, D.C. May 24–September 7, 1970.

"Lois Mailou Jones: Retrospective Exhibition." Howard University Gallery of Art, Washington, D.C. March 31–April 21, 1972.

"Los Angeles 1972: A Panorama of Black Artists." Los Angeles County Museum of Art, Los Angeles, California. February 8–March 19, 1972.

"Marie Johnson, Betye Saar." San Francisco Museum of Modern Art, San Francisco, California. April 15–May 29, 1977.

"Masterpieces of African Sculpture." Joe and Emily Lowe Art Center, Syracuse University, Syracuse, New York. February 16–April 1, 1964.

"Melvin E. Edwards, Jr." Whitney Museum, New York. March 2–29, 1970.

"The Negro Artist Comes of Age: A National Survey of Contemporary American Artists." Albany Institute of History and Art, Albany, New York. January 3–February 11, 1945.

"Negro Artists of the Nineteenth Century." Harlem Cultural Center, New York. 1966.

"The Negro in American Art." University of California, Los Angeles, California. September 11–October 16, 1966.

"Negro in Art Week." Art Institute of Chicago, Chicago, Illinois. November 16–23, 1927.

"New Names in American Art." The G Place Gallery, Washington, D.C. June 13–July 4, 1944.

"New Orleans Collects: African Art." Isaac Delgado Museum of Art, New Orleans, Louisiana. February 2–March 31, 1968.

"New Perspectives in Black Art." The Oakland Museum, Oakland, California. October 5–26, 1968.

236

"New Vistas in American Art." Howard University Gallery of Art, Washington, D.C. March–April 1961.

"Norman Lewis: A Retrospective." City University of New York, New York. October–November, 1976.

"Other Sources: An American Essay." San Francisco Art Institute, San Francisco, California. September 17–November 7, 1976.

"The Painter's America, Rural and Urban Life, 1810–1910." Whitney Museum of American Art, New York. September 20–November 10, 1974.

"Paintings and Sculptures by Four Tennessee Primitives." Nicholas Roerich Museum, New York. January 12–February 9, 1964.

"Paintings by Ellis Wilson, Ceramics and Sculpture by William E. Artis." Carl Van Vechten Gallery of Fine Arts, Fisk University, Nashville, Tennessee. April 18–June 2, 1971.

"Paintings, Sculpture by American Negro Artists." Institute of Contemporary Art, Boston, Massachusetts. January 5–20, 1943.

"Palmer Hayden." Carl Van Vechten Gallery of Fine Arts, Fisk University, Nashville, Tennessee. 1970.

"The Portrayal of the Negro in American Painting." The Bowdoin College Museum of Art, Brunswick, Maine. 1964.

"The Prevalence of Ritual." Museum of Modern Art, New York. 1971.

"Prints and Paintings." Union South Gallery, University of Wisconsin, Madison, Wisconsin. February 7–25, 1972.

"Raymond Saunders: Recent Work." University Art Museum, Berkeley, California. January 6–February 22, 1976.

"Rebuttal Catalogue: Catalogue of the Rebuttal Exhibition to the Whitney Museum." Acts of Art Gallery, New York. 1971.

"Reflections: The Afro-American Artist." Benton Convention Center, Winston-Salem, North Carolina. October 8–15, 1972.

"Resurrection II (An Exhibition of Works by the Weusi Artists)." Wesleyan University, Middletown, Connecticut. November 1–December 15, 1973.

"Robert S. Duncanson: A Centennial Exhibition." Cincinnati Art Museum, Cincinnati, Ohio. March 16–April 30, 1972.

"Sargent Johnson." The Oakland Museum, Oakland, California. February 23–March 21, 1971.

"The Sculpture of Richard Hunt." The Museum of Modern Art, New York. March 23–June 7, 1971.

"Selections of Nineteenth Century Afro-American Art." The Metropolitan Museum of Art, New York. June 19–August 1, 1976.

"Ten Afro-American Artists of the Nineteenth Century." Howard University Gallery of Art, Washington, D.C. February 3–March 30, 1967.

"A Third World Painting-Sculpture Exhibition." San Francisco Museum of Art, San Francisco, California. June 8–July 28, 1974.

"Thirty-ninth Arts Festival Exhibition. Sculpture by Richard Hunt, Paintings by Sam Middleton." Ballentine Hall, Fisk University, Nashville, Tennessee. April 21–May 17, 1968.

"Three Afro-Americans. Paintings by Merton Simpson, Sculpture by Earl Hooks, Photography by Bobby Sengstacke." Fisk University Art Galleries, Nashville, Tennessee. April 20–May 15, 1969.

"Three Graphic Artists: Charles White, David Hammons, Timothy Washington." Los Angeles County Museum of Art, Los Angeles, California. January 26–March 7, 1971.

"Three Negro Artists: Horace Pippin, Richmond Barthé and Jacob Lawrence." Phillips Memorial Gallery, Washington, D.C. 1946.

"Three Self-Taught Pennsylvania Artists: Hicks, Kane, Pippin." Museum of Art, Carnegie Institute, Pittsburgh, Pennsylvania. October 21–December 4, 1966.

"Tradition and Change in Yoruba Art." E. B. Crocker Art Gallery, Sacramento, California. 1974.

"Twentieth-Century Black Artists." San Jose Museum of Art, San Jose, California. September 3–October 8, 1976.

"Two Centuries of Black American Art." Los Angeles County Museum of Art, Los Angeles, California. September 30–November 21, 1976.

"William H. Johnson: 1901–1970." National Collection of Fine Arts, Smithsonian Institution, Washington, D.C. November 5, 1971–January 9, 1972.

Periodicals

Adams, Agatha Boyd. "Contemporary Negro Arts." *University of North Carolina Extension Bulletin*, June 1948.

"African Art—Harlem." *American Magazine of Art*, October 1932.

"Afro-American Artists 1800–1950." *Ebony* 23 (1967), pp. 116–22.

Albright, Thomas. "The Blackman's Art Gallery." *Art Gallery* (April 1970), pp. 42–44.

"American Negro Art." *New Masses*, 30 December 1941, p. 27.

"American Negro Art at Downtown Gallery." *Design*, February 1942, pp. 27–28.

"And the Migrants Kept Coming." *Fortune*, November 1941, pp. 102–09.

"And the Migrants Kept Coming." *Vogue*, September 1943, pp. 94–95.

Andrews, Benny. "The Black Emergency Cultural Coalition." *Arts Magazine* 44 (Summer 1970), pp. 18–20.

———. "On Understanding Black Art." *New York Times*, 21 June 1970, section 2, pp. 21–22.

"An Art Exhibit Against Lynching." *Crisis*, April 1935, p. 107.

"Artist in the Age of Revolution: A Symposium." *Arts in Society*, vol. 5, no. 3 (Summer-Fall 1968), pp. 219–37.

"The Arts and the Black Revolution Issue." *Arts in Society*, vol. 5, no. 3 (Summer-Fall 1968).

Ashton, Dore. "African and Afro-American Art: The Transatlantic Tradition at the Museum of Primitive Art." *Studio*, November 1968, p. 202.

Baker, James H., Jr. "Art Comes to the People of Harlem." *Crisis*, March 1939, pp. 78–80.

"Baltimore Art by Negroes." *Art News*, 11 February 1939, p. 17.

Barnes, Albert C. "Negro Art and America." *Survey*, 1 March 1925, pp. 668–69.

———. "Primitive Negro Sculpture and Its Influence on Modern Civilization." *Opportunity*, May 1928, p. 139.

Bearden, Romare. "The Negro Artist and Modern Art." *Opportunity*, December 1934, pp. 371–72.

———. "The Negro Artist's Dilemma." *Critique: A Review of Contemporary Art*, vol. 1, no. 2 (November 1946), pp. 16–22.

Bement, Alon. "Some Notes on a Harlem Art Exhibit." *Opportunity*, November 1933.

Bennett, Gwendolyn B. "The Future of the Negro in Art." *Howard University Record*, December 1924, pp. 65–66.

Bennett, Mary. "The Harmon Awards." *Opportunity*, February 1929, pp. 47–48.

"Black America 1970." *Art Time*, Special Issue, 6 April 1970, pp. 80–87.

"The Black Artist in America: Symposium." *Metropolitan Museum of Art Bulletin*, new series, vol. 27 (1968–69), pp. 245–61.

"Black Lamps: White Mirrors." *Time*, 3 October 1969, pp. 60–64.

Blodgett, Geoffrey. "John Mercer Langston and the Case of Edmonia Lewis, Oberlin, 1862." *Journal of Negro History* 53 (July 1968), pp. 201–18.

Bontemps, Arna. "Special Collections of Negroana." *Library Quarterly*, July 1944, pp. 187–206.

Bowling, Frank. "Black Art." *Arts Magazine* 44 (December 1969– January 1970), pp. 20–24.

———. "Discussion on Black Art." *Arts Magazine* 43 (April 1969), pp. 16–20.

———. "It's Not Enough to Say 'Black is Beautiful.'" *Art News* 70 (April 1971), pp. 53–55, 82.

———. "The Rupture: Ancestor Worship, Revival, Confusion, or Disguise." *Arts Magazine* 44 (Summer 1970), pp. 31–34.

Bradford S. Sidney. "The Negro Iron-Worker in Ante Bellum Virginia." *Journal of Southern History* 25 (May 1959), pp. 194–206. Reprinted in Meier and Elliot M. Rudwick, eds. *The Making of Black America*, vol. 1. New York: Atheneum, 1969.

Bushnell, Donald D., and Carew, Topper. "Black Arts for Black Youth." *Saturday Review*, 18 July 1970, pp. 43–46, 60.

Campbell, Lawrence. "The Flowering of Thomas Sills." *Art News* 71 (March 1972), pp. 48, 66–67.

Carline, R. "Dating and the Provenance of Negro Art." *Burlington Magazine*, October 1940, pp. 115–23.

Catlett, Elizabeth. "A Tribute to the Negro People." *American Contemporary Art*, Winter 1940, p. 17.

Childs, Charles. "Bearden: Identification and Identity." *Art News* 63 (October 1964), pp. 24–25, 54.

Coffin, Patricia. "Black Artist in a White World." *Look*, 7 January 1969, pp. 66–69.

Coleman, Floyd. "African Influences on Black American Art." *Black Art: An International Quarterly*, Fall 1976, pp. 4–15.

Conroy, Frank. "Salvation Art." *Metropolitan Museum of Art Bulletin*, new series, vol. 27 (1968–69), pp. 270–72.

Davis, Douglas. "What Is Black Art?" *Newsweek*, 1 June 1970, pp. 89–90.

Douglas, Carlyle C. "Romare Bearden." *Ebony*, November 1975, pp. 116–22.

Drummond, Dorothy, "Pyramid Club." *Art Digest* 24 (1 March 1950), p. 9.

Du Bois, W. E. B. "Criteria of Negro Art." *Crisis*, May 1926, pp. 290–97.

Ellison, Ralph. "Romare Bearden: Paintings and Projections." *Crisis* 77 (March 1970), pp. 80–86.

"Exhibition of Paintings and Sculpture by Negro Artists." *Montclair Art Museum Bulletin*, February 1946, pp. 3–4.

Fax, Elton C. "Four Rebels in Art." *Freedomways*, Spring 1961.

"Federal Murals to Honor the Negro." *Art Digest*, 1 January 1943.

"Fifty-Seven Negro Artists Presented in Fifth Harmon Foundation Exhibit." *Art Digest*, 1 March 1933, p. 18.

Fine, Elsa Honig. "Mainstream, Blackstream and the Black Art Movement." *Art Journal*, Spring 1971, pp. 374–75.

"Fisk Art Center: Stieglitz Collection Makes It Finest in South." *Ebony*, May 1950, pp. 73–75.

Gaither, Edmund B. "The Museum of the National Center of Afro-American Artists." *Art Gallery* 13 (April 1970), pp. 44–46.

———. "A New Criticism Is Needed." *New York Times*, 21 June 1970, p. 21.

Garver, T. H. "Dimensions of Black Exhibitions at La Jolla Museum." *Artforum*, May 1970, pp. 83–84.

Genovese, Eugene. "Harlem on His Back." *Artforum*, February 1969, pp. 34–37.

Ghent, Henri. "The Community Art Gallery." *Art Gallery* 13 (April 1970), pp. 51–55.

———. "Forum: Black Creativity in Wuest of an Audience." *Art in America* 58 (May-June 1970), p. 35.

Glueck, Grace. "A Brueghel from Harlem." *New York Times*, 22 February 1970, section 2, p. 29.

Greene, Carroll. "Perspective: The Black Artist." *Art Gallery* 13 (April 1970), pp. 1–31.

Grigsby, Eugene, Jr. "Art Education: An Overview." *Black Art: An International Quarterly*, Winter 1976, pp. 44–62.

Gunter, Carolyn Pell. "Tom Day, Craftsman." *Antiquarian* 10 (September 1928), pp. 60–62.

"Harmon Exhibit of Negro Art, Newark Museum." *Newark Museum Bulletin*, October 1931, p. 178.

"Harmon Foundation Exhibition of Painting and Sculpture, Art Center." *Art News*, 21 February 1931, p. 12.

Herring, James V. "The American Negro as Craftsman and Artist." *Crisis*, April 1942, pp. 116–18.

———. "The Negro Sculpture." *Crisis*, August 1942, pp. 261–62.

Hughes, Langston. "The Negro Artist and the Racial Mountain." *The Nation*, 23 June 1926, pp. 692–94.

Hunter, Wilbur H. Jr. "Joshua Johnston: 18th-Century Negro Artist." *American Collector* 17 (February 1948), pp. 6–8.

Jacobs, Jay. "The Cinque Gallery." *Art Gallery* 13 (April 1970), pp. 50–51.

———. "Now I'm Boss." *Art Gallery* 13 (April 1970), pp. 40–41.

Johnson, James Weldon. "Race Prejudice and the Negro Artist." *Harper's*, November 1928, pp. 769–76.

Jones, Lois M. (Pierre-Noel). "American Negro Art in Progress." *Negro History Bulletin*, October 1967, pp. 6–7.

———. "An Artist Grows Up in America." *Aframerican Woman's Journal*, Summer/Fall 1942, p. 23.

Kay, June H. "Artists as Social Reformers." *Art in America* 57 (January 1969), pp. 44–47.

Killens, John O. "The Artist in the Black University." *The Black Scholar* 1 (November 1969), p. 6

Kramer, Hilton. "Black Art and Expedient Politics." *New York Times*, 27 June 1970, section 2, p. 19.

———. "Black Experience and Modern Art." *New York Times*, 19 February 1970, section 2, p. 31.

———. "Differences in Quality." *New York Times*, 24 November 1968, section 2, p. 27.

———. "Trying to Define 'Black Art': Must We Go Back to Social Realism?" *New York Times*, 31 May 1970, section 2, p. 17.

LeGrace, Benson G. "Sam Gilliam: Certain Attitudes." *Artforum* 9 (September 1970), pp. 56–58.

Locke, Alain. "American Negro as Artist." *American Magazine of Art* 23 (September 1931), pp. 210–20.

———. "Chicago's New Southside Art Center." *Magazine of Art*, August 1941, p. 320.

———. "Negro Art in America." *Design*, December 1942, pp. 12–13.

Marvel, Bill. "In Art Too, the Word is 'Soul.'" *National Observer*, 11 May 1970, p. 22.

McCausland, Elizabeth. "Jacob Lawrence." *Magazine of Art* 38 (November 1945), pp. 250–54.

McIvaine, Donald. "Art and Soul." *Art Gallery* 13 (April 1970), pp. 48–50.

Mellow, James. "Black Community, the White Art World." *New York Times*, 9 June 1969.

Neal, Larry. "Any Day Now: Black Art and Black Liberation." *Ebony*, August 1970, pp. 54–58, 62.

Nora, Francoise. "From Another Country." *Art News*, March 1972, pp. 28, 62–63.

"On Black Artists." *Art Journal*, Spring 1969, p. 332.

Perreault, J. "Henry Ossawa Tanner." *Art News*, December 1967, p. 47.

Pincus-Witten, Robert. "Black Artists of the '30's." *Artforum*, February 1969, pp. 65–67.

Pleasants, J. Hall. "Joshua Johnston, the First Negro Portrait Painter." *Maryland Historical Magazine* 37 (June 1942), pp. 121–49.

Pomeroy, Ralph. "Black Persephone." *Art News*, October 1967, pp. 45, 73.

Porter, James. "Afro-American Art at Flood-Tide." *Arts in Society*, vol. 5, no. 3 (Summer-Fall 1968), pp. 257–70.

———. "Four Problems in the History of Negro Art." *Journal of Negro History* 27 (January 1942), pp. 9–36.

———. "Negro Art on Review at the National Museum." *American Magazine of Art* 27 (January 1934), p. 34.

———. "Versatile Interests of the Early Negro Artist." *Art in America* 24 (September 1931), pp. 210–20.

Robbins, Warren. "The Museum of African Art and Frederick Douglass Institute." *Art Gallery* 13 (April 1970), pp. 55–56.

Rose, Barbara. "Black Art in America." *Art in America* 58 (September-October 1970), pp. 54–67.

Rustin, Bayard. "The Role of the Artist in the Freedom Struggle." *Crisis* 77 (August-September 1970), pp. 260–65.

Schjeldahl, Peter. "For Bob Thompson, a Triumph Too Late." *New York Times*, 23 February 1969.

"Second Afro-American Issue." *Art Gallery*, April 1970.

Siegal, Jeanne. "Robert Thompson and the Old Masters." *Harvard Art Review*, no. 2 (Winter 1967), pp. 10–14.

———. "Why Spiral?" *Art News*, September 1966, pp. 48–51.

Spriggs, Edward S. "The Studio Museum in Harlem." *Art Gallery* 13 (April 1970), pp. 46–48.

Stavisky, Leonard. "Negro Craftsmanship in Early America." *American Historical Review* 54 (1948–49), pp. 315–25.

"Symposium—Black Art: What Is It?" *Art Gallery* 13 (April 1970), pp. 32–33.

Thompson, Mildred. "Mildred Thompson, Sculptor." *Black Art: An International Quarterly*, Spring 1977, pp. 20–31.

Thompson, Robert Ferrisl "From Africa." *Yale Alumni Bulletin*, March 1971, pp. 16–21.

Thurman, Wallace. "Negro Artists and the Negro." *New Republic*, August 31, 1927.

"What Is Black Art?" *Time*, 1 July 1970, p. 90.

Wilson, Edward. "A Statement." *Arts in Society*, vol. 5, no. 4 (Fall-Winter 1968), pp. 411–16.

Winslow, Vernon. "Negro Art and the Depression." *Opportunity*, February 1941, pp. 40–42, 62–63.

Woodruff, Hale. "My Meeting with Henry O. Tanner." *Crisis* 77 (January 1970), pp. 7–12.

———. "Negro Artists Hold Fourth Annual in Atlanta." *Art Digest*, 15 April 1945, p. 10.

Young, J. E. "Two Generations of Black Artists, California State College, Los Angeles." *Art International*, October 1970, p. 74.

Index

243

246